AltaMira Studies in Food and Gastronomy

General Editor: Ken Albala, Professor of History, University of the Pacific (kalbala@pacific.edu)
AltaMira Executive Editor: Wendi Schnaufer (wschnaufer@rowman.com)

Food Studies is a vibrant and thriving field encompassing not only cooking and eating habits but issues such as health, sustainability, food safety, and animal rights. Scholars in disciplines as diverse as history, anthropology, sociology, literature, and the arts focus on food. The mission of **AltaMira Studies in Food and Gastronomy** is to publish the best in food scholarship, harnessing the energy, ideas, and creativity of a wide array of food writers today. This broad line of food-related titles will range from food history, interdisciplinary food studies monographs, general interest series, and popular trade titles to textbooks for students and budding chefs, scholarly cookbooks, and reference works.

Appetites and Aspirations in Vietnam: Food and Drink in the Long Nineteenth Century, by Erica J. Peters

Three World Cuisines: Italian, Mexican, Chinese, by Ken Albala

Food and Social Media: You Are What You Tweet, by Signe Rousseau

Food and the Novel in Nineteenth-Century America, by Mark McWilliams

Man Bites Dog: Hot Dog Culture in America, by Bruce Kraig and Patty Carroll

Hot Dog Culture in America

MAN BITES DOG

BRUCE KRAIG AND PATTY CARROLL

ALTAMIRA
PRESS

A DIVISION OF ROWMAN & LITTLEFIELD PUBLISHERS, INC.
Lanham • New York • Toronto • Plymouth, UK

Published by AltaMira Press
A division of Rowman & Littlefield Publishers, Inc.
A wholly owned subsidiary of The Rowman & Littlefield Publishing Group, Inc.
4501 Forbes Boulevard, Suite 200, Lanham, Maryland 20706
www.rowman.com

Estover Road, Plymouth PL6 7PY, United Kingdom

British Library Cataloguing in Publication Information Available

Library of Congress Cataloging-in-Publication Data
Kraig, Bruce.
 Man bites dog : hot dog culture in America / Bruce Kraig and Patty Carroll.
 pages cm. — (Altamira studies in food and gastronomy)
 Includes bibliographical references and index.
 ISBN 978-0-7591-2073-0 (cloth : alk. paper) — ISBN 978-0-7591-2074-7
(electronic)
 1. Frankfurters—United States. 2. Hot dog stands—United States.
 3. Food habits—United States. I. Carroll, Patty. II. Title.
 TX371.K69 2012
 641.6'6—dc23

 2012030076

⊗™ The paper used in this publication meets the minimum requirements of
American National Standard for Information Sciences—Permanence of Paper for
Printed Library Materials, ANSI/NISO Z39.48-1992.

Printed in Mexico

Contents

Acknowledgments

This book is the result of an almost twenty-year friendship during which we swapped ideas and Bruce swiped (always with permission) Patty's photographs to illustrate lectures on hot dog history and to use in other publications. The idea for *Man Bites Dog* comes from those lectures, most of which were centered on explanations of the meanings of Patty's pictures. We hope that readers will go to our site, hotdoggeries.com, for more of these pieces of art.

We thank all the people who own and run the hot dog places we visited over the years. All of them were unfailingly kind, generous with their time—and hot dogs—and were informative about what they did and about their lives. Both of us have a serious appreciation for the world they inhabit and for them. The same goes for hot dog makers from whom we learned a lot about the science and business of sausages.

We have the great luck to have had guides to hot doggeries in various parts of the country. First is John Fox, the New Jersey guru of all things doggie, who took us on an amazing tour of paradigmatic places in his home state— from near Newark to the Pennsylvania border. Without the ever-cheerful Doug Duda, who took us around and sampled everything, we would never have gotten through it all. Professor William Lockwood, the authority on Balkan culture and hot dog stands in Detroit and Flint, Michigan, guided us in southeastern Michigan, answered all of our questions, intelligent or not, and ate way too many coneys with us. Dan Strehl, who has written wonderful works on Mexican food history, took us to many a Sonoran stand in Tucson, filling us in on social and cultural history of a surprisingly (to us) diverse and culturally rich Tucson, Arizona. Without Linda Civatello we would never have made it through the traffic and complexities of Los Angeles. A well-known food (and screen) writer who has published the standard food history textbook used in culinary schools, she was amazed at the great varieties of hot dogs in Los Angeles. We have deep gratitude to her and to everyone else who pointed us in the right directions and, seriously, who sampled many a hot dog for us.

Both of us are also grateful to our spouses. Tony Jones came up with the book title, found us many an interesting tidbit to use, and has been subjected to more hot dog sampling and photographing than any respectable gentleman should be. Jan Thompson gave good advice on book organization, but mainly it is her undimmed love for Chicago-style hot dogs that spurs one on, especially when that means a trip to a favorite stand.

Our thanks, too, to Sally and Lisa Ekus, who made the connection to AltaMira Press, and to Wendi Schnaufer, who has shepherded us through writing and illustrating *Man Bites Dog*. It was like the proverbial herding of cats—who love hot dogs.

ACKNOWLEDGMENTS

Introduction

This is a book about one of the most humble of all American foods and a very symbol of American culture. In song and story, in all the popular media, the hot dog is celebrated as not just fun food, but as a presentation of how Americans think about themselves. Consider this: the world's greatest of all immigrant nations is a historical hot dog. Lots of ethnicities are mixed together, seasoned, and stuffed into a sleek, streamlined casing, and then given a joke name, "hot dog." Dress the dog in toppings that reflect the country's various regions, and we have an American icon.

The hot dog story is told by showing the places in which these unassuming sausages are sold and by the people who sell them. "Americanness" is not just eating any kind of hot dog, certainly not the characterless, home-microwaved types. To fully savor a hot dog gustatorially and culturally, it has to be eaten in its native setting—at stands, ballparks, from street carts, in the good open air of North America. That is what we'll show.

Two main themes run through the book. One is American ideologies and what hot dogs tell us about them. The second is the world of imagination. Each is connected to the other, and one of the best ways to explain these twins is by looking at hot doggeries in their natural settings.

Under the first category come our assumptions—our standard mythologies—about economics, individualism, and social mobility. It is about how and where we live and, especially, how Americans think about their places in the world. For instance, hot dogs are the great democratic food. Go to a hot dog stand or cart in New York, Chicago, Detroit, New Orleans, Oakland, or Los Angeles, among other cities, and sooner or later a cross-section of local society will appear—rich and poor, laborer and executive, high and low. It's the same at ball games, where people of all social standing rub elbows while stuffing the same kinds of hot dogs in their mouths between cheers or jeers.[1] Whether carried out in real life or not, social equality is a main American idea that runs through all of our history: it's what makes us suspicious of social pretension, and what could be less pretentious than a hot dog?

1

Hot dogs belong to the realm of entrepreneurs and small-scale markets. Hot dog stands are mostly owned by petty entrepreneurs who want to make a decent living. For new immigrants, this was and is a way to rise in the world, to "make it in America, the land of opportunity." Many do; some don't. Here is the American story, told from the very beginning: you, the individual, can make it by pluck and luck. Hot dog places are all about this. They're also about the neighborhoods in which the proprietors set them. The décor reflects their social and physical environments. A stand in a predominantly Mexican community will look very different from a "white bread" suburban one. An upscale hot dog stand, such as the great Hot Doug's with its mixture of standard Chicago hot dogs and exotic sausages, could never exist in the deeply ethnic and local South Side Chicago neighborhoods.

In a way, related to décor and vendors' expectations, hot dogs are a paradox. They are an industrially made food that is then turned into something individual, just like the décor of a stand or cart. Americans revere the idea of individualism and, at the same time, community. Going into a stand or standing on a street and eating from a cart gives strength to all of these feelings that rise from the experience. Think of it like a hot dog itself, meaty, juicy, and complex, and yet simple because packaged so neatly. Americans love simplicity in their culture, and there is nothing more basic than snacking on the little hot dog—only it's not that simple.

The second motif is that of the imagination. It is a kind of twilight zone, "a middle ground between light and shadow," where hopes, dreams, and culture are expressed by vernacular design and décor. If ever there was an "outsider art," the hot dog stand is it.

There's a reason why hot dogs places have particular kinds of designs. The stands may be simple boxes—or descendants of them—or carts and wagons. Some may be cookie-cutter–designed strip mall restaurants. But almost all are vividly colored, filled with bric-a-brac and with plenty of handmade vernacular art in their signage and logos.

To find out why, go to a hot dog stand and watch the diners. Upon getting their hot dog and fries, an otherworldly expression settles on the diners' faces. For the moments that they're in the dining area and eating that delectable dog, each one is out of the mundane world and in another. Whether dining alone or with others, the effect is always the same. Hot dog iconography reflects this fanciful world. Stands can look like hot dogs—images of happy hot dogs begging to be eaten, dancing hot dogs, flying hot dogs, well-dressed hot dogs, and even real dogs dressed as hot dogs grace eating places. Hot dogs are fun in this carnival world. Think Little Oscar and Munchkins, all imaginary, all American themes, and all in tacit opposition to the corporate business realm.

More than only fun, hot dogs to be consumed in public places represent a world as we remember it, or as we would like it to be. Who doesn't remember that hot dog bought at the neighborhood stand, or maybe even at Nathan's in Coney Island? Who doesn't look forward to going to a ball game with family or friends, or maybe a picnic, in anticipation of a perfect world, and all featuring America's great culinary creation?

DISCLAIMER

Dear Reader: We have tried our best to show the background and culture of hot dogs in America. In traveling across the United States and into Canada we quickly realized that this book cannot be a complete catalogue of hot dog styles. There are just too many hot dog eateries, and many, many more individual tastes to ever get them all in a slim volume, or even a big fat one. You have our deepest apologies. Nevertheless, we hope to have given you the core of the matter: the beautiful hot dog itself, embedded in and embellished with culture.

Because we know that there are so many opinions about everyone's favorite hot dogs, we invite readers to contribute to our blog, www.manbitesdogbook.com. Also see our website.www.hotdoggeries.com. Sharing ideas about hot dogging is always great, especially rational ones.

LORE AND HISTORY

THE BASIC HOT DOG

*A*ll living, breathing Americans know what hot dogs are, or think they do. Whether they call them frankfurters, franks, wieners, weenies, tube steaks, coneys, grillers, shaggy dogs, or just plain "dogs," everyone knows that hot dogs are tubes of meat, placed in buns with toppings.[1] They have always been the quintessential public dining treats—long before the rise of hamburgers—sold on streets, at fairs and festivals, at picnics (weenie roasts), and in fast food venues. From hot dog stands to service stations, hot dogs are everywhere American food is served.

The U.S. Department of Agriculture has a specific definition of them, to wit: hot dogs, also called frankfurters, wieners, or bologna, are made of very finely chopped (comminuted) raw skeletal meats from various livestock, mixed with seasonings, curing ingredients (that add color and flavor), and other semisolids, that are stuffed into casings, in which state they are cooked and smoked. Hot dogs are "link-shaped" and come in various lengths and diameters, hence tiny cocktail franks and jumbo half-pounders at Las Vegas's Slots-A-Fun Casino.

Like their namesakes, dogs—in the sense of the original domesticated wolf dogs and not the many genetically manipulated breeds we have today—few pure or natural hot dogs exist in the real world. Some artisanal makers, like Gilbert's Craft Sausages of Sheboygan, Wisconsin, are close. Gilbert's product is made with beef sirloin, beef, and water, with small amounts of salt and natural flavorings, in a beef collagen casing. This is ideal for high-end hot dog places, but most "hot dogs" fit the simple USDA definition. By far, most of them are skinless, meaning that the chopped meat is stuffed into an artificial casing, cooked, and then the casing is stripped off. It is a process invented in Chicago in the 1930s that is now the industry standard.

Nor are all hot dogs entirely made of nothing but meat. By rule, they are allowed to contain 10 percent water, 3.5 percent "nonmeat" binders and extenders such as dried milk or cereals, and 2 percent soy protein. As for fat,

 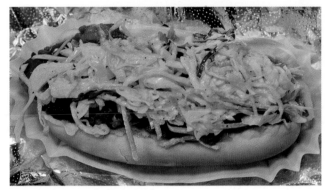

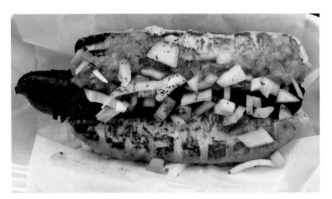

the substance that carries flavors, it adds a kind of texture, and even a fat flavor, and can be up to 30 percent of the total ingredients. A 2-ounce hot dog, the normal size, might be only 1.1 ounces of actual meat. Oddly, turkey and chicken hot dogs have no such restrictions on fat, so in theory they can contain far more of the substance than "normal" hot dogs.[2]

Some hot dogs are hybrids of highly processed meats and nonanimal protein substances, but other hot dogs are wholly nonmeat (aside from the small numbers of unavoidable insect parts allowed by law). Manufacturers of vegetarian products, such as Yves, Hain, Tofurky, and Field Roast, produce sausages whose central protein ingredient is either wheat gluten or soybeans (tempeh or tofu) or both. All of them need binders to hold their shapes, so Tofurky's franks label shows them containing "water, vital wheat gluten, organic tofu puree (water, organic soybeans, magnesium chloride, calcium chloride), expeller pressed non-hexane extracted isolated soy protein, expeller pressed canola oil, spices, sea salt, onion powder, evaporated cane juice, pepper, natural vegetarian flavors, natural smoke flavor, granulated garlic, xanthan gum, konjac flour, carrageenan, wheat starch, natural caramel color and annatto." Water, the first ingredient, goes toward the product's low calorie counts.[3] These kinds of "sausages" are not confined to home use or health food dining spots, but they are increasingly part of menus at newer, trendy hot dog places, especially in California and New York City. Vegetarian hot dogs are one of the best sellers at Vicious Dogs in Los Angeles, a place that caters to many young people. As for flavor, in a test of several major brands, *Consumer Reports* noted: "The dogs were so off the mark ('they seemed to just mimic real food,' said one tester) that even a vegetarian might find them hard to swallow."[4]

Hot dogs/sausages have other iterations. Some years ago Texas A&M University's agriculture department experimented with fish hot dogs. The result was a product that was described as canned tuna fish in a tube.[5] In parts of Chicago's South Side the mother-in-law dog is a local delicacy. A cornmeal-based "tamale" (not using traditional Mexican *masa* but Mississippi cornmeal grits, tamale style) is served in a hot dog bun with the usual Chicago condiments. The dish is a carbohydrate fiend's dream, but at least one stand serves it with an actual meat sausage in the middle of a split tamale.[6] Even Swedish (or Slovak) potato sausages usually served with a thick, dill-laced cream sauce have been known to appear in the middle of a bun. Like Italian or Polish sausages served on buns or bread, these might not be called "hot dogs," but they are analogs, eaten and thought of in the same ways.

If lots of products are called "hot dogs," then what are the common elements? Among them are the cultural power of the name, and the tubular shape. The world has other foods that come in generally oblong shapes. The tamale is a stuffed food, and *cevapcici* is a sausage-shaped chopped meat product familiar in the Balkans. Both can be served as street food, and they appear in the United States, but they just do not have the cachet of meaty hot dogs and will never really replace them in Americans' minds.

What makes the hot dog familiar, endlessly amusing as an object itself, to say nothing of lewd jokes, is the shape. The hot dog is a classic example of form following function, in architect Louis Sullivan's memorable phrase.[7] Since intestines are long tubes, stuffing them makes for cylindrical objects. The hot dog, wrapped meat defined by closure at each end, is an exemplar of industrial products, though invented in the preindustrial age. They are mass produced in a single shape and function as a portion-controlled food. In fact, they might be the

first such product in America. Hot dogs are easy to handle and convenient to prepare, hence they are perfect for street food vendors and consumers alike. Like many other factory-made prepared foods that followed, they embody the industrial processes that produced them. Eating a hot dog is really absorbing the history and current practices of America's entire food production systems.

HOW HOT DOGS ARE MADE

There is a folk saying, often attributed to Otto von Bismarck, apocryphally, and used in politics: "It's like sausage. You don't want to know how it's made." Many sausage eaters agree or are indifferent, but inquiring minds—to cop a phrase—want to know what they are and what is in them. And if sausages, hot dogs specifically, are industrially produced, then they also are the products of industrial history. As manufactured items, made by hand and machine, sausages are dressed in lots of cultural ideas, not the least being the fear of what is in them and the effects of their consumption on diners.

DANGEROUS DOGS

A political cartoon in the *Chicago Daily Tribune* of November 1, 1884, depicted political figures standing at the edge of a pig mire watching a pig with James G. Blaine's (the Republican presidential nominee that year) face on it. Standing on the bank is Carl Schurz, German-born, the great and utterly honest reformer, and although he is a Republican, he is an opponent of Blaine's. A thin figure with a beard says, "A pig is the true embodiment of everything that is excellent, it makes the frankfurter wurst, and both, like me, you must take on trust."[8] Most of us take hot dogs on trust of their federal inspection laws, even if we don't trust our political leaders.

Americans' relationships with industrially made foods have always been uncertain. The old advertising phrase "untouched by human hands" is meant to portray an image of gleamingly stainless steel machines, sanitary beyond hint of corruption by germs.[9] By that definition, hot dogs ought to be considered ideally safe foods, but in reality they are not seen as such. Anthropologists who have written about food in human cultures often observe that some foods are considered less desirable than others, to the point of taboo in some cases. Consider pork in Jewish and Muslim food practices, or less formally, eating canines and felines in most Western societies as examples. In anthropologist Mary Douglass's memorable phrase, the division is purity versus danger.[10] Hot dogs lie somewhere between those poles. Americans are told by the meat industry that the products are bacteriologically safe and protected by government regulations. When purchased in stores they seem to be hygienically packaged and labeled, so no dog or cat, lungs, and lips could be ingredients. But, historical memory lingers in folklore. That is, Upton Sinclair's novel, *The Jungle*, with its horrific description of unsanitary sausage making in a giant Chicago meat packing house in 1906, is the way that many people still view sausage making. Herbert Scott's poems "Ham" and "Red Meat," the former about maggoty meat, among many other horrors, are testimony to a wariness about meat in general in America.[11]

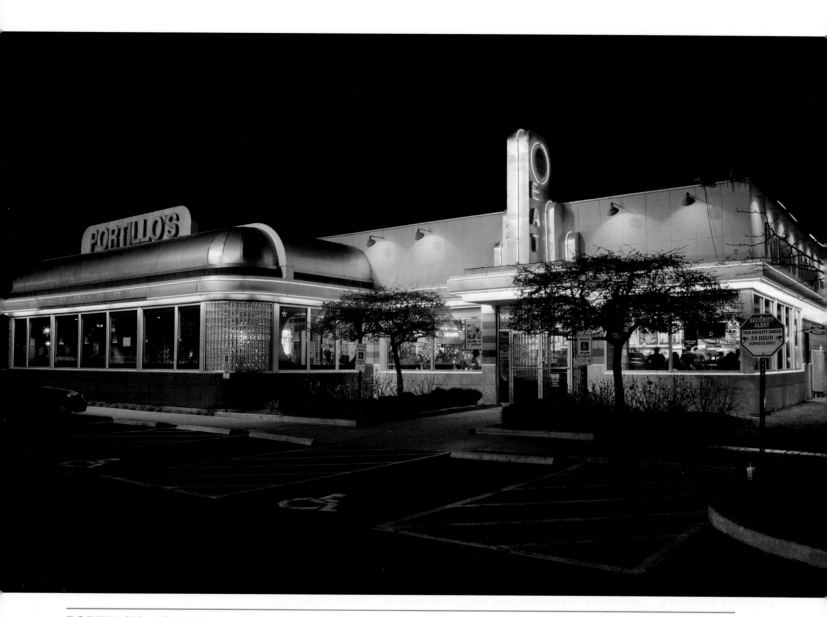

PORTILLO'S, FOREST PARK, ILLINOIS. A SLEEK, RETRO-1950'S STYLE WITH STREAMLINED FORMS.

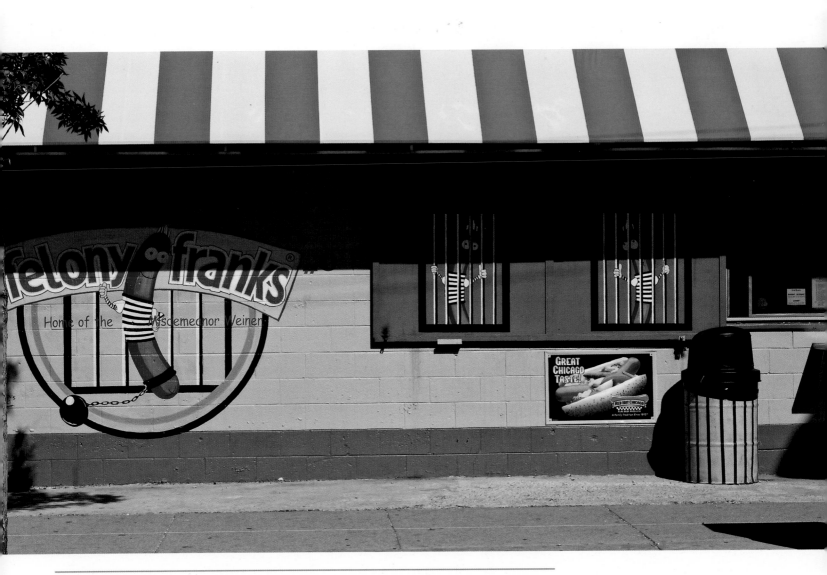

FELONY FRANKS, CHICAGO. DANGEROUS DOGS IN DANGEROUS PLACES.

Apart from ethical questions about eating animals, health is the main consumer concern about sausages in general, hot dogs in particular. In former days, "unclean ingredients" were both legitimate worries and the subjects of mordant jokes. In the twentieth and twenty-first centuries, advocates of "healthy" eating have brought hot dogs into low repute, no matter how many Americans consume them. The main culprit, according this view, is fat, but other ingredients might be just as dangerous. Sodium nitrite and nitrate are among them. A detailed and well-researched study published by the World Cancer Research Fund in 2010 shows that sodium nitrite can lead to carcinogenic "N-nitroso compounds (NOCs) in the [rodent and human] gastro-intestinal tract."[12] The report does not say that eating smoked meats absolutely will cause cancer in individuals, but organizations such as the Physicians Committee for Responsible Medicine (PCRM)—and many vegetarian websites—have declared that a fact. The PCRM put up a large billboard at the 2010 NASCAR Sprint Cup race in Indianapolis showing an open cigarette box filled with grilled hot dogs. One billboard in Illinois declares: "Hot Dogs Cause Butt Cancer," with an image of a male patient in a surgical gown opened in the back to reveal his posterior and holding a hot dog in his hand. Actually, the USDA considered banning nitrites in the 1970s, but decided not to do so, stating that small amounts in food were no danger to the public. That decision has never appeased critics, but it has pleased the processed meat industry.

Since the later decades of the twentieth century, cholesterol has become the great Satan of America's health industry. In voluminous literature and almost daily imprecations in the popular media, saturated fats are held responsible for all kinds of deadly ailments from clogged arteries to obesity. Naturally, hot dogs are on the grill, as it were, because the meat versions contain goodly quantities of "bad" fats. USDA regulations allow not more than 30 percent fat content in a hot dog; that is, in the standard 2-ounce hot dog a half ounce will be saturated fat. In a petition to the USDA in 2004, Michael Jacobson of the Center for Science in the Public Interest demonstrated that 1 percent of the total American consumption of these harmful fats came from hot dogs.[13] Considering the amounts of saturated fats in the American diet from other sources such as dairy products, one might not complain about an occasional hot dog. The nachos served at many public events are cholesterol nightmares, but these little sausages have a special place in the catalogue of dangerous foods.

Folktales about the danger of eating dogs go further, as we shall see, in the name itself. A few years ago a reporter for a local Chicago television station gave a breathless account of a near-fatal event at a picnic held in a county forest preserve. A middle-aged woman told about how her very young niece had nearly choked to death on a chunk of hot dog. "I always tell them, don't never give babies hot dogs," she said, shaking her head and clucking her tongue. She echoed a commonly held fear that babies should never be fed hot dogs because small pieces can clog a tiny gullet. More proof comes from the 1989 movie *Field of Dreams*, itself now part of American mythology, and the book on which it is based, W. P. Kinsella's *Shoeless Joe* (1982). In both, a young girl, Karin, is choking on a piece of hot dog lodged in her throat and is saved by a ballplayer-doctor Archibald "Moonlight" and "Doc" Graham (an actual person who played in only one inning of a major league game in 1905). It is a heroic and touching moment that every viewer and reader understands. In 2010 the American Academy of Pediatrics issued a warning about almost the same thing. The group suggested that hot dogs be redesigned so that "their size,

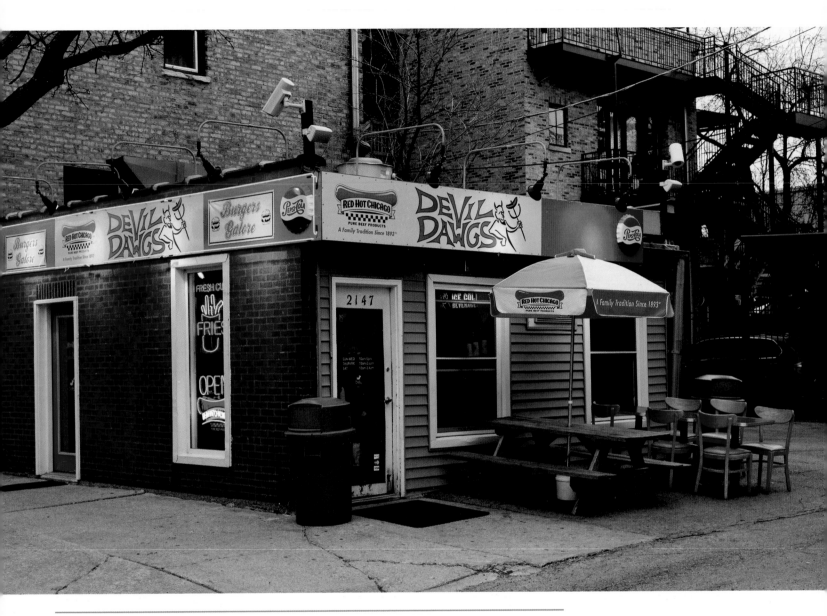

DEVIL DAWGS, CHICAGO. NOTHING COULD BE MORE EVIL THAN THE DEVIL.

shape, and texture make them less likely to lodge in a youngster's throat." Food safety guidelines published by the USDA say very much the same thing, only they add precautions about avoiding bacterial contamination, namely listeria.[14] Hot dogs might be contaminant-free but dangerous in other ways.

MANUFACTURING

Years ago the scientist C. P. Snow suggested that in the modern world of thought there were two cultures, science and humanities. The same can be said for the hot dog world. On one side are aficionados, critics of various stripes, plain fans, and casual consumers. The people who work in the industry dwell in the other realm. Here are the people who make and sell them. They range from the scientists who know about the chemistry, physics, and mechanisms of production to the executives and street-level sales forces that market and distribute hot dogs. Sometimes the divide is crossed by serious amateur researchers, but on the whole what the makers do is something of a magical mystery for most consumers.

An educated hot dog lover ought to know something about how are they made and what is actually in them. This is especially so because hot dogs embody the concept, history, and both trust in and fear of America's industrialized food system.

Meat trimmings (meat cut from the bone) of beef and/or pork, poultry in some sausages, are cut or ground into small pieces and placed in a mixer. High-speed choppers blend the meat, spices, ice chips, and curing ingredients into an emulsion or batter. The mixture is then pumped into an automatic stuffer/linker machine, where it flows into casings. Most hot dogs use cellulose casings, which are later removed. Natural and collagen casings are left in place. The long-linked sausages are sent to a smokehouse, where they are cooked and smoked under temperature-controlled conditions. They are then delinked by cutters and packaged in various ways.[15]

This description is neater and simpler than the actual process, because a great deal of science and engineering goes into sausage production. Like all technologies, hot dog machinery developed over time for varieties of reasons. Among them were demand from the public for cheap meat products, the meat producers' desire to maximize every part of the animals they were processing, and the impetus of technology itself. That is, people working in an industry usually look for ways to optimize the machines used. They are driven by the notion that new mechanisms and ways of doing things can do the job better than old ones. The innovators might be profit-driven, but like the late Steve Jobs, they are more often moved by the general idea of progress and the art inherent in the creation of the "new and improved." Lest this sound esoteric, the world would not have the fast food industry it does today without these motivating ideas.

Hot dogs are imbued with history, and that means the history of food processing as well as popular culture. Meat is a bloody business and often dirty. Before there were machines to grind and chop meat and press them into hollow animal guts, everything had to be chopped by hand using cutting blades. Encased meats go back to the last Ice Age, if *kiviak* is any example. A delicacy among Inuit people of Greenland, it consists of placing a dead auk (a kind of gull resembling a penguin) in sealskin and burying it for some seven months—until it is fully rotted.

The result is a stinky dish with a slightly sweet flavor. Cooks in ancient Europe certainly stuffed animal intestines and stomachs with cut-up meat and seasonings, classical Roman and Greek recipes being well known.[16] Less appetizing animal parts as ingredients are represented by the famous Scottish haggis, made with sheep organs and oats. Haggis might even be a holdover from the early postglacial or Neolithic (first farmers) age. For millennia the technology of encased meats remained the same.

Food was and is a central part of the industrial and commercial revolutions that began in the later eighteenth century. For homemade sausages, the manual meat grinder is essential. It was evidently invented in the first half of the nineteenth century by the German Karl Wilhelm Friedrich Christian Ludwig, Freiherr Drais von Sauerbronn, better known as Karl Drais. Using a screw and interchangeable cutting-plate technology, Drais's device remains essentially unchanged, unlike the primitive, pedalless bicycle that he invented (he is considered to be the father of all bicycles). Since its introduction in nineteenth-century America almost every American farm family owned one, many bought from mail-order catalogues such as Montgomery Ward and Sears, Roebuck and Company. Butcher shops also used them for basic ground meats such as loose sausage meat and sausage patties widely sold today. Various animal parts might be ground up, but home cooks used only skeletal meats. Not so large-scale producers.

Beginning in the early nineteenth century up to the present day, a series of inventions led to faster chopping and grinding of meat. Before the Civil War (1861–1865), individual butchers made sausages in their shops, by now increasingly German ones. In a pioneering New York City market survey, Thomas Farrington De Voe wrote in 1867: "The best sausages are prepared altogether from pork, chopped small, seasoned, and run or stuffed into casins [gut casings]. Those made in the city are usually quite small in size, as the meat is run into the lamb casins [sic]."[17] De Voe understood the danger of sausages: "There is danger, also, in the kind and quality of the flesh which some use, it being almost impossible to tell, from outward appearance, of what animal or in what condition the flesh was, when hid in those skins; and the only protection for the buyer is to purchase of those dealers who are certainly known to you, or else to buy the meat and prepare it yourself." The author also mentions a predecessor of hot dogs, sold to working men, Common Pudding. "These puddings are made of the pork skins, beeves' head meat, pigs' liver, etc., seasoned and stuffed into beef's casins [sic], and cooked." Mysterious ingredients, cheap prices, and a filling dish are all hallmarks of the hot dog business and mythology.

The march of progress meant greater efficiency, and that meant new machines. In the words of a European-trained master baker, "First, you have to learn how to work with your machines." The same holds for sausages generally, and especially hot dogs because most of the latter are machine-made, produced in huge quantities, and sold in wide regional or national markets. Local butcher shops and smaller manufacturers make hand-crafted sausages, and some do hot dogs for specialized markets, such as the dogs used at Otis Jackson's Soul Dog in Los Angeles and other upscale hot dog restaurants.

The first industrial sausage machines were power choppers, much of the technology coming from the sausage fatherland. Germans have always been innovators in food technology; for instance, Germans invented stainless steel grain grinding mills and chocolate-making machinery that revolutionized American food manufacture.

The earliest knife-cutter–style power choppers came to meat processors in the 1860s, some American, others German. The Millet bowl cutter, a revolving bowl in which knifelike blades moved across the meat, was patented in 1853, and many other equipment makers followed this design.[18] Steam-powered choppers were in use by 1868; the first invented by John E. Smith processed a hundredweight in thirty minutes. Within a generation more sophisticated mixers and choppers, such as the famous Hobart Buffalo bowl chopper (1905), and machines made by the Cincinnati Butchers Supply Company were in wide use.[19] Ever-increasing speeds of choppers could reduce large amounts of meat and trimmings (mainly fat) into a slurry, ready for stuffing.

By the 1920s, choppers were up to about twenty-four hundred pounds per hour. By the turn of the century huge amounts of meat, trim (basically fat), and scraps could be chopped and ready for sausage machines. In 1935 Usinger's in Milwaukee boasted that its silent cutter had six blades revolving at fifteen hundred times per minute to reduce hundreds of pounds of meat to sausage size.[20] Today, fifteen-hundred- to three-thousand-revolution bowl cutters are common. Until new cutters came into the market, open bowl types could be dangerous. Sausage makers often lost fingers, the numbers lost being marks of honor.[21] There was nothing new in such injuries—they have always been a hazard of butchery.

The industrialization of food involves not just processing it, but transportation systems. It is widely thought that today's supermarket foods, both raw and processed, travel at least fifteen hundred to two thousand miles to get to the consumer. In the first era of industrialization the raw materials for sausages had to be brought to the production sites. Some American cities became production centers. Chicago, a prime example, began using locally grown animals. It is difficult to navigate diagonal streets that were old trade and cattle trails. One of them, Clybourn Avenue, was named for the city's first butcher. Indiana farmers moved their animals up a trail later called Michigan Avenue (and earned scorn from city folks who called them "hicks" and "Hoosiers"). Even larger cattle-herding enterprises brought Texas beef to Kansas in the middle of the nineteenth century and provided subject meat for later Western movies. All of these were replaced by railroads in the 1850s and 1860s when large-scale meat production took off.

Machines and production techniques evolved to implement the new food systems. Railroads were one area of innovation. Refrigerated cars, first used in 1850 to bring fruit from southern Illinois north and then meat from Chicago and Hammond, Indiana, to the east, revolutionized the way meat was processed, preserved, and sold. Most important were new stockyards where cattle and hogs were brought. From Chicago and Hammond, Topeka and Kansas City, large yards appeared across the Midwest. Cincinnati had already been called "Porkopolis" because of its massive production. Chicago would outdo the Queen City beginning in 1865, when Chicago's Union Stockyards were founded. At its height, the yards are said to have slaughtered and processed fourteen million to eighteen million animals a year, including a few human ones, according to Upton Sinclair. Innovations were early. In 1865, *The Jonesboro Gazette and Egyptian Vindicator* reported the following:

> They kill pigs by steam in Chicago. A great iron claw hooks out the pigs which are quarreling in the pen below, and lifts the porkers to a gibbet nearby, and then plunges them again into scalding water. By the machine fifty porkers were killed, scalded, cleaned and split and hung in rows ready for salting within an hour.[22]

No doubt, the greatest change in the meat industry was the invention of the processing plant. In the 1870s huge ones were built by such entrepreneurs as Gustavus Swift and Philip Armour. Both were dis-assembly lines (Henry Ford's concept of the automobile assembly line seems to have been influenced by Swift's factory) where animals were brought into upper floors, and then broken down on successively lower floors. The sausage-making section was on the bottom floor amid offal and other leftover scraps. It was here that cheap sausages for the poor masses were made. As Swift is alleged to have said, he used every part of the pig but the squeal (or grunt in some versions).

Companies such as Swift, Armour, Morris, Hammond, Cudahy, Morrell (in Cincinnati), and Hormel (Austin, Minnesota) all produced meat in similar manner for the national market. Most of them are still in business, if not as independent companies then as brand names, and they all make hot dogs. Hot dogs still stand as core businesses even though they began life as mass-market products left over from processing.

The hog killing and processing in 1865 mentioned above were crude and inefficient. In 1946 Ray Townsend invented a pork skinner that replaced the old, time-consuming, hand-cutting method. He sold it to meatpackers in the Chicago stockyards, and it quickly became an industry standard. Townsend was a Des Moines, Iowa, native who spent a lot of time in his father's machine shop. A tinkerer and inventor all of his long life (he died in 2011 at age ninety-seven), his most famous contribution to the meat industry was the Frank-a-Matic hot dog machine. Introduced in 1960, the machine was a continuous-flow system that produced thirty hot dogs per hour using only two machine operators.[23] Within two years almost everyone in the industry used it because it brought sausage prices down by perhaps half.

At about the same time, Oscar Mayer and Company, located in Madison, Wisconsin, invented their much-publicized wiener tunnel, dubbed the "hot dog highway." In 1958 Edward C. Sloan, the company's vice president and director of research, put together a team to discuss ways to increase production of their eponymous "wieners." The company had been buying up manufacturing facilities around the country and was now expanding into a national brand, but capital for new building was limited. Originally they thought that an integrated system would be as large as a football field if it were constructed as a linear assembly line. The final solution was something described as a "roller coaster" of manageable size. Raw meat went in one end, was chopped-comminuted-mixed, seasoned, stuffed, smoked, stripped of its artificial casing, and finally packaged in an anaerobic package. Willie Wonka's chocolate factory is really a sweet vision of the same sort of process. Dow Chemical worked closely with Oscar Mayer, using their new Saran-coated polymer film. Oscar Mayer hot dogs then had a much longer shelf life than they had previously and could be produced in one-tenth the time as with previous methods. Thus, the true mass-market hot dog was born, but only after dealing with a major bottleneck, casings.[24]

Natural casings are usually prized by discriminating hot dog fans because they give the product a "snap" when bitten: texture is important here, just as it is in many other foods. These casings are animal intestines, and diameter varies according to the creature, but not exclusively. Pig intestines can range from one-and-one-eighth inches to two-and-one-fourth inches; sheep intestines are similar, and beef can be up to four-and-one-half inches. The usual two-ounce hot dogs will use smaller casings; large ones, such as quarter-pounders, will call for larger diameters. Most natural casing sausages, including chicken ones sold in upscale markets, use pork, while

MAN BITES DOG

all-beef ones that descend from kosher sausages use sheep. These sizes dictate sausage weight—either eight or six to a pound, and even after natural casings were no longer used, hot dog sizing remains the same. Actually stuffing these with chopped meat is time consuming and takes some skill since the walls of many intestines vary in thickness and might tear. They are also uneven in exact size, so using them in the past meant not having uniformity—a problem for mass marketers. Today there are machines for that, such as Marel Corporation's (the owner of Townsend Manufacturing) MasterTwist Pro.[25]

Guts are by-products of the meat industry. As food in and of themselves, they are mainly eaten in ethnic communities, the best known being chitterlings, a staple of African American fare. Of course, they are mainstream in sausages. In the new abattoirs of the post–Civil War era, animal guts became big business, and they are labor intensive and foul: intestines stink. Heavy scraping and washing by hand were not pleasant. But casings were big business after the mid-nineteenth century, and still are.

In the 1880s large processors such as Armour and Swift in Chicago sent their casings to Cincinnati to be processed and then returned to be used in sausages. Casings tend to be delicate, not exactly uniform in size, and expensive since most sheep casings are imported from such places as New Zealand and Australia. The best alternative came in the 1920s when Chicagoan Erwin O. Freund invented cellulose casings made from purified cotton cellulose. Once filled with the meat slurry, cooked, and smoked, the casing was stripped off. The line running down one side of packaged supermarket hot dogs is the remnant of being stripped with a cutting blade. Freund's company, Visking Corporation (now Viskase), altered the hot dog business and made skinless hot dogs, the dominant breed.

Collagen casings are another form of casing. Invented in the 1920s, they are made from chemically treated cowhides, the slurry then extruded to form sausage casings. In the 1960s scientists at Johnson and Johnson were looking for stronger medial suture material, and they extracted the central layer of cowhide and found that the proteins are edible by humans. Invented in that year in England were coextrusion machines, such as Marel's Townsend XQ Systems, to extrude sausages with precisely formulated collagen coatings. Using collagen or the alternate algenate (a coating made from brown algae) or a hybrid of the two, sausages can be shaped to exact specifications.[26] Many kosher sausages are made this way, and a number of artisanal companies, like Gilbert's, use the system. The result is a hot dog with good texture that approximates a natural casing.

Depictions of sausages in the past often show them in long, linked chains. Even with many modern machines, tubes of sausages have to be twisted into the requisite lengths, and in former days, individual sausages were twisted and tied with string. Some can recall seeing long strings of them in retail stores, such as the food sections of old department stores and in modern, usually ethnic, butcher shops. Cutting them in factories was skilled work, usually by highly dexterous women who could gauge size by sight.[27] Murray Handwerker, the son of Nathan's Famous hot dogs founder, Nathan Handwerker, recalls working at the Coney Island stand in the 1930s. Among his jobs were unloading boxes of hot dogs from delivery trucks, opening them, and hand cutting the links into individual sausages. Very tedious, he said, and not nearly as much fun as being in the front of the house with customers.[28] Some manufacturers still hand cut hot dog links, but for larger operations, there are cutters built into continuous flow machines or separate ones. In any case, integrated hot dog machines are the order of the day for the mass market.

WHAT'S IN THE HOT DOG, ANYWAY?

Not all sausage companies use continuous-flow processes; many smaller, regional companies make their products in batches. When asked about bratwurst, James "Dr. Jim" Klement, copresident of Klement's Sausage Company in Milwaukee, says that he makes sausages in batches. He thinks of the company's products as high quality, partly because of the artisanal qualities of smaller production. Fritz Usinger, of Usinger's, also in Milwaukee, agrees, noting that batches are easier to monitor and can be controlled for the kinds of flavors one wants. Both makers say that neither of them could never match a company such as Johnsonville (in Sheboygan) because the latter is a national company that could outproduce either by five or ten to one: Klement's makes about four million hot dogs a year, small in comparison to the national market. On the other hand, batch production allows smaller producers to do specialty products such as halal (Klement's does this) products because they can be made in discrete groups. Production volume may make for differences in hot dogs, but the art and sciences of sausage making, as Dr. Jim says, are what make each one unique.[29]

Hot dog aficionados distinguish between two major kinds of hot dogs: commodity products that can be found in any grocery store and sometimes called "kid's hot dogs," and "adult hot dogs." The latter means the kinds mostly sold at stands and hot dog restaurants and are made from the muscle meats trimmed from the bone, usually all-beef or pork and beef mixtures. John Fox, the guru of New Jersey hot dogs, says that he would never eat supermarket hot dogs because they have no flavor or texture. There certainly are differences, and much depends on markets and pricing.

According to the U.S. Department of Agriculture, frankfurters and wieners, also known as hot dogs and bologna, are cooked and usually smoked meat products. The meat composition varies by type of sausage, by manufacturer, and by price of ingredients in relation to the intended market. Meat, by USDA definition, means "the part of the muscle of any cattle, sheep, swine, or goats which is skeletal or which is found in the tongue, diaphragm, heart, or esophagus, with or without the accompanying and overlying fat, and the portions of bone (in bone-in product such as T-bone or porterhouse steak), skin, sinew, nerve, and blood vessels which normally accompany the muscle tissue and that are not separated from it in the process of dressing."[30] The controversial "pink slime" that has been banned in schools and by fast food corporations across the country is just this product.

Most hot dogs, and certainly the better varieties, are made from meat trimmings. By definition these are "derived from the skeletal muscle of a carcass. There are grades of trimmings, ranging from in pork from harder to soft, and in beef with or without connective tissue. For beef, sausage makers can use more of the muscle, called Grade 1 or 2 (10 percent), or lesser trimmings containing more fat (20 percent)."[31] Hot dog makers know these properties and adjust ingredients accordingly.

Fat, evil to some, delicious to many, is necessary in all sausages; without it a sausage would be so dry as to be inedible. Sausage makers carefully regulate how fat and proteins work in their products. In making the emulsion to be used in stuffing, water and meat are mixed to encapsulate fat. Myocin is the acting protein, and it needs salt, plus the water, to release it from the muscle fiber. Knowing how this works and using it to make

the kind of sausage one wants, along with seasonings, goes to the art of the sausage maker. Jordan Monkarsh, founder of the celebrated Jody Maroni's Sausage Kingdom stand at Venice Beach, California, and an upscale sausage manufacturer, says that he is forever in search of ways to encapsulate fats and thus make the greatest sausages he can.[32]

Regulations control fat—hot dogs cannot contain more than 30 percent fat and a maximum of 10 percent water. However, if the fat level is 25 percent then 15 percent may be water. Again, water and salt are critical to making sausages. Other fillers can include 3.5 percent "non-meat binders and extenders (such as nonfat dry milk, cereal, or dried whole milk) or 2 percent isolated soy protein," but they must be labeled as such. Nor are these all the additions to many hot dogs, since gelatins and carrageenan (made from seaweed), blood plasma, transglutaminase (an enzyme that helps in binding), sugar, corn syrup, monosodium glutamate (a flavor enhancer), food coloring, usually orange or red #40 (red #2 having been banned as carcinogenic in 1976), and preservatives—mainly sodium nitrite—are also used. Hot dogs that use all-natural ingredients, such as Gilbert's Craft Sausages, Applegate Farms, Nature's Rancher, American Grassfed Beef, and High Plains Bison, among others, make uncured products and substitute ingredients such as cultured celery juice powder, sea salt, and, in some, cherry powder.[33]

Because hot dogs are cooked sausages, most of them are cured and smoked. Before 1900 this meant brining sausage meat for weeks before processing, but industry innovations made for much faster cures. This meant that meat could be chopped with mixtures of salt, sodium, or potassium nitrate (saltpetre), or sodium or potassium nitrite. The nitric oxide produced combines with the myoglobin in the meat to create color in the sausage. Nitrites protect meat products from botulism and rancidity, and they allow flavors to remain intact. Ascorbic acid or sodium erythrobate is often added to the mixture to speed the curing.[34] Cures are usually sold in packets and mixed with seasonings. The latter are formulae proprietary to each manufacturer because they give each hot dog brand its unique flavor. Many flavor profiles are so similar to one another that they fall into styles, such as "Chicago" or "New York." Almost any formula can be deconstructed by chemists, and most sausage makers can replicate another's, but doing so has invited legal action. The most common seasonings in hot dogs are garlic (the most widely used), pepper, paprika, nutmeg, and mace. Specialized ones might also contain cloves, ginger, cinnamon, cardamom, chili powder, coriander seed, cumin, and pimento. Smoke also flavors the sausage. Most makers use a form of liquid smoke to speed the process, but really good producers use smoke pits with real wood—usually hickory—to impart much deeper flavors. For years Usinger's used smoke pits that went back to the company's founding in the 1880s. Many commodity brands' smoke flavors are very sharp and unpleasant, but as Jim Klement says, advances in chemistry have made liquid smoke products almost as good as pit smoking. The manipulation of these ingredients is part of the sausage maker's art.

"Adult" hot dogs are made with skeletal beef, pork, veal, or poultry, often from specific cuts such as sirloin. Many of the major national commoditized brands are mixtures of other meats. Chicken has become common, but not the kind of whole-meat poultry found in upscale brands. Deboning an animal by hand leaves scraps of meat on the bone, a waste of protein. In the 1960s mechanisms were devised to harvest the scraps. Mechanically separated

meat (MSM) is widely used in the industry and usually labeled on retail packages as "mechanically deboned," usually chicken or turkey. Several kinds of machines can be used to extract such meats—piston and belt systems and ones using high or low air pressure. For instance, chicken necks, wings, and incompletely deboned parts are put in a machine that uses an air pressure system to suck the remaining meat through filters. The result is a slurry that by rule must be at least 14 percent protein and not more than 30 percent fat. Bone particles are also permitted but can be no larger than .05 to .85 millimeters. Beef is also subject to harvesting, but bovine spongiform encephalopathy (mad cow disease) of the 1990s necessitates stringent control of beef MSM because spinal cord parts could slip into the mix.

Beef, pork, or mixtures of them make up most of the better grade of hot dogs, but the qualities of meats have changed over time. For pork, lower fat shoulder, called "picnic" cuts, and fatter bellies are common. For beef, the front of the animal is preferred, usually plate and chuck among other cuts. Both pork and beef have become leaner over the years as USDA grading guidelines have changed. Concerns about fat have made for less heavily marbled meats; that is, mainly grass-fed animals rather than those heavily fattened on feed grains. In past times, the best hot dogs came from Northern bull meat because it was said to provide more fiber, hence better mouth feel. Southern-raised cattle were thought to be too water laden. Actually, bull is rarely used because artificial insemination of cows precludes the need for bulls, so scarcity makes them expensive. Cattle bred for meat are a major source for hot dogs, but so are other bovines. The inseminated cows provide a portion of the meat for hot dogs—they are dairy cattle that have outlived their milking lives. The thought of old milk cows, especially pretty ones like Brown Swiss or Jerseys (Elsie the Borden Cow is a Jersey) might disturb Americans, but hot dog eaters rarely complain. After all, meat, milk, and eggs from factory farms—concentrated animal feeding operations (CAFO)—do not seem to bother most consumers, as long as the price is right.

Still, all-beef hot dogs have some prestige in the American market. Even mass producers such as Oscar Mayer and Ball Park make and strongly market their all-beef products. Fast food chains that claim to have better food than competitors, such as Sonic Drive-Ins and Steak 'n Shake, boast of all-beef dogs. One reason for this interest is that two hot dog traditions use all-beef dogs, Chicago and New York City. Another is the rise of interest in "natural" foods. A third is that since so many hot dogs are made from mechanically separated chicken with little flavor and texture, all-beef is touted as better in all ways. Cattle fed on pastures and not in feedlots fit these criteria. Within this category, certain cattle breeds have also been marketed as giving forth better sausages than others. Angus beef is one, now heavily marketed nationally by McDonald's, among others. Angus is a black-coated breed originally hailing from Scotland that has been naturalized in the United States since the 1870s to the 1880s. Although Angus is supposed to be well-marbled meat and tasty, it is doubtful that most hot dog, or meat, eaters can tell the difference between it and other varieties. To be truly Angus, cattle have to be certified by the American Angus Association. In reality, the cattle have been cross-bred for so long that many "Angus" cattle are just that, hybrid Angus. Certified Angus is quite expensive, the regular is not, so premium prices and the prestige value that goes with that are really only marketing tools. The same can be said for other single breeds.

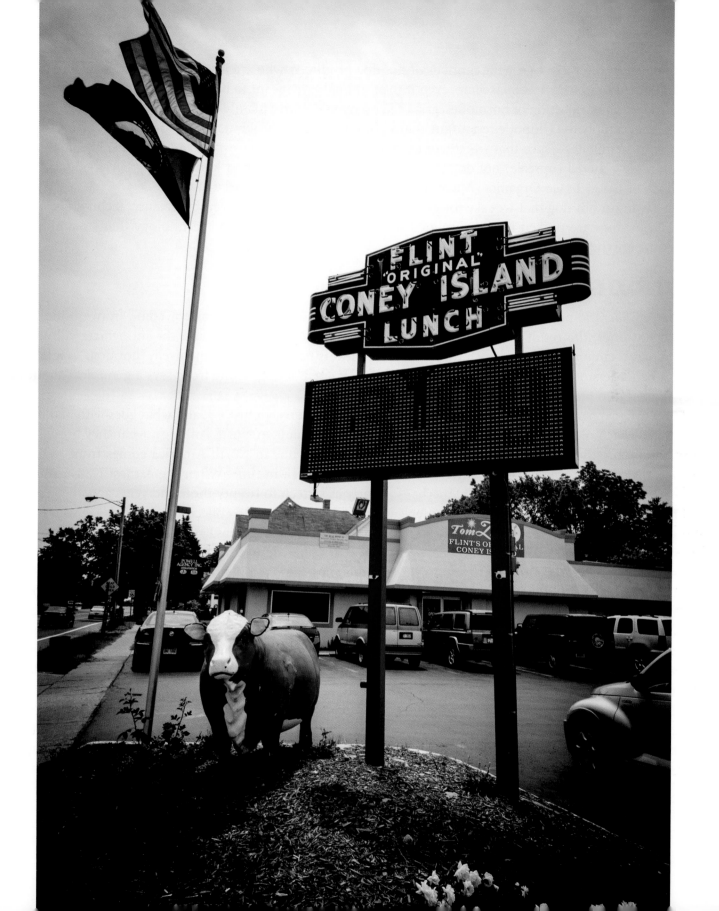

Nonetheless, there are a growing number of hot dog producers who are interested in sustainable agriculture, unadulterated food, and animal welfare, even if their animals are meant to be consumed by humans. Not raised by the ingestion or injection of hormones, grass-fed on open pastures mainly by rancher cooperatives like Niman Ranch (they supply the Chipotle restaurant chain), hot dogs using this kind of beef are usually unsmoked, with no nitrates or nitrites—save that which comes naturally from celery juice—and not artificially colored. More and more new model (upscale) hot dog stands serve these, among the best known being Let's be Frank in San Francisco or Good To Go Organics (Applegate Farms products) in New York City.

The common hot dog that we take for granted is the end result of considerable science, technology, and art. And all hot dogs are packed into streamlined tubes. In fact, the science and technology that streamline food processing are the real story of America's food.

HOT DOG HISTORY

As the pre-Socratic philosopher Parmenides said, more or less, something cannot come from nothing. So it is with hot dogs, the result of a long history of elemental food in America and the immediate cultural and technological circumstances in which they appeared. Meat is basic, but the name itself, "hot dog," is a joke that cannot be understood outside of its historical context. Where hot dogs come from says a good deal about how they slipped into popular culture.

There are two parts to the story: one being the sausage itself, a recent history; and what goes with and into the hot dog, a much older tale. The hot dog story is one of immigrants to North America, what they brought with them, and what they developed in their new lands. Since everyone in North America comes from immigrant origins, if not direct migrants themselves, the story goes far back in time. When the earliest Native American people began arriving on the continent, perhaps as early as sixteen to twenty thousand years ago, they certainly did not eat hot dogs because they were hunter-gatherer food foragers and collectors who lived on wild foods— some of which may have been encased. Later, actual dogs were on the menu, as Lewis and Clark discovered during their voyage of discovery to the Pacific Ocean from 1804 to 1806 (Meriwether Lewis liked dog meat a lot). What indigenous peoples did contribute to hot dog history is a grain basic to hot dog production: corn.[35]

Maize is a native crop of the Americas and was domesticated from a wild grass over at least two millennia in Central America—Mexico most likely. After about 2000 BCE it became a staple crop upon which the pre-Columbian civilizations of that region were based. Corn spread to North America during the later first millennium CE and was only a fairly recent food crop among the Wampanoags when English Puritans first set foot on the Massachusetts shore in 1620. The grain, also considered to be a seed and a vegetable, has been manipulated over the following centuries and is one of the major GM (genetically modified) ingredients sold by biotech companies today. Feed corn, all of it engineered in some way, makes up almost 50 percent of the nation's total corn crop. That is, almost all the meat eaten in the United States, almost all the meat used in hot dogs, comes from corn-fed animals. So great is the use of corn in this way that food writer Michael Pollan can state, justly, that a chicken nugget is nothing but corn transformed. Like a hot dog itself, the basic elements that go into it are the results of an industrial food system.[36]

Corn is not all that goes into the deeper history of hot dogs. Within the fast service sector of the restaurant industry, hot dogs have been called "hot dog sandwiches" almost from the beginning. They are called this since sandwiches are bread slices, buns, or rolls that are filled with another food and eaten out of hand. The first requirement is to have a wrapper, and in traditional America that means products made from wheat flour. The first European settlers—and conquerors—of the New World brought wheat with them. That grain was far more desirable than any other, not only for taste but also because it held far greater prestige value than barley, rye, or native corn. The new Americans brought several kinds of wheat, mainly soft varieties. These are very good for biscuits, quick breads, and pastries, but not so much for hot dog buns because such grains are low in gluten. High-protein flours that produce strong gluten are needed for buns that have to stand up to hot foods and even steaming, as in some classic hot dog styles. Hard spring and winter wheats do that. Varieties of hard wheats were introduced to the prairie lands of Minnesota in the 1870s and Kansas in the 1880s. The turkey red wheat brought by Mennonite immigrants from the Ukraine to the latter state is the most famous example, though most of the state's wheats were varieties brought and developed in the 1920s.

Technological advances made wheat into a commodity and hard wheats widely available to bakers across the nation. Beginning with Oliver Evans's powered flour mills on Pennsylvania's Brandywine River in 1790 (which food historian Andrew F. Smith places as perhaps the beginning of America's industrial revolution), to railroads linking the Midwest to the East Coast in the 1850s post–Civil War, wheat and flour could get to markets quickly. Improvements in milling such as grain-crushing powered steel rollers introduced by Cadwallader Washburn in his Minneapolis plants in the 1870s revolutionized the industry and gave rise to consumer-oriented companies such as General Mills and Pillsbury. Commercial bakers also grew with technology. In the 1890s new assembly-line machinery molded, weighed, and packaged automated baking so that large quantities could be produced—much like sausage production. Incidentally, sliced bread machines were invented in 1927, perfected with automatic wrapping in 1928, and made popular by Continental Baking Company's Wonder Bread brand beginning in 1930. These breads were all bleached white, just as we expect in buns today.[37]

Buns are important components of the hot dog eating experience, as any true hot dogger will say. Since the bun is a platform for the sausage and toppings, it cannot be too mushy, nor should it be too hard to chew. The texture and even the bun's flavor ought to merge with the sausage and toppings, at least in theory. The earliest mention of specific buns for frankfurters dates to 1871 and refers to Brooklyn's Coney Island boardwalk.[38] Called "milk rolls," they were probably a version of German weissbrot (white bread) using milk as the liquid to be mixed with flour. Recipes for milk rolls appeared in the mid-nineteenth century and in one 1908 book are called "Vienna Milk Rolls." It is not known if the sausage was served in the roll/bun or alongside it, as was common in Germany.[39] If it were used in a sandwich, then the bun would have been very soft and not acceptable to modern eaters.

Though modern buns are made with higher gluten flours, one solution to having a firm exterior is to toast the bun. Most buns are split lengthwise, down the sides, and loaded that way. Many of the griddled versions of hot dogs, such as on America's East Coast, have buns heated to almost crispness on the same griddle. New England buns are even more so. These are unique in that they have flat sides, are split along the top and filled that way. The

"bare" sides are often griddled to toasty. The Friendly's chain, founded in 1935, may have been responsible for making this bun style popular throughout New England and in select places around the country. Firm textures with more "mouth feel" are a mark of newer "upscale" hot dog restaurants. Hot Doug's is perhaps the most famous of them, owner Doug Sohn having his made especially for his various hot dog iterations. Otis Jackson's Soul Dog in Los Angeles and a number of others have followed suit. That French hot dogs use chewy baguettes may have had some influence, as might Italian American Philadelphia cheesesteak buns. Certainly chef-operated hot dog places such as Hot Doug's have European tastes and textures in mind.

The first hot dogs sold from carts, wagons, and trucks dressed their hot dog sandwiches with mustard and not much else. In the words of an 1899 *Kansas City Star* article: "Dog wagons are indigenous to New Haven and are the result of the appetites of Yale men who appreciate the fact that the hot wienerwursts snugly imbedded in rolls and covered in mustard are ready to bark at any time." The same has held for hot dogs sold by ballpark hot dog vendors for as long as they have existed. Mustard is a must for almost all hot dog iterations. The name itself comes from an Old French word that descends from the Latin *mustum* or "must," meaning unfermented or unaged wine. Literally, this means mustard seeds ground into a paste with a soured liquid, wine, or vinegar. Mustard, a brassica related to a wide variety of plants that include broccoli and canola (rapeseed), is probably the oldest condiment known to humans. It appears in Roman culinary sources, but its use likely goes back to at least the Paleolithic age because everyone likes a little spicy heat in at least some dishes. Medieval cookery books list several kinds of mustard, and it was commonly used throughout Europe from then to the present time. Any respectable colonial American household had mustard pots in their inventory of housewares. Mostly the mustards were coarsely ground yellow varieties.[40]

Today, there are many varieties of prepared mustards, but three styles dominate the hot dog market. Yellow mustard is the most common by far. French's, originally from Rochester, New York, claims to have introduced the now standard smooth yellow mustard in 1904, when their French's Cream Salad Brand appeared at the St. Louis World's Fair.[41] However, H. J. Heinz of Pittsburgh, Pennsylvania, had a bottled yellow mustard on the market as early as 1877. His was based on Bostonian William Underwood's (of deviled ham fame) successful bottling business begun in 1822. Heinz brought high-quality mustard seed from Europe and then developed an upmarket Düsseldorf mustard that was popular among Germans both in their homeland and in America.[42] Yellow mustard is made with yellow mustard seed (one of the three main varieties) mixed with turmeric, for yellow color, vinegar and various spices, depending on the manufacturer. All are mildly flavored. The Düsseldorf version is made with brown seeds that may be double ground to increase its pungent flavor. Düsseldorf, and a French-style Dijon (made with wine), can be found at the newer upscale hot dog places, but they will never reach the volume of yellow mustard consumption. One challenge to yellow dominance is Cleveland brown mustard. The original formula was invented by Joseph Bertman, a Polish immigrant, in 1920. In the 1930s it appeared in League Park, the Cleveland Indians' home, and it became widely popular. This mild mustard, made with vinegar, salt, and some sugar, is produced by both the Bertman Company and a rival, Stadium Mustard. Both products are now sold nationwide and are especially associated with sporting events.

SHELLY'S, CHICAGO. ALL-BEEF AND A WHOLE HISTORY OF FOOD ON A BUN.

Other hot dog toppings are just as old as mustard, and many come from the food traditions that entrepreneurs, mostly immigrants, brought with them. Chilies used in chili are Hispanic/Caribbean, as are the sport peppers used on Chicago hot dogs, only the latter are pickled, a European preserving technique. Tomatoes are New World in origin, most likely from the lower-elevation mountains of Peru and Ecuador by way of Mexico to Southern Europe and then back again to the Americas as Italian and Greek foods. Coney sauces of Michigan and Cincinnati contain cinnamon and other spices whose use goes back to the earliest Southwest Asian and Indian civilizations. These spices traveled in time and space through Persia, Mesopotamia, through Byzantium and Ottoman Turkey, into Greece and the Balkans, and thence to American fast food. Korean and Japanese styles add equally old ingredients, literally in the case of really good soy sauces. In short, lots of historically and culture-specific ingredients go in and onto a hot dog sandwich.

The operative word is "sandwich," because, as the former Philadelphia chef Fritz Blank has said, tongue-in-cheek, America's two greatest contributions to world cuisine are sandwiches ... and chewing gum. That McDonald's operates in almost every country in the world is proof of the former; gum-chewing GIs in world-flung bases the latter. But hot dogs came first in the United States. They are fast food and can be copious, as in the famed Dagwood sandwich of cartoon fame.

Americans have always dined quickly and copiously—especially prizing meat. European visitors to the new United States were awed and appalled by America's food and Americans' dining habits. In 1827 Frances Trollope, an English author (and mother of an even more famous one, Anthony Trollope), traveled by steamboat down the Ohio River to Cincinnati, to open a hotel. She tartly commented on the poor quality of preparations and the amount of ham and beef that people ate, morning, noon, and night (she was revolted by the amount of spittle from tobacco chewers that soaked the boat's carpets). The Frenchman Michael Chevalier visited the United States in 1836 and remarked that Americans' only concern in life was business and anything that distracted one from it, including dining, was a waste of time, for "time is money" ruled the stomach. Charles Dickens noted much the same thing when writing about his travels in America and lamented the speed and gluttony with which Americans ate (thus angering his devoted Americans fans). The frying pan was king in American cookery, producing food that glistened with fat and was quickly made. As food historian Harvey Levenstein has put it, "The national motto, according to one European, was 'Gobble, Gulp, and Go.'"[43]

Fast food is in our cultural blood, even though the name of our favorite version is not American in origin. There are many claims to antiquity of placing some food between two slices of bread, or in a roll. Though a 2006 ruling by a Worcester, Massachusetts, judge claimed that a sandwich has to have two slices of bread to be called such (in this particular case to differentiate it from a burrito), few people would argue that a hot dog, or a hamburger on a bun, is not a sandwich.[44] Any time there is bread, or some equivalent, and meat, eaten together while on the go, then the idea of a sandwich is already in place. The earliest street sausages, sold by German vendors, were always accompanied by bread. One suggestion is that such combinations were called "bread and meat," or "bread and cheese," in sixteenth-century England and were well known when the name "sandwich" was taken from John Montagu, the fourth Earl of Sandwich, about 1762. The standard story is that the Earl was a

card player (whist, or faro, perhaps) who was so addicted to gambling that he spent twenty-four hours a day at the table. Unable to tear himself away, he ordered beef between two slices of bread, and the name *sandwich* stuck. Research shows that Montagu was not a mad gambler but a dedicated public official who served in high offices, such as First Lord of the Admiralty (Captain James Cook named one of his discoveries after him, the Sandwich Islands, now called Hawaii). He did spend many hours at his desk and may have eaten such a creation there or while rushing around London on business, but not at the card table. Nevertheless, the same "sandwich" stuck, as historian Edward Gibbon noted in 1762.[45]

The important points are that sandwiches were ordered, thus ready-made by someone other than the eater, and that the name comes from a well-known aristocrat. That is, a name is a kind of branding that appears in the eighteenth century, driven by an attachment to social prestige. Were bread and cold meat not already commonly eaten together, this might be an example of trickle-down culture, from elites to mass consumers. The reverse also happens, as well, when a common, low-class name is taken up by middle and even upper social ranks as signs of democratic thinking or cultural appropriation. Like blue jeans, the hot dog is just one example among many.

Sandwiches appeared in America probably in the colonial era and were in wide use by the nineteenth century. Early sources include Eliza Leslie's 1840 book *Directions for Cookery, in Its Various Branches*, in which recipes for potted lobster, marbled veal, and the staple ham sandwiches appear. As Andrew F. Smith observes, almost all early sandwiches were cold, many served in tea rooms and other polite venues. Little, crustless squares and wedges have often been mocked in popular culture.[46] Hot and larger sandwiches more suited to working-class people, real street food, did not come about until the later nineteenth century, and then from wagons or carts. They were rude food for the masses. That is when the ancestors of hot dogs came on the American scene, as evidenced by an article in the *San Jose Mercury News* in 1887:

> Then he shuts the can, pries open the lid of his big oval basket and whips out two slices of bread and a square bottle. With his knife he spreads out some horseradish on one of the slices, deposits thereon the wurst and then slaps on top of it the other slices of bread and hands it over, a kind of sandwich, with the ends of the wurst sticking out like amputated fingers and the horseradish oozing out all around under the pressure. It is eaten just like a sandwich, with much spluttering, because it is very hot, but it is a delicious morsel to the man who is filled up with beer or something stronger.[47]

Hot dogs descend from several kinds of German sausages—along with some East European varieties and influences. Naturally, European sausages have a long history, but in German-speaking lands they are at the center of culinary culture. This is not the case in the British Isles, where traditionally sausages were limited to a few, mainly fresh pork, varieties. Savory pies can be thought of as analogues, and anyone who has eaten gristly English and Australian (Pea Floaters) can attest that less agreeable animal scraps have often been used, just as in early hot dogs. The legend of Sweeney Todd reflects the same suspicion of meat pie ingredients as of sausages in America. Immigrants from both areas of Europe brought their food preferences with them, but German sausages beat out meat pies as fast and street food favorites.

Germans have had two hundred or more kinds of sausage from which to choose. Existing recipes date to the fourteenth and fifteenth centuries, and the oldest sausage regulation discovered so far dates to 1432 in Weimar. The regulation is for Thuringer Rostbratwurst, one of the most famous of all sausage types. An older reference dates to 1404, and no doubt the style runs back much further in time.[48] Longer and thicker than many others, classic Thuringers are made of pork (pork and beef in modern versions) and resemble the Weisswursten of Bavaria (these are made with bacon and veal). They are usually grilled and, according to rule, were to be consumed on the day that they were made, a wise precaution for fresh sausages. Among the many sausages brought to the new country were frankfurters and wieners. About their origins, there are several stories about frankfurters, none of which are reliable. Frankfurters started as cooked and smoked pork sausages but are now pork and beef mixtures with mild seasonings, such as coriander, garlic, ground mustard, nutmeg, salt, sugar, and white pepper among them, and special smoke flavors. All-beef versions appeared in the late nineteenth century, made popular by the Gref-Völsings sausage company. In American cities at the turn of the twentieth century with large Jewish populations, the name "frankfurter" and all-beef hot dog became synonymous, though the connection to Frankfurt is suspect. Wieners are precooked "sausages from Vienna." In Germany they are finely chopped beef, pork, and veal mixtures. As Fritz Usinger of Usinger's in Milwaukee says, there is not much difference between frankfurters and wieners, except for perhaps more garlic in the latter and sausage diameter. When translated to America and mass produced, the word "wiener" usually means a pork, pork and veal, or nowadays pork and poultry mixture, mildly flavored and of soft texture, more like a European Cervelat or a precooked Weisswurst. In the nineteenth and twentieth centuries, wieners and bologna (baloney) were often seen as the same thing because the texture (or emulsion) and seasonings were and are much the same.[49]

According to the federal census bureau, about fifty million Americans claim German descent. Germans immigrated to America as individuals and in groups from the eighteenth century onward. Germany was not a single nation-state until 1871, and it still retains many regional cultures, dialects, and religious groups. What they did share was a similar food culture when they came to America in large numbers after 1848 to 1849. In the 1850s roughly a million Germans came to America, one-and-a-half million in the 1880s, and similar large numbers in other decades of the century. They brought lager beer—lighter than English ales and now the most popular American style—and places where it was sold, beer halls and beer gardens. Beer gardens were regarded with much suspicion by religiously puritanical Anglo leaders of American cities because they were centers of political (heavily Socialist) activities. But beer triumphed over all obstacles and so did the food that went with them. Beer, sausages, and breads go together. Since German cuisine resembles other North and West European fare and it is hearty, much favored in the nineteenth century and among working men and women, some of their dishes entered the general American food inventory, if for no other reason than German drinking and food establishments became popular among the general populations. German restaurants were staples of urban life, though now are much reduced in numbers.

In earlier American cities street vendors served a good deal of everyday food for the less than affluent public. That is the case in many lesser developed countries today; in Africa, for instance, as much as 50 percent of peoples'

diet comes from street food. America's nineteenth-century cities were closer to that model than to modern cities. Food safety was an issue that concerned authorities at the time. A study by a health commission in New York City in 1906 concluded that street food was actually fresher than that sold in many cheap restaurants because vendors got their food straight from the wholesale markets every day and had no means to save it, unlike fixed-location restaurants. To this day, New York retains its street food carts, unlike places like Chicago, which systematically eliminated them.

German sausage sellers took to the streets. In 1870 an otherwise unidentified woman named "Fannie" wrote to a friend in Philadelphia about life in her hometown of Cincinnati. By then about 35 percent of the population were German immigrants or of German ancestry. Most of them lived in an area called "Over the Rhine" where German was spoken and foodways were of the Old Country. Fannie wrote:

> Debby, the cook, was ailing last Wednesday, so Robert and I dined at Wielert's. The music was fine, as usual, and the "Poet and Peasant" was being played when we arrived. We saw several of our acquaintances present, with many German families enjoying the evening from Grossmutter to infants, all having a good time.
>
> The dinner was good but a little heavy to my taste. A sausageman walked about with his large tray of sausages and at his heels there followed a small boy with bread, salt, and pepper. I am always amazed at the quantity of beer some of these people can absorb. Robert says it is nothing and that at many Cincinnati breweries a big cask is kept open at all times for employees to help themselves, and many of the men drink fifty to sixty steins daily. They look jolly and well, but no wonder so many of them have not seen their feet for years.[50]

The sausage man mentioned here was in a restaurant, but it is not hard to think that the sausage man also worked the streets and public events because that is how sausages had been sold in Europe since the Middle Ages.

That Germans sold sausages in public places by the middle to later nineteenth century is inherent in the story of the supposed first vendor on Coney Island, Charles Feltman. A native of Hannover, Germany, he arrived in Brooklyn in 1856. Coney Island was just emerging as a popular resort for New Yorkers.[51] By 1870 he owned a bakery and, according to the standard account, began selling pies from a wagon to the bathers and beach strollers. Newly linked to the cities of Brooklyn and New York by rail and trolley, Coney Island attracted people who came to beat the heat of city summers. Finding that potential customers wanted hot sandwiches, in 1867 or 1874, Feltman asked a wheelwright to make him a wagon with a burner unit in it. With this device, a pot of water could be heated, sausages plunked in, and then set into the "milk" buns mentioned before. Here, too, is a story of hot dog origin, if not in name then in product, and it is not fully attested.

Quite the contrary, Charles Feltman was a restaurateur whose landmark Ocean Pavilion was a fine-dining establishment located on the Boardwalk from perhaps 1871. It specialized in "Shore Dinners" that featured local seafood, especially fried and baked clams. A baker by profession who owned a bakery in Brooklyn, Feltman realized the potential of serving increasing numbers of Coney Island pleasure seekers by opening his full-service restaurant. During the next quarter century Feltman expanded his place into a dance pavilion, with a carousel and even an open-air movie theater. Serving thousands of customers ("caterers to millions," he said), he also

seems to have had seven sausage grills, rather like the Weilert's in Cincinnati, only in set locations, not served from a tray.[52] There is no good evidence of Feltman's sausage cart, but the fact is, he disliked stands. In 1886, along with other businessmen, he deplored the number of small booths that had sprung up and "Mr. Feltman broached the sausage stand nuisance, condemning it."[53]

The message in the Feltman story is like many origin tales: people's desire to have a single, solid origin for a popular phenomenon. For instance, Henry Ford did not invent the automobile or even the assembly line; many steps and people led to its development, sale, and marketing. In the case of hot dogs, here is a cheap, popular food linked to public venues. It is also a story of ethnicity and entrepreneurship in America. Ignatz Frischman's career is another example. He was a German who arrived in New York before 1850 and died in 1904. In his obituaries he was described as a pioneer baker who helped make Coney Island and its Bowery—the area that had amusement stands, tobacconists, and kiosks that had frankfurters hot from the grill, among other treats. His small bakery "started the manufacture of a certain oblong roll that the frankfurter men needed for their business." The obituary also notes that frankfurters were ubiquitous and were so part of the scene that every visitor is required by custom to down one of them before leaving the island. Perhaps because Germans handled the sausage business, as names in contemporary Brooklyn newspapers show, frankfurters were the name used, not hot dog. Soon thereafter, other nationalities followed and so did a name change.[54]

Another apocryphal tale about German entrepreneurs, sausages, and sandwiches is associated with another famous public event, the 1904 Louisiana Purchase Exposition, also known as the St. Louis World's Fair. There are a good number of food origins stories attached to the Fair, ranging from hamburgers to peanut butter, iced tea, and cotton candy. None are true, and neither is the following. Anton Feuchtwanger was a Bavarian immigrant who was employed by sausage makers John Boepple and William Tamme, while his brother owned a bakery, all in St. Louis. One of the eighty or so fast food vendors at the Exposition, Feuchtwanger supposedly loaned white gloves to his customers to hold the hot, greasy sausages. People did not return the gloves so, thinking quickly, he asked his brother for help. The solution was a long, soft bun into which the hot dog was slipped and happily coated with mustard. The hot dog was born.[55]

There is no evidence that this event ever took place. What vendor of cheap food would use expensive gloves, and, if they were returned, have the ability to wash greasy gloves between uses? Besides, sausage sandwiches were already more than a quarter-century old. A variant of the Feuchtwanger story is more plausible: he sold sausages on the street in the 1880s. The real story is about immigrants and ethnicity. Feuchtwanger was a Bavarian in a city and region heavily settled by Germans who spoke different dialects, were of different religious persuasions, and had their own sausage traditions. Bavaria, centered in Munich, bordered the food capital of Central Europe, Vienna. The wiener was and is synonymous with hot dogs, so sausage men like Feuchtwanger might have drawn on this cultural cachet. Later sausage companies did the same, from Oscar Mayer, also Bavarian, to Chicago's Vienna Beef Company, founded by German and Hungarian Jews. Both companies date to the end of the nineteenth century, clearly the foundation time for hot dogs. By then, sausages made, sold, and eaten in urban America, often as street food, were identified with Germans.

The final identification of Germans and the future hot dog goes to the "Sage of Baltimore," H. L. Mencken. One of twentieth-century America's most important writers, a mature and famously cynical Mencken looked back at his youth in the 1880s and 1890s:

> For I devoured hot-dogs in Baltimore 'way back in 1886, and they were then very far from new-fangled. They differed from the hot-dogs of today in one significance. They contained precisely the same rubbery, indigestible pseudo-sausages that millions of Americans now eat, and they leaked the same flabby, puerile mustard. Their single point of difference lay in the fact that their covers were honest German Wecke made of wheat-flour baked to crispness, and not the soggy rolls prevailing today, of ground acorns, plaster-of-Paris, flecks of bath-sponge, and atmospheric air all compact.
>
> The name hot-dog, of course, was then still buried in the womb of time: we called them Weckers, being ignorant that the true plural of Weck was Wecke, or in one of the exceptional situations so common in German grammar, Wecken. They were on sale at the Baltimore baseball-grounds in the primeval days before even Muggsy McGraw had come to town, and they were also sold at all picnics. In particular, I recall wolfing them at the annual picnic of F. Knapp's Institute. One year I got down six in a row, and suffered a considerable bellyache thereafter, which five bottles of sarsaparilla did not cure. My brother Charlie did even better. He knocked off eight Wecke, and then went strutting about with no bellyache at all. But Charlie, in those days, had a gizzard like a concrete-mixer.[56]

The baseball team of Mencken's youth was the old Baltimore Orioles club of the American Association, a rival of the older National League. John "Muggsy" McGraw, later the pugnacious legendary manager of the New York Giants, began his career in 1891, so Mencken's Weck would date to the 1880s, just the era when sausage sandwiches became widely known throughout the country. It's perhaps a coincidence that McGraw in his New York incarnation appears in the seminal myth about how the hot dog got its name. Fast food, ethnicity, industrialization, and popular culture with sports an important element are the bases upon which the hot dog stands as America's iconic food.

2 Democratic Food and Popular Culture

*A*mericans have a whole inventory of ideas about themselves that are expressed through the origins of popular and political culture. These might be called myths that, in anthropologist Clifford Geertz's famous phrase, are "stories they tell themselves about themselves."[1] Myths serve to explain who a people are, where they came from, and what they do in everyday life. One of these ideas is expressed in the famed (and not much read these days) Horatio Alger novels: that young people coming from humble circumstances can, through luck and pluck and virtue, rise to middle-class respectability (not riches, as is often supposed). Most Americans believe that they belong to the great middling ranks of society and work hard to achieve or remain in that status, thus making Alger's exact point. Underlying the onward and upward theme is a general democratic sentiment. Alexis de Tocqueville was struck by Americans' lack of regard for aristocracy and demand for democratic institutions, especially on the western frontier, when he visited in 1831 to 1832. Charles Dickens saw something similar in the 1840s, only he saw Americans as a bunch of business sharpies whose behavior reflected their equal-access greed.

There are lots of ramifications within the notion of "democracy." One is that as in Alger's novels, we all have equal access to eventual success—meaning economic security. Translated to the society in general, most Americans have traditionally thought that they are in a rough equality with all other people regardless of their social status. That might not be so obvious in the early decades of the twenty-first century, but politicians who represent the wealthy elites still mix with ordinary folks while on the campaign trail and seemingly relish cheap common foods. Woe to those who do not, as some failed politicians have discovered. In that realm, hot dog stand owners almost universally say that their customers come from all walks of life and eat standing side by side. As Beverly Pink of Pink's Hot Dogs in Los Angeles says, while customers from a cross-section of society stand in line to order their food, celebrities drive up in fancy cars and get the same dishes. Sometimes they even get out of their vehicles.[2]

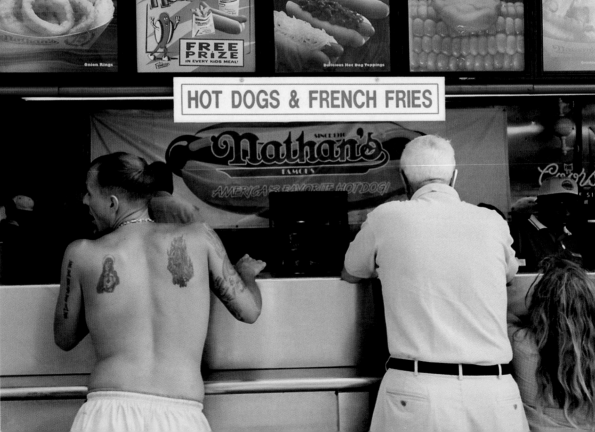

Americans also cherish their personal liberties and freedoms. Historians and political scientists note a difference between these words. Liberty implies individual rights; freedom means people being free to act within their communities. Although often confused, both concepts run through American culture.[3] Crudely put, as advertising often is, consumers were told by a corporate hamburger chain to "have it your way." The foods in this and similar eateries come from a central commissary and are uniform from coast to coast. By putting a topping of choice on the basic hamburger, diners can exercise their unique tastes. Beer advertising does much the same thing. Beer drinkers are shown on camera wearing rustic outfits, outdoor shirts especially, and sporting two or three days of beard growth. The image is a way to tell consumers that they, too, can be rugged individualists by downing this or that brand of mass-produced brew. No one wants to be told that he is simply a number on a corporate spreadsheet.

Hot dogs draw on the same mythology because although they are mostly factory made, diners can individualize their sandwiches by adding various toppings according to taste. That taste can be driven by something else. Many hot dog stands, carts, trucks, and restaurants are located within communities and often identify with them. Ask any group of Chicagoans which place has the best hot dogs and an argument quickly ensues as each respondent claims that it is the neighborhood place where he or she grew up. Go to Rutt's Hut in Clifton, New Jersey, on a designated club weeknight and there will be a sea of motorcycles outside, as often tattooed, happy, friendly enthusiasts down the various versions of "rippers" for which the restaurant is famous. In both cases, there is freedom to eat what one likes, but within the bounds of one's neighbors, friends, community. This is an idea Americans cherish, even if it spills into occasional nostalgia.

If democratic Americans have equal access to all things economic, then they should share in the bounty of the land. From the earliest European settlement of North America, literature dwelt on the abundance to be found in America. For hungry immigrants, this idea of an American cornucopia was a compelling image.[4] It meant not just land and bread, but meat. In a number of Horatio Alger novels, the most famous of which was 1868s *Ragged Dick; or, Street Life in New York with the Bootblacks*, when poor boys get some paltry sums of money, they go to cheap restaurants to eat beefsteak and drink coffee, with not a vegetable in sight. Some of them yearn to have even larger and more richly marbled steaks. Eating a lot of food, centered on meat with few, if any, vegetables, is a venerable ideal. Hot dogs partake of the carnivore's heaven, as iconography shows. On stand signage and advertising of many kinds, hot dogs are depicted as large, stuffed into buns, and often loaded with delicious accoutrements. The foot-long hot dog is a perfect example. There are several claims to its "invention," but a long hot dog whose ends stick out on either side of the bun says that it is more meat for the money.[5] In an 1899 story set in New Orleans, O. Henry has a cunning tramp, disguised as a reputable artisan, given "a foot of Frankfurter and half a loaf by a vendor who regarded him as an equal."[6] Equality and abundance walk hand in hand through America's fast food scene.

The manner of eating fast-food hot dogs involves these democratic themes. There is a considerable literature on how Americans learned how to live in a polite, "civilized" society in the nineteenth century. Eating is a fundamental way to mark progress toward that end by middle-class people. It is also a demarcation of lack of progress, or, simply, rudeness. Not wanting to be burdened by unaccountable rules, at least of dining, many an American deliberately flaunts canons of polite eating. Doing so can also be a way of bonding with one's community. For instance, Italian workers in Philadelphia's turn-of-the-twentieth-century shipyards brought huge sandwiches for lunch stuffed with sliced, cold meats, cheese, tomatoes, and perhaps other condiments. No knives and forks, no linen napkins, just a lot of food hand held, and if crumbs and tidbits fell from the food or the mouth, so what? The sandwich was called a "Hoagie" or "Submarine" and is now a staple of fast food chains whose sandwiches are properly denatured.[7]

It's an old theme that historians sometimes set in Andrew Jackson's era, a time when the supposedly crude backwoodsman (he was not) came to the White House. Jackson claimed to reflect a raucous democratic society that had risen in the generations after the Revolution. That is the society that Charles Dickens saw on his travels and heartily loathed.

Dining at a Nashville inn in 1831, the army officer James Edward Alexander reported:

> No ceremony was used; each man helped himself with his own knife and fork, and reached across his neighbour to secure a fancied *morceau*. Bones were picked with both hands; knives were drawn through the teeth with the edge to the lips; the scalding mocha and souchong were poured into saucers to expedite the cooling. . . . Beefsteaks, apple tart, and fish, were seen on the same plate the one moment, and had disappeared the next![8]

Alexander's observation tells us something about gesture, for there are hot dog eating protocols. Widespread in literate Europe from the fourteenth century onward, etiquette manuals appeared in America in the eighteenth century; even George Washington had one. A manual from 1715 advises readers: "Bite not thy bread, but break it; but not with slov[en]ly fingers, nor with the same wherewith thou takest up thy meat." This preludes sandwiches from polite dining. Washington, at age fifteen, copied this sensible rule for his own use: "bedew no man's face with Spittle by appr(oaching too nea)r him (when) you Speak." Polite people did not put their elbows on the communal table, did not eat with their hands, kept a proper distance from other diners, wiped their mouths while turning away from their fellow diners, and so on. All of these are the very things that hot dog eating is *not* about.[9]

Eating among all cultures is a ritualized process, and fast food is no exception. Many hot dog iterations are covered with potentially messy toppings. A fully loaded Chicago dog has mustard, bright-green relish, chopped onions, tomato slices, pickle slices, and small sport peppers jammed onto the bun. If standing up, as diners must at classic stands such as Jim's, or Jim's Original, the Express Grill, Gene and Jude's, and a host of others, they must lean forward, holding the sandwich away from the body to avoid a spattering of food down their shirts. If sitting the posture is the same—lean forward, like a wolf biting into the body cavity of dead prey. And the bites must be large ones, taking big chunks into the mouth and filling one's cheeks, like a squirrel with nuts. It is the same with Detroit coneys and other chili-topped hot dogs—eat face forward and take big bites, or else dun-colored meat

MAN BITES DOG

PARKY'S, OAK PARK, ILLINOIS. A JOKE ON POLITE HOT DOG EATING.

sauce will soon squirt out.[10] At places where there are counters, or long highboy tables, as at Rutt's Hut, people eat elbows on the surface, side by side, jostling one another for condiments or drinks. French fries are in the same category, eaten from necessarily greasy fingers; they are anything but dainty finger foods. Here is boorish cuisine, and the people who eat it are proud to do so—it is an expression of democratic solidarity.[11]

On June 8, 1939, Britain's King George VI (the king of *The King's Speech*) and his wife, Queen Elizabeth, paid a visit to President Franklin Delano Roosevelt and his wife, Eleanor. Their trip to the United States was the first in a major attempt by the British to gain support for what many Britons and Anglophiles thought would be a coming war. The lunch menu that day has become a staple of hot dog lore: Swift hot dogs were served the royal couple. Neither they nor any of the top consular staff had ever eaten them. The *New York Times* headline about what happened read: "KING TRIES HOT DOG AND ASKS FOR MORE And He Drinks Beer With Them." It might be surprising that the royal couple and the upper officials had never eaten hot dogs since they had been served at British football and rugby matches since the 1920s. But these were not the sports of kings in those days, so no royal mixed with the proletarian crowds who attended these games. The White House dogs were served from a silver tray, but George and Elizabeth ate from paper plates. Reportedly, Queen Elizabeth asked FDR how, exactly, to eat them. He replied: "Very simple. Push it into your mouth and keep pushing it until it is all gone." Nonetheless, she ate them with a knife and fork. Emily Post would have approved.[12]

In reality, FDR and Eleanor could not have cared less about what they ate. White House food was notoriously bad in their years because as good Progressives they were only interested in solving the nation's problems, with some high culture and baseball thrown in. No more astute politicians ever existed than the Roosevelts, and they well understood the meaning of cultural symbols. The hot dog story tells us about American uniqueness and cultural solidarity among all levels of society. The proper Queen Elizabeth may have used utensils and probably ate small, prissy bites. But George was also politically savvy since he gobbled down two, by hand, and with relish, we are told. The king could be a "regular guy" who had sympathy for the American people, democracy, and their food. He even used the vulgar phrase, "hot dog."

The same theme runs though American popular culture: A rich person or an aristocrat takes interest in the lower orders. In some of the Alger novels a rich man becomes the patron of a poor but likely lad. Mark Twain's *The Prince and the Pauper* is a satire on the premise, and the 1936 Hollywood film *My Man Godfrey*, the theme of which was how people of wealth should be interested in economic justice, was certainly fresh in mind. As William Powell's character said, "The only difference between a derelict and a man is a job." King George VI was well tuned to American cultural ideals.

A darker side runs underneath the happy scene. All too human, most Americans have traditionally feared the unknown. Unfamiliar food and foods that might be unsafe are understandable fears. So is wariness of people with whom they are unfamiliar. Recent immigrants make up one group; African Americans another. In this age of integration, as a number of school textbooks have it, Americans celebrate their heterogeneous origins and associations. Nowadays hyphenated designations are perfectly fine with most people who think of themselves as wholly American. That is, almost all of the minorities were or are being assimilated into general culture, and

it is often done through food. A dish common among one group can cross cultural boundaries into social and gustatory acceptance by the general public in several ways. The proximity of groups to everyone else in a closely confined urban setting led certain food leaking out, say Jewish bagels and pastrami sandwiches and Italian pizza on New York's Lower East Side or Chicago's Near West Side and Southern fried chicken from African American/ Southern communities. Asked why Jimmy Buff's and other Italian hot dog stands in northern New Jersey use all-beef hot dogs, a Jewish sausage, Jimmy Racioppi, whose family invented the style, replies that it was because in Newark everyone was a neighbor and his family wanted to please them all.[13]

Another factor in acceptance of the unfamiliar is cheap food, some purveyed by street vendors, some by inexpensive restaurants. In both cases entrepreneurs opened the pathway to the American market. Chop suey, made in the Taoisan region of China, near the city of Canton, as it was called, was brought to America by immigrant laborers. It fueled a restaurant boom in nineteenth-century America beginning in New York City, when financially poor but culturally adventurous "Bohemians" discovered these "exotic" Cantonese eating places.[14] The same can be said for Italian American fare. Although pasta in the form of macaroni and spaghetti was well established in America by the eighteenth century, southern Italian immigrants beginning in the 1880s made it, tomato sauce, and meatballs cheap and popular in local restaurants and then among home cooks: the Franco-American company was canning Italian products by the 1890s. If a dish is to be assimilated it had be somewhat familiar to diners and then Americanized. It is a common joke that when Italians visiting the United States are presented with a plate of spaghetti and meatballs loaded with thick tomato sauce, they wonder what it is because no such dish is found in the home country. The same goes for chop suey, chow mein, and a host of Chinese American dishes. A Chinese chef once said about all the sticky goop on such creations: "We Chinese are the world's smartest people; we understood that Americans like a lot of gravy on everything, and we gave it to them." The dish has to be naturalized or similar enough to what the general public eats in order to be accepted. Large amounts of meat in a basically vegetarian dish is a key diagnostic trait.

There are many other similar stories, including in German cuisine. As a dyspeptic Mencken put it: "So with the German sauerkraut—a superb victual when properly prepared for the table. But how often, in America, is it properly prepared?" "Even the Germans coming here, lose the art of handling it as it deserves. It becomes in their hands, as in the hands of American cooks, simply a sort of stewed hay, with overtones of the dishpan."[15]

Hot dogs were "the reductio ad absurdum of American eating . . . a cartridge filled with the sweepings of the abattoirs," in Mencken's words. Sausages were consumed in German-speaking countries either plated in restaurants or at home, usually accompanied by sauerkraut or potatoes in some form. As street food they have long been eaten in a small bun, just enough to hold the middle of the sausage. The traditional topping is mustard in a regional style. In a kind of cultural reflux movement—from the colonized area back to the homeland—a new form appeared in Germany. When large numbers of Americans appeared after World War II, so did larger buns, and so did sauces for German hot dogs. The most famous version of sauced sausage is currywurst, likely invented by Herta Heuwer (a Trümmerfrauen, or "rubble woman" conscripted to clear the debris left by World War II destruction) in Berlin in 1949 using ingredients she got from occupying British troops. Made with chunks

of bratwurst, covered in a sweet-hot sauce, it is served on paper plates. Currywurst is a German national icon, but it is not the kind of dish brought by nineteenth-century German immigrants to the United States. Rather, these were the various sausages mentioned in chapter 1, especially frankfurters and wieners. When they became industrialized commodities, served in buns, and with toppings, hot dogs became naturalized. It is the toppings—the analogue of gravy—that made them both American and multicultural at the same time.[16]

Food might be a vehicle of tolerance for an ethnic minority, albeit with some reluctance when sold from street carts, but total acceptance is another matter. The suspicion of newcomers, "outsiders," flows in America's cultural arteries. So, when and where cultural barriers were crossed, even if only in small steps, lies at the heart of the hot dog's role in popular culture: mid-nineteenth to early twentieth centuries, and urban in character. Immigration to the United States flowed deep and strong in this period. Many came to work in the new factories and the raw materials industries that fed them. By the 1890s one-third of all industrial workers were immigrants. In Chicago 79 percent of the total population was foreign born. In historian Alan Trachtenberg's words:

> Often crowded into cramped living spaces, in slum tenements or abandoned middle-class housing in older districts, working-class families tended toward ethnic and racial enclaves where native languages and styles of life prevailed. Work was often dirty, backbreaking, and frustrating. Working women and children seemed at odds with middle-class ideals of home and school. In the popular press, workers found themselves stereotyped as the unwashed, unenlightened masses, swayed by disreputable-looking bomb throwers and associated with brutish caricatures of Irish potato eaters, slow-witted Slovaks, fun-loving Italians. On every count, labor seemed to represent a foreign culture, alien to American values.[17]

No wonder novelist Henry James fretted about how these alien people and their ways could not be escaped. As social historian Lawrence Levine observes: "The worlds of strangers did not remain contained, they spilled over into the public spaces that characterized Nineteenth century America and that included theaters, music halls, opera houses, museums, parks, fairs, and the rich public cultural life that took place daily on the streets of American cities."[18] Levine shows how "order" was achieved in the era by the establishment of various rules of behavior. Patriotism and public education were among the tools used by American elites, but public entertainment and its foods retained plenty of their old, rough character. The fact that Charles Feltman wanted to remove sausage stands from near his grand, fine dining pavilion in 1886, and failed, testifies to the irreducible vulgarity of hot dogs.

If the press portrayed immigrants as stereotypes, then the images were redoubled on stage and in the other venues Levine mentions. Minstrel shows that rose in the early nineteenth century were the first widely popular characterization of an ethnic group in mostly pejorative terms. The name "Jim Crow" comes from a pioneer song and act. White performers wearing blackface makeup, and later black ones doing the same, showed African Americans in ways that are painful for modern audiences to watch. If black stereotypes were more than acceptable to white audiences, so were others. A new, more respectable entertainment called "vaudeville" appeared around 1880. One of the founders, Tony Pastor, put on a skit—vaudeville was made up of separate acts—called "Go West;

WIENER'S CIRCLE, CHICAGO. A LATE-NIGHT, VERY INFORMAL PLACE.

or, the Emigrant Palace Car in an Uproar." With hardly any plot, the characters were a manic collection of ethnic comedians—Irish cop, Dutch (German), Italian, and black—who spoke a cacophony of malapropisms. It was a huge hit and played to sold-out houses. Not that white ethnic jokes were new, only now they became a staple of American humor.[19]

Usually called "dialect" comedians, people of any background could play the stock character of others. Two of the most celebrated, Weber and Fields, were Jews from Manhattan's Lower East Side who did a "Dutch act," meaning Germans. Adopting thick accents, as in "Vatever I don't know, I teach you," they were the very image of all comic Germans. The thick accented "Carl Pretzel" was the model of the type, established in the 1870s by the comic Chicago writer Charles H. Harris in such works as 1872's "Carl Pretzel, Vedder Brognostidikador Almineck Kalinder." In the O. Henry story mentioned previously, the tramp uses phony German pronunciation when he meets up with some German "marks."[20] Jews, Italians, Greeks (as in the later "Greek" Parkyakarkus—actually Harry Einstein—who mangled English on the Eddie Cantor radio show), Irish, rustic Southerners, and others were all subject to the same treatment. The jokes were usually based on malapropisms and misunderstandings of plain English. Awful puns and now almost incomprehensible jokes were delivered in rapid fire, paving the way for later iterations, such as the Marx Brothers. The other staple of comedy was slapstick. Anyone who has ever seen The Three Stooges, who began as comic relief in Ted Healy's vaudeville song and dance act, knows exactly what that entailed. In fact, many classic musical comedy stars and comedians came directly from vaudeville to radio and screen.[21]

While Americans at turn-of-the-twentieth-century America were taking up "ethnic" dishes, food was part of comic caricatures. Blackface minstrels strummed banjos and exchanged banter when eating watermelon and fried chicken. Irish characters put down shots of whiskey along with stinky corned beef and cabbage. Chinese jabbered over their rice bowls and chop suey; Italians sucked down spaghetti and red wine; Kosher dietary laws were much mocked; and Germans gulped steins of beer and "talked funny." What went into their signature sausages? Well, who knew what?

It is easy to characterize such comics as lending a sense of superiority to the audience and denigrating the subjects of the crude satire. But, as scholars suggest, these figures were a way to bring ethnic Americans into the national dialogue and make them more acceptable—that's what comedian Jack Benny (born Benjamin Kubelsky) thought and said so. As the rawness of first cultural encounters wore off, and through assiduous work to naturalize ethnic differences, ethnic comedy came to be much more about assimilation, food included. From The Goldbergs to Life with Luigi, and even Fred Allen's Allen's Alley, radio and early television dialect performers became thoroughly American. For African Americans that privilege came later.

However ameliorated during the course of the twentieth century, the language and tone of this entertainment came right from the rough city streets, in saloons and bordellos, and much of it created by impoverished im-

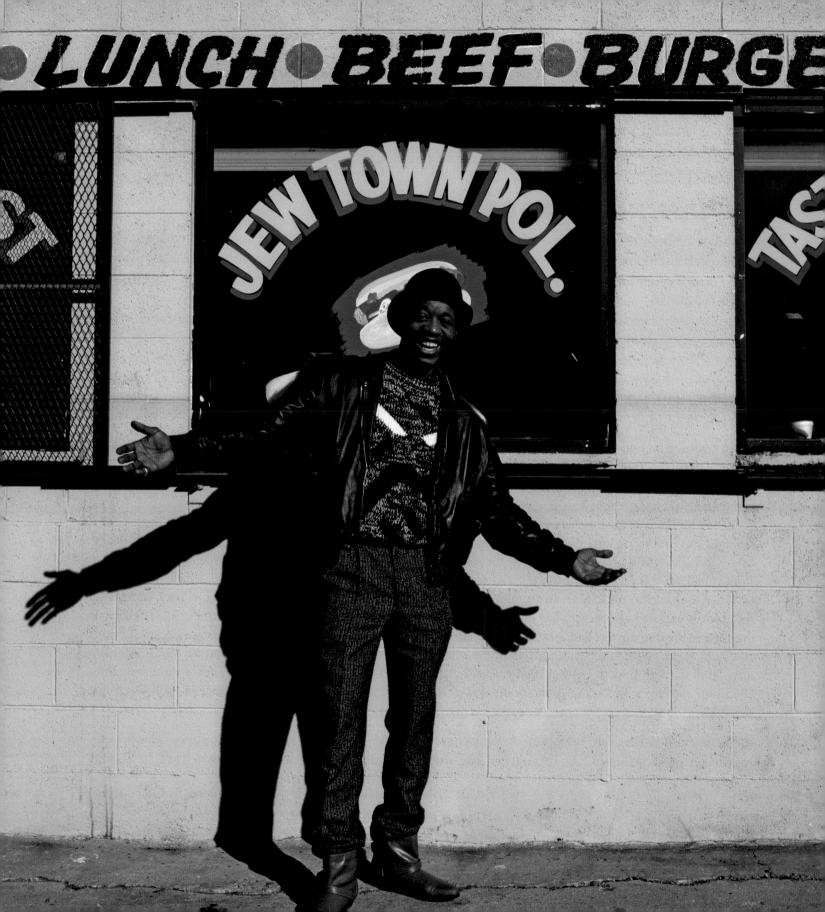

migrants and African Americans. Performed by brilliant entertain-

Opposite: **ROYAL PALACE, CHICAGO. A FANTASTICAL "VAUDEVILLIAN."**

ers, they brought Americans into the swift pace of urban life, from factories to new transportation systems, with all of its raw language and mores. It is in this milieu that the hot dog appeared and got its name. Elements of these origins run right through hot dog culture into the present day: New York's hot dog carts and Tucson's Sonoran hot dog venues are closer to the world of 1900 than they are to McDonald's.

THE NAMING OF DOGS

Of all enduring popular entertainments, Coney Island apart, none is more closely associated with hot dogs than sports, especially baseball. The most famous myth about the term "hot dog" centers on that greatest of American sports. Though often told in print and online, the story is worth repeating because it tells us something about American culture.

There are several versions of the story, but the celebrated journalist Quentin Reynolds wrote the now standard version in a 1935 issue of *Collier's Magazine*.

The weather was cold that day (in most versions, the date is usually given as April 1901), and the crowd of fifty thousand were frozen in their seats. The game should have been called off, but fifty thousand tickets was a lot of money for a struggling team to return. The concessionaire, Harry M. Stevens, had ice cream, soda pop, and peanuts on hand, along with the scorecards, but nothing to warm the body internally.

> Harry Stevens stood there for a moment thinking very, very fast and when he got down to thinking fast he could think very fast indeed. . . . "Hey, you," Stevens called to one of his men. "Get the boys up here. Hurry up. I've got an idea." He had an idea that was going to make him five million dollars within the next few years—though he didn't know it at the time.
>
> "Send around to all the butchers in the neighborhood," Stevens barked at his assistant. "Buy up all of those German sausages you can, those long dachshund sausages—what do they call 'em, frankfurters? Then hustle around to the bakers in the neighborhood and buy up all the rolls you can find. These people want something hot. We'll give them something hot. And get some mustard."
>
> "The boss has gone nuts," his men grumbled, but they hustled out to the butchers and they came back with yards of the "dachshund" sausages Stevens had ordered. They had a small kitchen under the stands and under Harry's direction they heated the frankfurters and then Harry himself smeared them with mustard (later the mustard became optional) and stuck them between the sliced halves of the rolls. "Take 'em out and sell 'em," Harry barked to his astonished men. "Call out that they're 'red-hot.' Remember that, 'red-hot.' Those people are freezing. They'll want something." "Red-hot," the boys called as they went up and down the aisles. "Get a red-hot dachshund sausage in a roll. Dachshund sandwiches . . . red-hot . . ." The crowd bought them through curiosity at first—then with enthusiasm.

In the press box that day sat Thomas A. Dorgan, alias TAD, "greatest of newspaper sports cartoonists and phrasemaker extraordinaire." As he watched the crown devour this heretofore unknown treat, he thought, if

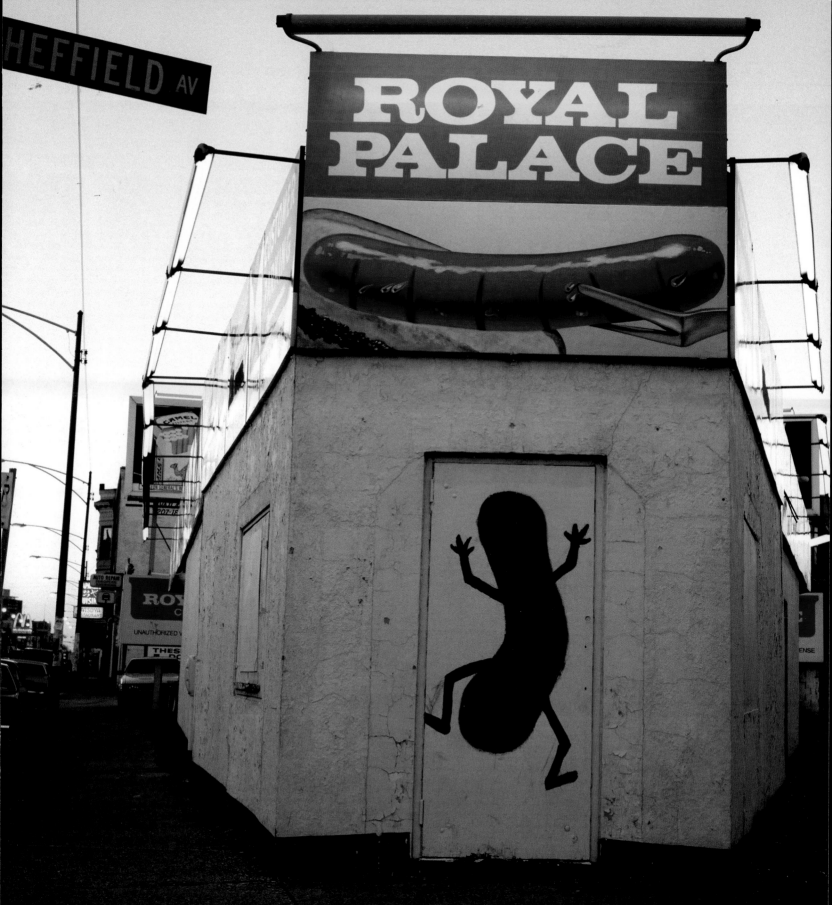

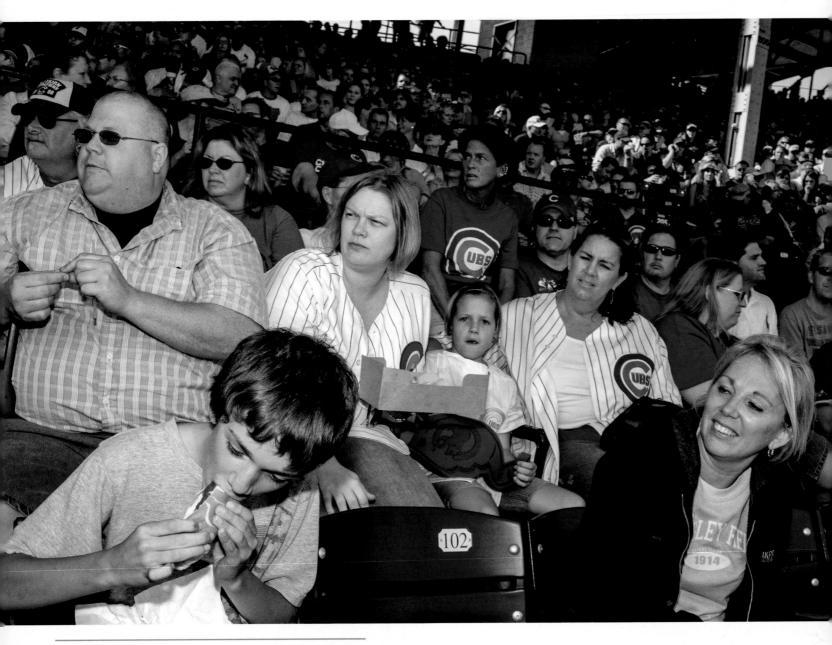

YOUNG CUBS FAN, WRIGLEY FIELD, CHICAGO

these were hot dachshunds, why not just call them hot dogs? TAD drew a cartoon of the event, and so the name was born—as well as the sandwich itself according to this account. And, says Reynolds: "That cold day which had begun so dolefully really made the Stevens' fortune and helped considerably in making Harry M. Stevens, Incorporated, the largest firm of outdoor caterers in the world."[22]

This wonderful story is one of those origin myths that scholars of mythology and religion often discuss, and like most of those, it is almost completely factually untrue. In fact, as researchers have found, Harry M. Stevens himself debunked the story in 1926. Nevertheless, like other myths, it strikes deeper cultural notes. In the first place the Polo Grounds, home to the New York Giants baseball club, located in Coogan's Hollow between 155th and 157th Streets and Eighth Avenue in Manhattan, was a small-scale wooden structure when the event supposedly occurred. After a fire, a concrete and steel stadium was built in 1911 and enlarged to its final fifty-thousand-seat capacity in 1923. This was the ballpark of epic centerfield proportions, the scene of Willie Mays's great catch in the 1954 World Series. John McGraw, the legendary manager, had not gotten there yet from Baltimore—where he likely ate "wecks"—until 1902, to begin his long and glorious run as a player and manager.

Nor has the "original" cartoon ever been found. The earliest TAD hot dog creation dates to 1906 to the six-day bicycle races held at Madison Square Garden. Stevens himself said that his sons persuaded him to sell hot dogs for the first time to these crowds. Nevertheless, Dorgan always claimed the Polo Grounds story was true, and his prestige as a popular phrase coiner probably added to the story's durability. Dorgan was said to have invented slang phrases such as "duck soup," "kibitzer," "yes, we have no bananas," "drug store cowboy," and a host of others.[23] As for "dachshund sausages" being a common term for sausages in 1901, no evidence has been found to corroborate that usage. Dachshunds were certainly well known at the time since the breed was registered by the American Kennel Club in 1885. A New York newspaper story from 1909 reported that two youths were charged with stealing twenty-eight feet of bologna and eleven-and-a-half feet of wienerwurst from a delicatessen. One of them denied it, declaring that he had bought it for his little dachshund, which "has a terrible appetite." The magistrate then called the dog a "bologna dog." Aside from the natural association of a German dog shaped like a sausage with the product itself, likely the later popularity of the idea dates to World War I when Germans were reviled and their culture ridiculed in America.

A native of London, England, born in 1855, Harry Mosley Stevens immigrated to the United States and became a steel mill worker in Niles, Ohio, in 1882. During a strike in 1887, he became a door-to-door book salesman (of a biography of Civil War hero General John A. Logan, himself from humble origins) and thus found his true calling. In that year, while attending a baseball game in Columbus, Ohio, Stevens realized that, lacking numbered jerseys, fans could not distinguish the players, at least the visitors, and so he perfected the program and scorecard, engendering the phrase, "You can't tell the players without a scorecard." Box score cards had been an important part of baseball since the 1850s, baseball being about statistics, but they were a haphazard production, and not fan friendly. After buying the scorecard concession at the ballpark, Stevens apparently sold them at the 1887 World Baseball Championship between the St. Louis Browns of the American Association and the National League's Detroit Wolverines. Described as a natural-born salesman, he expanded his operation to other cities, including

New York by 1894. His product line included such foods as peanuts, soda pop, popcorn, and, eventually, hot sausages served in buns—the hot dog.

By the time of his death in 1934, Stevens had built a catering empire. The great sports writer Grantland Rice said of him: "He could direct an effective hot dog one minute, and a minute later tear into Shakespeare, or Browning, or Keats. He was a merchant and a poet combined, but he was always a poet at heart." "Above all, he had the striking type of personality that caught instant attention—the vital human spark that so few ever hold."[24] Stevens, an immigrant sales genius and business entrepreneur, is the very story that Americans were being told about themselves in all public media and schools. He was a poor boy who had come to America to seek his fortune: none of the stale, class-bound society of his native country for this rugged individualist. Though pluck and a little luck, he became a major success by building a company, pleasing the masses—the meaning of the hot dog story—and leaving a wonderful patrimony for his sons, who inherited and expanded the catering business. One could say that he was of the same cloth as other industrial heroes of the era, from Thomas Edison to Alexander Graham Bell, and Henry Ford (he was not a hero to unionizing workers).

Even in the 1930s, during the Great Depression, when many people were cynical about the validity of the American Dream, the Horatio Alger story worked. "Only in America" was and is a powerful phrase that really describes the idea of American exceptionalism. In no other place in the world could poor immigrants, or even indigenous poor folks, make it to some level of economic prosperity. In the new industrial age where more and more Americans worked in factories and large businesses, this is a comforting thought, especially for people who thought of themselves as socially and economically respectable: owners of consumer goods, such as automobiles, rather than street peddlers. Fans who attended professional baseball games would have agreed. Many of their heroes on the field came from humble, and often immigrant, roots, and made it to the Big Leagues through talent and grit. John McGraw was its embodiment, and it is a story that we still like.

Sausages in buns were also the edible symbol of the ideal being told to the immigrant working-class masses. The wildly popular sport of baseball was not as socially leveled as might be supposed. Prices for National League seats were fifty cents for grandstand seats at a time when skilled workmen might have made five hundred dollars a year, and there were cheap seats for the ordinary people. However, at the ballpark everyone ate hot dogs for a nickel, all prepared the same way, and everyone rooted for the home team in unison. They, the sausages, came to be linked to the game and its fans because they were a unique American invention (that's the meaning of the King George and the White House episode), sold by common folks just like us, and consumed by all at the great American ritual—the ballgame. In this way hot dogs were a means of self-identification by all Americans. That theme has been reinforced ever since, over and over again.

How hot dogs came to achieve this status is not just some folkway, rising from the bottom up, but was driven by marketing and its servant, advertising. The Reynolds story is a light puffery, told in honor of an ancient denizen of the Polo Grounds. TAD was conscious of his role as an American humorist/sports cartoonist and promoted his creations. Stevens played himself and relished his image as a great businessman and sportsman with a big heart. That he was a pal of the great McGraw is true, but the relationship was also good advertising. His catering

company serviced many sports arenas, parks, and racetracks. There is nothing like good personal relations with teams to cement business and drum up more, so Stevens became a well-known fixture at venues. That he was interviewed as a star in the *Sporting News* in 1926 about the hot dog story shows how important he was. Journalists always need to know influential people, so the flattering, fictitious tale of the origins of hot dogs was often retold by them. Many stories we think are true are really the creations of public relations and advertising writers. They have become the modern mythmakers.

THE REAL NAME

The name "hot dog" is a joke—several kinds of jokes, and not TAD's. One is of the black variety, relating to danger. Another is about class and economics (as in, who would eat these things unless they were poor?), and a third is about ethnicity, first German, then others. All the jokes come from the cultural milieu discussed above expressed through popular slang. They run through popular culture even to this day.

Consumers have looked at sausages with much suspicion since at least the Middle Ages. Among the feared ingredients were dogs, rats, cats, and sometimes humans. As an example, an 1857 Chicago newspaper account of urban pig rearing in New York City says that city inspectors discovered the poor creature being fed dead rats and all sorts of other putrid filth. One might suppose that disgust at the thought of eating dogs has to do with modern ideas about dogs and family members. Not so, especially in the squalid American cities of the nineteenth century. With little organized garbage disposal (or clean water, for that matter), packs of stray dogs roamed the streets, and lots of them scavenged for garbage. Think of feral dogs in third world countries and the picture is clear. Would anyone know if they went into sausage machines? A note in an 1886 issue of the *National Police Gazette* sums it up: "Weinerwurst sausage is being imported from London. The hydrophobic scare has caused the slaughter of 10,000 dogs in the metropolis."[25]

Stray dogs are one thing, but dear pets are another. Cute household companions being kidnapped and then ground up were the subject of many a sardonic joke in the last two centuries. That butchers had dogs, or that dogs hung around butcher shops, is logical and true, but rarely were these purebreds such as dachshunds. Written and cartoon depictions of such unfortunate animals show mostly little fluffy or wire-haired terrier types. Maybe the most famous dog and sausage joke, before the name "hot dog" appeared, is Septimus Winner's 1864 song "Der Deitcher's Dog." The title is comic German and is set to a folk song called "Z' Lauterbach hab Ich mein Strumpf verlor'n," or "I Lost My Socks in Lauterbach." "Oh where, Oh where ish mine little dog gone? Oh where can he be? His ears cut short und his tail cut long: Oh where, Oh where ish he? Un sasage ish goot, bolonie of course, Oh where can he be? Dey makes um mit dog und dey makes em mit horse, I guess de makes em mit he."[26]

Generations of children who have sung the first lines of this ditty have no idea of its real meaning. Contemporaries got the joke, but in our pet-friendly times, it is cringe-inducing. By the end of the century the crude joke had become integrated into popular culture probably by common usage. A "dog wagon" in New Haven, Connecticut, in 1899 was just a normal way to say "hot dogs." The joke lives on in hot dog culture, sometimes in its original sense, mostly in nonthreatening iconography.

A group of lexicon scholars led by Leonard Cohen, Barry Popik, and the late David Schulman has been working on the origins of the word for more than twenty years. Their and other researchers' work shows that the actual word appeared in the early 1890s. The Yale College humor magazine of 1895 mentions The Kennel Club, a lunch wagon and also the name of a clothier in town. It seems likely that the phrase meant not only a food but was applied to sharp dressers or good athletes, similar to today's use for someone who is a showoff. In 1899 Billy, the Kennel Club's founder, set up his popular Dog Wagon—actually a mobile diner—and the phrase was set. Magazines from Cornell, Harvard, and the University of California, Berkeley, used the phrase at about the same time. Likely more will turn up as research into period publications continues.[27]

There are even earlier dates for the exact term "hot dog." Newspapers from 1893 in Knoxville, Tennessee, and New Brunswick, New Jersey, use the word, the latter a story about how the shore resort town of Asbury Park was cracking down on itinerant hot dog stands, just as Coney Island had done in the 1880s. The very earliest so far is December 1892 from the Paterson, New Jersey, *Daily Press*. As Ben Zimmer of Visual Thesaurus.com describes it, in the story a young ice skater asks a vendor for a quick hot dog. Further research shows that the vendor was Thomas Francis Xavier Morris, alias "Hot Dog Morris" and "Pepper Sauce Morris." A native Jamaican, Morris was a circus performer who lived in Germany for some years. After 1880 he supplied frankfurters to saloons and obviously had a hot dog cart. Whether he served hot dogs with his popular hot pepper sauce is not known. How long before 1892 the name "hot dog" was used is also not yet known, but the pattern is clear: hot sausages, put in buns with a smear of mustard and known by a crude joke word were widespread.[28]

From these earliest roots, the phrase spread rapidly. An April 1897 edition of the Kansas City, Missouri, *Star* says, "A 'hot dog' is a sliced bun and wienerwurst. The origin of the term goes back to the current facetiousness of university towns." The *New York Sun* that year talked about famous Yale "Dog Wagons," specifically the Yale Kennel Club Lunch Wagon: "The wagon itself is a gorgeously painted affair, the foundation color being true Yale blue. Upon it are panels bordered in red and green and yellow representing all manner of dogs, but principally hounds and dachshunds. Stained glass windows ornament the front and ends, with dogs' heads as the chief decorative subject—'Memorial windows' the Yale men call them."[29]

Within a very few years the name "hot dog" had spread everywhere, but there is an even earlier iteration of a closely related name, Red Hots. The terms "hot dogs" and "red hots" are interchangeable in many circumstances, as in Stevens's supposed coinage "get your red hot dachshund dogs." A Chicago street vendor was selling "red hots" in 1890, so the label must have been older for a sausage on a bun. "Hot" is the operative word here because it relates to popular culture and entertainments of the period. A "red hot" refers to a heated sausage, not to spice levels in it, as in "hot tamale." In the way that a casually given name comes to define the product, hot dogs had to be literally red in various regions of the country. In their normal state sausages are gray to brown, so red coloring is added. A former vice president at Ball Park Franks tells of his boyhood days as a Chicago White Sox fan in the 1930s. He never wore a white shirt because invariably the front would get long streaks of red from the hot dogs' coloring agents and, as a consequence, he would incur the wrath of mother.

"Hot" was the popular descriptor at the turn of the century, though certainly not new in English usage. When the United States decided to take the remains of Spain's empire after the Spanish-American War of 1898, the theme song was Joe Hayden and Theodore Metz's "There'll Be a Hot Time in the Old Town Tonight." It's still known to most Americans in one form or another. Hot cars, hot jazz, the hot corner (third base in baseball), and even "The Last of the Red Hot Mamas," Sophie Tucker, reflected how a simple word could take on cultural meanings. In Tucker's case, this famous entertainer sang sexually suggestive songs, as befitting her sobriquet, from the age of vaudeville into the television era. In a similar way, hot dogs retained their somewhat disreputable reputation, as well as love, even to sexual innuendos inherent in their shape—think "weenie."

Urban slang and culture spread across the country quickly. Newswires permitted newspaper readers in small towns to follow breaking international events, stage shows, primitive movies, sports, world's fairs, and many smaller ones. Among other means of communication in the 1890 to 1910 era newspapers allowed Americans to learn about the new popular culture. Many of these new ways came from urban, immigrant America, as in the many Jews, Italians, and African Americans who shaped popular music. By the teens and twenties new idioms such as "twenty-three skidoo," and "for crying out loud," supposedly invented by T. A. Dorgan, or "to see red," "makin' whoopee," "weenie roasts," and many others seemed to describe the new ways, especially for the young.[30] Red hots and hot dogs were among those neologisms. That is how stories of the Yale Dog Wagon got to Kansas City. That's how the name and ideas about hot dogs became national: they all seemed just about right to everyone.

FROM FERAL DOG TO DOMESTICATED DOG: MODERN HOT DOG CULTURE

Just as the arbiters of taste wanted to civilize American dining in the past two centuries, just as social reformers wanted to integrate the new immigrants into American culture, so hot dogs had to be made safe for Americans. That meant not just in terms of public health but culturally as well. If urban folks insisted on eating from street carts, then the vehicles had to be controlled. If suspicious sausages were sold in retail outlets, then it was in the interest of the manufacturers to make them widely acceptable. One way to accomplish all this was, in a famous phrase, to invent traditions. Those who create the conventions use existing habits; otherwise few people will adhere to them. Whether these new cultural institutions percolate up from within a culture or from the top down (by self-interested elites is the usual argument) by appropriating genuine folkways has been a running argument among scholars. Going to movies, Sunday drives in the newly popular automobiles, the rituals of sports, and a host of other traditions are all new but based on older patterns of behavior. Once established, traditions become entrenched with people's minds and hearts. They are observed by rituals and patterns of thought that are hard to change. Because they were popular public food, hot dogs were right in the middle of many changes in America from the new industrial and urban age to the post–World War II transformation, and into a new uncertain era.

How hot dogs are symbols of changed or enduring American cultural ideas can be seen in the ways that they were and are presented to the public. That means marketing and advertising, two of the main forces in shaping

modern American cultural ideas. Americans know hot dogs in two main ways, through dining spots and by retail sales. Both make their wares and ideas surrounding the goods through branding. In the first instance, the sequence runs from little to no signage to large-sized self-promotional displays. In the case of retail marketing, packaging and then advertising in print and electronic media have been the trends since the early twentieth century. All Americans know the most famous brands.

Early carts had no signs telling customers what companies made their hot dogs. Every morning the vendors went to the wholesale meat market—usually the same area as the vegetable and fruit markets—and bought just enough sausages for the day. They were not boxed, but sold in strings, each link having to be cut before cooking. Later on jobbers did the same pickups, then distributed product to stands and carts.[31] Carts and stands might have hand lettering on them saying "frankfurter," but no company logo. One of the distinctive features of New York City carts is an umbrella protecting the vendor and customers from sun, rain, or snow. They were in use from at least 1900, but today many bear company symbols, notably Sabrett. Founded in 1926, the company hit upon this marketing ploy sometime in 1930s—give out branded yellow and blue umbrellas as a way to establish the brand. It worked as Sabrett became a dominant player in the market. Though other manufacturer's names are found on cart umbrellas, Sabrett is always linked to them.[32]

Chicago's Vienna Beef Company did just the same thing, only using a wide variety of signage. The company was formed as result of the 1893 World's Columbian Exposition by Emil Reichel and Samuel Ladanyi. Located in the old Jewish quarter on Halsted Street and Roosevelt Road, it was an important local company during World War II. For more than a generation beginning in the 1930s, a vice president for sales named Henry Davis (born Davidovich) built the company business by advising potential stand owners, loaning them money, and sometimes helping in construction. Naturally these places were loyal to Vienna and displayed the logo prominently. After World War II, as hot dog stands increased and spread across the metropolitan region (there are roughly 2,500 of them) Vienna came to dominate the Chicago market. An ever more attractive logo and plenty of other artistic signs went with doing business with the company.[33]

At least as early as the 1910s when Hygrade Sausage (now Ball Park Franks) banners appeared on a Coney Island stand, Sabrett, Vienna, Red Hot Chicago, Farmer John, Hoffy (Pink's hot dogs), Zweigle's of Rochester, New York, and Sahlen in Buffalo, among others, have learned that onsite signage is an effective way to establish one's brand. To customers, seeing these signs reassures them that the quality will be good. More important, customers and sellers alike regard these brands as the only authentic hot dog for their community. Taste and flavor are important, but visual marketing may be more decisive.

Stands themselves become trusted brands embedded in communities. Nathan Handwerker, who founded Nathan's Famous stand on Coney Island, always said so, as he sold frankfurters by the millions. Nathan's is an often-told story. A young lad who had emigrated from Poland, Nathan first worked at Max's Busy Bee deli in the Bronx, opening up another unit for them. He then left for Feltman's on Coney Island, working as a roll cutter, but obviously ambitious to rise in the business. The standard story told by his son Murray was that vaudeville entertainers Eddie Cantor and Jimmy Durante, who were performing in local theaters, persuaded the voluble

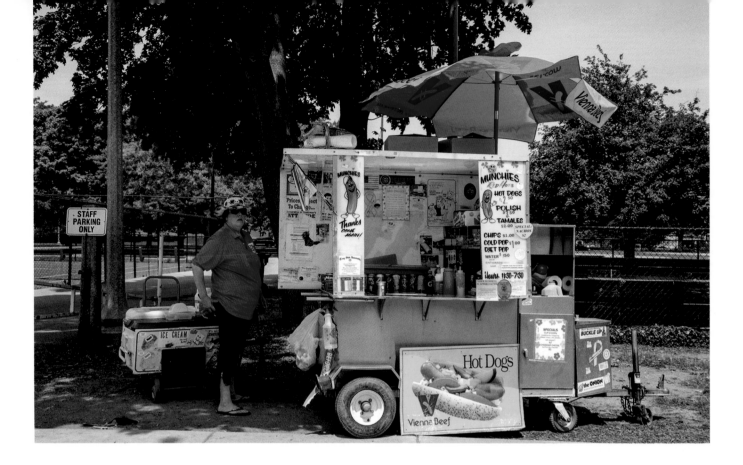

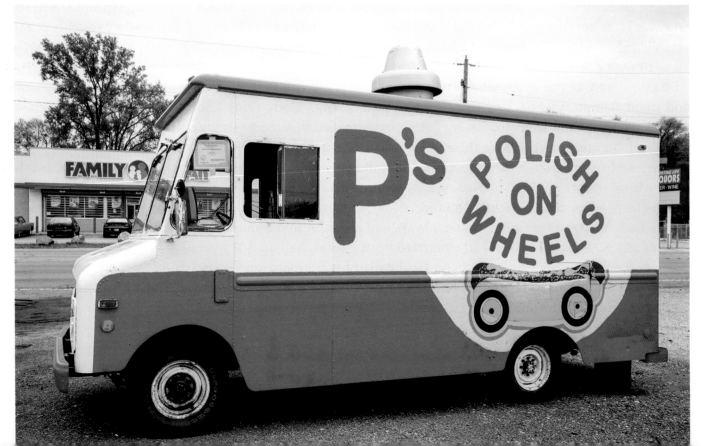

young man to open his own place. He did, and it grew into America's most famous hot dog stand. The signs were critical. As Murray said:

> The sign? It's our logo and dates to about 1925. See he didn't have a sign. When he opened up he had nothing on it. People told him to put a sign up to attract people, so he put up "Nathan's Famous." That's how he got the name. Nowadays when you open up the first thing you do is put up a sign identifying your operation. See, it was incorporated in 1925, that's when he got the signs. Then after that the neon sign came into being.[34]

Coney Island and Nathan's go together in the public mind; Nathan's annual hot dog eating contest is evidence enough. The old hot dog stand is now large enough to encompass most of a city block; it is a nationally franchised chain and a branded supermarket hot dog. The place is the thing where the hot dog is king, said Murray.

Because baseball is so tied to America's historical culture, dripping with nostalgia, and linked to hot dogs, manufacturers promoted their ties to their local baseball teams. It was big news in Boston in 2009 when Kayem of Chelsea, Massachusetts, landed the Fenway Frank concession at the Red Sox's ballpark. Kayem, founded by Kazimierz Monkiewicz in 1909, was always a well-known New England producer, but he did not compete in that market segment since Kahn's, a division of meat giant Sara Lee, had long made the franks. Kayem decided to expand their sales by using their new connection to the beloved Red Sox. As a result, eight million hot dogs were prepared for New England supermarkets.[35]

Other teams have their dogs. Hunter brand, a division of John Morrell, itself a division of the huge Smithfield Packing Company empire, makes the St. Louis Cardinals official hot dog, sold at Busch Stadium and in retail packs across the Cards' home territories. In Cincinnati, Kahn's, founded in 1883, has long been the Reds' wiener, and Dodger Dogs made by Farmer John's—now owned by Hormel of Austin, Minnesota—are among many meat company–sports teams ties. One large manufacturer's baseball-linked product line was so successful that most people no longer know its original name. Hygrade, an old New York firm, was bought out and its headquarters moved to a Detroit suburb in the early 1950s. When they won the contract for the Detroit Tigers park, Briggs Stadium, an employee won a naming contest for the hot dog with "Ball Park Franks." The name stuck and is the main brand of the Hygrade company.[36] Ball Park's baseball association spilled over into retail marketing. When looking to distinguish it from other brands, company executives focused on their sausages' characteristic plumping when heated in water. Theoretically, this happened because the fresh meat used retains its cell structure and moisture.[37] Television advertisements in the 1970s began by showing a pot heating on a stove suddenly developing large dents: the hot dogs plumped so much that the pot could hardly contain them. The scene moved to a hot dog vendor whose hot box was also dented: "A voice-over then explained, 'Ball Park Franks are plump full of juicy red beef, lean meaty pork, and young, tender veal so they plump when you cook 'em.'" Ball Park drew on not only baseball but also the endless American desire for abundant food at a cheap price.

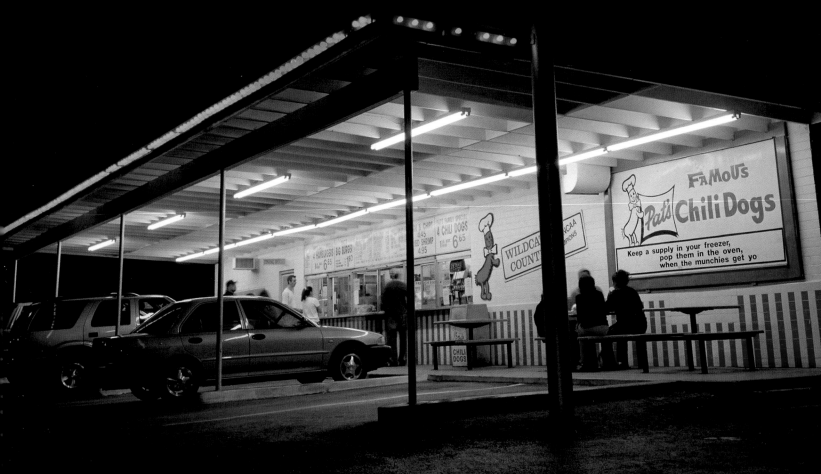

One might suppose that any sports team associations would be actively sought by hot dog makers. In reality teams so squeeze profit margins that many a maker could not do business with them. As one company executive said, it's like doing business with Walmart—forget normal markups. Larger companies can do such business as the price of marketing, especially if retail sales justify it. Smaller companies that are really more closely related to their communities usually do not. Who can resist Dodger Dogs or Fenway Franks even if made by a large meat packer?

The main impact on the nation's notions about hot dogs came from large manufacturers because they have the money to advertise. The message sent to the public is a model for the ways that cultural changes come from both the bottom up and top down within American culture. No company played a larger role in the process than Oscar Mayer. Oscar F. Mayer immigrated to the United States in 1873 at the age of fourteen. Settling in Detroit, he worked at a meat market where he learned the meat business well enough to become a buyer for it and the company's stockyards. In 1883, his brother Gottfried, a trained würstmeister, joined him in a new butcher shop located on Chicago's Near North Side. Their original customers were the many Germans who lived nearby, to whom they sold bacon and wieners. Always ambitious, Oscar supplied sausage stands at the Columbian Exposition of 1893. Half of America's population visited the fair; they could not have missed the prominently displayed brothers' names. Their reputation for fine sausage was on the rise. Delivery vehicles emblazoned with their new brand name "Edelweiss" traveled back and forth across the city, making deliveries. Edelweiss is the name of a popular sentimental song that appealed to German customers. It's an early example of how the Mayers were tuned into just the right symbols as sales tools. The name also meant "purity," a theme, along with quality, that characterized much of their marketing in coming years. After World War I, the phrase *Oscar Meyer Approved Meat Products* appeared on packaging as a way to show the owner's personal involvement in preparing fine-quality products. In 1919, the company bought a packing plant in Madison, Wisconsin, in order to be closer to the source of raw materials, and it grew into a regional producer. Innovation geared to efficiency and with an eye to the market were the company's forte. In 1924 they patented sliced bacon packaging machinery in order to better serve the new self-service markets that had begun in California and really took root with the foundation of Piggly Wiggly in Memphis in 1916. In 1928 the Mayers found a way to brand each sausage, or at least a number of sausages in a boxed set, with the yellow band with its name in red. One jingle advised customers that Oscar Meyer was famous for quality since 1883 and to look for the brand with the yellow band. In 1944 during World War II a follow-up was the Kartridg-Pak that linked sausages together in a way that resembled bullet cartridge belts. It was highly successful. This led to the familiar kinds of packaging seen in supermarkets today. Likely, too, Oscar Mayer packaging set or reinforced the color scheme associated with hot dogs: yellow and red.

Oscar G. Mayer Junior said that his father and uncle were brilliant in both technology and in marketing and that his father, Oscar G. Senior, told him that *his* father, Oscar F., used to tell him stories from German mythology: dwarves and fairies, elves and all sorts of other magical creatures that were not threatening, more like the seven

dwarfs in Walt Disney's *Snow White*. Something similar can be seen in wall paintings at Usinger's outlet store in Milwaukee. While visiting the 1933 Chicago World's Fair he saw Nate Eagle's Midget Village at Chicago World's Fair 1934.[38] This was an entire village populated by little people who carried out everyday functions of life, including getting married. At the same time, national corporations such as General Mills had spokespersons such as Betty Crocker, and Aunt Jemima had been on the advertising scene since the Columbian Exposition. Most of all, the Mayers understood that by approaching children they could speak to entire families. In a business that is increasingly geared to retail sales in self-service markets, the Mayers were at the cutting edge of future advertising campaigns. They conceived of a brilliant way to get to their intended audience—and customers—the first Wienermobile built in 1936. In it was a small "chef" named Meinhardt Raabe, a seasoned performer (he would be succeeded by George Molchan), who had played the coroner in the 1939 film *The Wizard of Oz*. Little Oscar's life role was to be driven around to various neighborhoods and festivals, pop out of the wienermobile, and hand out small toys. It was brilliant because the wienermobile looked like an Oscar Meyer wiener, which was similar to popular theme restaurants of the day that were shaped in fantastic forms. The automobile had a yellow band around it and the "Chef," Little Oscar, charmed children and adults alike. It was an instant hit, and it has remained a public icon ever since.

Using children in advertising campaigns was not new. Campbell kids who sold Campbell's soups in print cartoons and the Brown Shoe Company's Buster Brown were well established when Little Oscar was born. The importance for hot dogs, again often viewed with suspicion, was that Oscar Mayer was moving them out of the dark side and into the sunlight world of innocent childhood and jokes. That theme was taken up with a vengeance after World War II. The Oscar Meyer Company became national in the period when the new American suburbs were being built and the country was being linked by a national road system. The 1950's popular culture celebrated child-centered families. Stay-at-home mothers went shopping in the new supermarkets, taking their children with them. Food hucksters drooled at the thought of children actually picking breakfast cereals, demanding sweets, and choosing lunch meats, hot dogs included. It was now that Oscar Meyer launched its most important marketing campaigns. An advertising man named Richard Trentlage composed an immortal jingle in 1963: "I wish I were an Oscar Meyer wiener." This ode to cannibalism (since it asks the singer to be eaten) remains immortal in folk memory. Another jingle, "my bologna has a first name," followed thirteen years later. All the advertisements were illustrated by happy, mostly white children.[39]

Oscar Meyer products themselves changed to meet this new market. With their new machinery, the famous wiener tunnel, they began to produce products that were bland and soft, literally made for children, or at least that's what many hot dog aficionados think. Novelist James M. Cain describes a similar machine:

> It took ground pink meat, fed it into a complex that stuffed it into skins, and changed it into dogs. Then, on a belt, it travelled these to a packaging mechanism. When they were wrapped in loose plastic bundles, the belt travelled these to a heater, where the plastic was neatly shrunk, so the bundles came out tight, falling into a basket and bouncing like playful pups. Finally it travelled them to a labeler, which covered one side with a happy scene of children having a cookout and eating dogs named GRANT'S. He tarried briefly by this mechanical miracle.[40]

What Oscar Meyer did was to make hot dogs fun. Children should not work, they should not be burdened with the cares of the world, but instead they should come home from school, turn on the television set, and snack on the foods that they saw in commercials. Other advertisers followed. It is estimated that $8 billion a year are spent on marketing food on children's television shows. Everyone knows the Armour hot dog jingle about the hot dog kids love to bite.

Wilson's hot dogs featured Muppets (who blasted off into space in a rocket ship); Eckrich showed children lovingly serving hot dogs to their mothers; Bryan Brothers, in West Point, Mississippi, the Southern rivals of Oscar Meyer, put a freckled boy on its labels; and Ball Park brand featured children with balloons and various riddles. Kahn's Wieners were billed at the time as "The Wiener the World Awaited," with commercials sometimes featuring a talking puppet in the shape of a "Man in the Moon" frankfurter. Kahn also sponsored the popular Uncle Al television program that ran from 1950 to 1986. Hot dogs were now a fully safe, fun food since children were expected not to want to eat anything that they could not play with or at least associate with play. In this vision of the world, hot dogs were now fully civilized, even if still eaten out of hand by children who were ruder than they ought to have been.

Yet the old ways remain. Hot dogs began as a kind of fun food among raucous Coney Island crowds, with the rough street vendors of city streets, boxing matches, horse races, and ballgames. Visit any city hot dog stand no matter how run down or sad the environment, and, without exception, it will be a cheerful place, filled with happy diners. People are lined up at, say, Pink's in North Hollywood, or Gene and Jude's near Chicago, and Nathan's on Coney Island. People grin as they anticipate stuffing hot dogs into their mouths. Even while eating, they banter with friends and strangers alike. Behind the counters, hot dog preparers work in tight quarters, together as teams, something that adds to the good spirits of the place. Hot dog fans do not have to be told what "fun" is. It just is.

MAX'S, LONG BRANCH, NEW JERSEY. THE CHEERFUL COOKS.

3

Hot Dog People: Entrepreneurs, Experts, and Fans

*L*ike the two cultures of hot dog manufacturers and consumers, there are two worlds of hot dog public dining: those who prepare and sell hot dogs, and those who eat them. Within each of sphere there are gradations of scale and appreciation. Purveyors range from hot dog cart operators, to fixed stand owners, large-volume dining places, and even chain restaurants. Hot dog lovers run from casual diners to serious fans who know a great deal about quality and local styles. The latter include experts who are or have been in the business and sometimes serve as consultants. Still others are explorers and explicators of what is or is not good in the hot dog world, at least according to them. Then there are enthusiasts, some of whom may be collectors of all things hot dog, from artifacts to pictures, to songs, or competitive eaters who down prodigious numbers of sandwiches in short order. It is a motley crowd but also a kind of community.

The point of contact for everyone is the hot dog stand, or its equivalent. It is here that interactions, the back and forth of commerce and love of food, create local hot dog cultures. For instance, a stand operator might introduce an innovation such as a hot dog sauce. Of course, anything new has to be familiar enough to be acceptable to the customers. If it is, the new item stays on the menu. If enough people like it other stand operators will follow, and a style of hot dog is born. This is why so many stands in one area serve very much the same thing. The process is also how people create their cultures, subcultures in this case, from the street level up. That is the strength of local food culture.

ENTREPRENEURS

In James M. Cain's 1934 steamy novel *The Postman Always Rings Twice*, a tramp named Frank Chambers is thrown off a truck at a wayside gas station–diner called the Twin Oaks. Owner Nick Papadakis hires him, and his

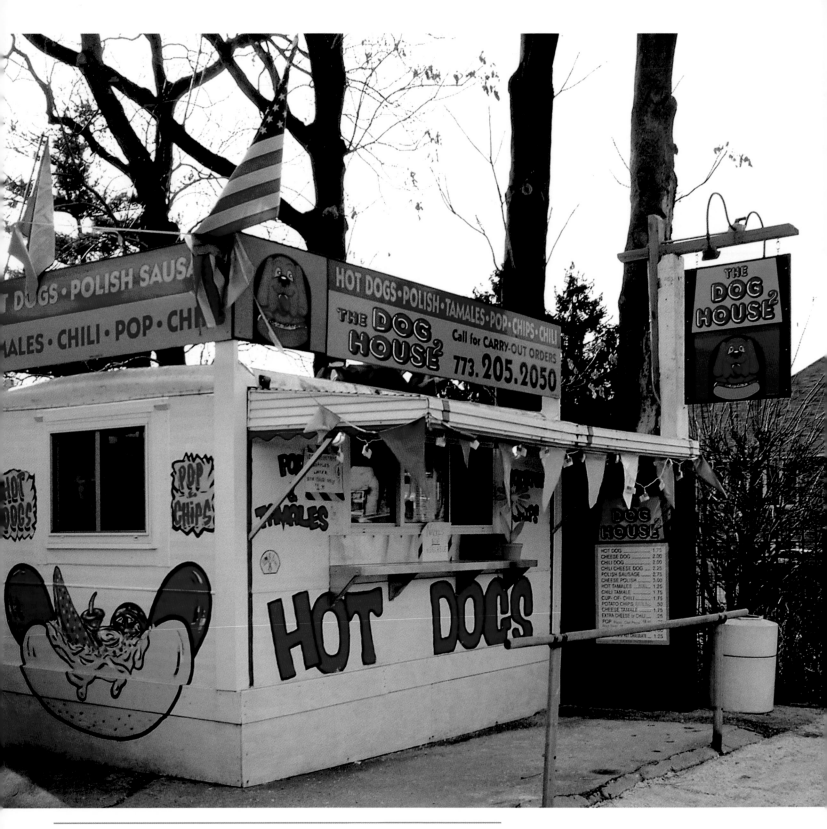

THE DOG HOUSE², CHICAGO. DIRECT CONTACT WITH CUSTOMERS.

pouty-mouthed wife, Cora, seduces him. Adultery and murder entangle Frank who, in desperation, thinks that he might leave and maybe open a beachside hot dog stand until something bigger comes along. That's as far as his aspirations take him because he has only $250. Besides, Frank's worldview is simple: "The whole goddam country lives by selling hot dogs to each other."[1]

Chambers might not have been a hot dog enthusiast, or even knowledgeable about them. What he did know was that he could make money selling cheap food at cheap prices. Marathon Food's Sabrett division tells potential buyers of their hot dog pushcarts exactly how and how much they can make. An average (New York) hot dog costs twenty-five cents and sells for $1.50, they say optimistically. At five days a week and one hundred hot dogs a day, the income is $32,000 a year; at two hundred and fifty gross income could be $81,250 in a year. Americans eat lots of hot dogs, on average sixty-five a year. The good thing about carts is that there is no overhead, as in a fixed location where property taxes, utilities, and other costs can add up.[2] Best of all, carts and lots of stands are cash businesses. What the tax man does not know is to the benefit of the vendor. Would that the way to wealth were so easy; some get there, others are disappointed.

Selling hot dogs to one another describes the kind of life Frank Chambers knew. It was a way out of his rootless life, a way up. If he could only get $350 (about $5,000 in today's currency), he and Cora would be all right. If only he were not on death row. What James M. Cain describes here is a version of anthropologist Sol Tax's coinage, "penny capitalism." Tax studied rural Guatemalans who operated the smallest of small businesses within their communities and, when they migrated to cities, brought their occupations with them. That might be anything from sandal making to selling homemade foods in a market. Without banking or credit they inhabit the informal economy that uses only cash money to make a living in an urban, industrialized world.[3]

People like this can be found in any lesser-developed economy, including America past and present. Petty entrepreneurs, at the margins of society, they occupy niches in the formal economy. In American lore, they were the peddlers who tramped the roads and city streets, the itinerant patent medicine men, bootblacks, and tinkers and fruit and ice sellers. In modern days they are the food sellers and hawkers who can be seen and appreciated on city streets, especially New York, where the marginal selling culture is strong. Hot dogs are often described as a "pennies business" because small amounts of money per item of product can add up over time. People who have been used to using their ingenuity to get by in a hard world—that means much of the world's poor—know what this means and how to maximize every bit of resource they can get. That attitude and perseverance are how some of the more famous hot dog places began, as carts and tiny stands.

Hot dogs can also be an ephemeral business. Frank Tillotson, born in 1910, described himself as an old-time "Carny Man" because he worked carnival circuits, including a hot dog stand, among other jobs. He tells what the life of the itinerant hot dog man was like.

In the early '20s the hot dogs were peddled out of a container that looked like a grocery basket. It fit on your arm and it was a container with two sides. One side was for the buns, one side for the dogs. It was heated by an alcohol burner. There were also the condiments. The peddler held it on his left arm and served with his right. It was made out of metal, sheet metal. Hot dogs were in a water container, the buns were on the other side steamed, on a rack. That was

the forerunner of the pushcart. They went from neighborhood to neighborhood, ball game to ball game, crap game to crap game. Some fellahs had a route that went from the crap games, some went to the ball games, some went to the parks. They each had their own routes, like an ice cream wagon. This was being done when I was a teenager in the '20s.

Each man was his own entrepreneur. One might be better than the others. Some might be mediocre; some guys were real hustlers. Then we made deals with Kosher Zion, Best Kosher and others who would deliver to local meat markets. You could pick them up there, then, instead of going downtown. And then when you were in the neighborhoods when you were about to run out, you might have a friend there with a stock at home in his refrigerators. Then you could go on for the rest of the day or night.

Wherever there was a crowd. You see in the '20s and '30s every neighborhood had its own little social club and there were ball games on every vacant lot. And then they went from that to the pushcart. The first ones were made from baby carriages. You took the reed body off and put a Fels Naphtha Soap box on there. It was just the right size. Assuming you had the right size, over there you put the burner and over here the burner. This was the basic pushcart. That was in the later '20s, but really in the '30s. I'm talking now about the southwest side, the Stockyards. Around the north side there were a few. You see the more foreign the neighborhood the more apt there were to be these peddlers. The southwest side of Chicago wasn't the elite, but it was one step up from downtown rough areas. Hot dog wagons hadn't got into those areas, around Halsted and Taylor [Streets—the old Italian neighborhood] and those areas. Maxwell Street [Jewish-Polish-Czech] was big then. There were maybe a half dozen stands on either side of Halsted Street. Levitt's and some others, there was one in each corner when you got off the streetcar in those days. Oh, the aroma of onions, garlic and hot dogs was wonderful. You couldn't pass a stand. No way you could pass a stand. The trolley ran down Halsted Street and about 13th Street. When you got off the streetcar the first stop was a hot dog stand. Any one of them, it didn't make any difference.

Well, as youngsters in the Depression days, we're always looking for a hustle as we called it. Some people could starve to death with a loaf of bread under their arm because no one ever told them how to open it. That's the temperament of some people. Now the next guy he has the power to make friends and influence people, so some would save up a few dollars and make up our little rigs and we would go to the ballgame and if it worked out good, then alright. If we could improve on it, that would be our summer Sunday money. We had to earn our own show money as it were, our own date money. That was Prohibition times in the early '30s. We'd go to a dance and chip in to buy a bottle of bootleg booze. Those were the facts of life. It wasn't that we drank a lot, it was just that peculiar thing that you knew you shouldn't. That was a big deal.

By this time trucks were coming in. Some guys would build the same kind of thing into their pickup trucks instead of pushing it. That was the mid '30s. Then into the '40s that kind of thing tapered off because you couldn't get the material and you had problems with rationing and so on. Then after the war came these, what we call affectionately "roach coaches" that ran in and out of the factories.

Hot dogs were always merchandised in the stores. A fellah would build his business on the taste of the dog. A lot of people don't think that there's a difference in tastes in the way the hot dog is served. Now the original hot dog, you have to remember, was only a nickel, so the dog itself wasn't very big and neither was the bun and then you put condiments on there. The situation was how to eat them. You could take the old one and almost put it in your hand like this and put the whole thing in your mouth and take a bite of the dog and the bun and the condiments. You'd have it all at once in a bite. But today the dog itself is bigger, the bun is bigger. You'd have a tough time eating it without getting it in your ears. Today's dog for instance, just wrap it up in a napkin and as you eat it move the napkin down.[4]

Tillotson spent a lot of time in Arizona and California, like so many young people during the Great Depression, hustling livings that went from the mouse and wheel game at carnivals to building furniture, teaching manual training in a school, and building Jeeps during World War II. He had a hot dog stand in Chicago and opened one in Arizona because that is how he knew he could make a little money when needed. He is an example of an internal migrant who moved within the United States, looking for the right place to settle, but ready to move on. Paul Pink is a successful example of an internal migrant who found the right place in Los Angeles in the same era. The new Sonoran hot dog stands of Tucson, Arizona, are latter-day versions.

The right place is not necessarily a geographic location; it can also be somewhere on economic and social scales. The allure of the stand cuts across class lines. A *Chicago Daily Tribune* story in 1913 states that A. E. Munier, a former professor of languages at Lake Forest College in Illinois, gave up "pedagogy for a more remunerative pursuit behind the counter of a moving peanut stand" from which he also dealt hot dogs on the campus of Northwestern University. His average take was $200 a month profit ($4,540 in 2011 dollars), or $20 more than college teaching.[5] Marianne Moroney, called the "queen of the street food," in Toronto, Canada, is a more modern version. A college graduate and actress, she lived abroad for some time and found herself at age twenty-eight in Toronto wondering what exactly she should do with her life. By chance, she won a lottery for a location to sell the jewelry she made between acting gigs, as she says, just outside Mount Sinai hospital on one of the city's main thoroughfares. The location turned out to be well known for hot dogs, not jewelry. With a small loan from a credit union, Moroney bought a hot dog cart and began what is the best-known street food business in Toronto. Overcoming personal loss and initial hardships, she has been in the street-vending business for nineteen years and is now the head of the Street Food Vendors Association. Moroney will not become rich, but she has a rich life because she knows and shares stories with many of the patients being treated at the hospital.[6] Street vending can be the beginning or a destination for willing entrepreneurs.

One need only walk down any street in New York where there are hot dog carts or visit most Chicago hot dog stands to see the influence of Jews on American hot dog culture. Two-and-a-half million Jews immigrated to the United States between 1880 and 1924. Yiddish speaking, most of them came from rural communities, shtetls, and small towns of Eastern Europe. Once here, they joined the three hundred thousand mainly German Jews who had arrived earlier in the nineteenth century. The latter were already assimilated Americans, many of them having made their ways in the world by moving from peddler to shop owners, and then into professional occupations.[7]

The Ashkenazim settled mainly in cities; New York, with one-and-a-half million, and Chicago, with more than a quarter of a million, were among the largest. Many began their American lives as garment workers, small shop owners, and peddlers in the neighborhoods where they lived: Little Italies and Chinatowns are analogues of the urban Jewish quarters. Many Jews were observant to some degree; a good number were not. Among both, something of the religious restrictions on foods was observed; in the case of sausages, beef was the rule. The all-beef hot dog sold by street vendors and in the many delicatessens that grew up in cities, made by Jewish manufacturers, came to be preferred over others. Even though most of the hot dogs were not kosher, beef sausages carried the reputation of purity in both cultural and actual physical quality senses. Beef hot dogs have come to

define the carts of New York and stands in Chicago, but not just because of Jewish connections. Beef also retained its cachet as higher-status meat, hence national companies, such as Oscar Mayer, Ball Park, and others make and advertise all-beef hot dogs as premium quality products. Fast food chains now promote all-beef hot dogs as featured items, Sonic and Steak 'n Shake among them.

Jewish-owned hot dog manufacturers did make pork and mixed beef and pork products, and they still do. Gregory Papalexis, the late president of Marathon Enterprises, owner of Sabrett, said that when he was a boy in the 1920s and 1930s most New Yorkers ate mixed pork and beef hot dogs. The Harry M. Stevens Company, the Nedicks, and Chock full o'Nuts chains all sold mixed-meat hot dogs, many of them made by Jewish manufacturers such as Hygrade and Greenbaum: "Jewish manufacturers selling non-Jewish products, non-kosher labeled products. I think the buck is getting in the way . . . there are a lot of good kosher places around . . . but too much of it has been commercialized."[8] The iconic New York and Chicago hot dogs, however, remain all-beef. Today Sabrett makes natural-casing all-beef hot dogs for many venues, New York's Papaya King and many other carts among them. They also make pork and beef products for others, such as New Jersey's The Windmill and the Hot Grill. Vienna Beef and Red Hot Chicago supply stands with the paradigmatic all-beef hot dogs. As Frank Tillotson said, "You travel around the country and you see places opened by a Chicago guy, maybe a Jewish guy, saying that they're Chicago style red hots. That's supposed to mean that you're getting a Jewish type red hot. It has authentic meat in it. That's what makes the dog. The trimmings are incidental."

As the next generations of Jews moved onward and upward, many left their families' original food business. Some remained and shaped public ideas about hot dog styles. Max's Famous Hot Dogs in Long Branch, on the Jersey Shore, is one of America's best-known hot dog restaurants. It was begin by Max Altman in 1928 as a small stand to serve vacationers and Monmouth Racetrack goers, most of who were from New York and northern New Jersey. Originally a small place at the end of Long Branch pier, Max was bought out by his partner, Milford Maybaum, in 1950. Mel kept the name and moved and expanded it into a good-sized restaurant with table and counter seating. Mel's son, Robert, his wife, Madeleine, and daughters Jennifer and Michelle run this highly popular restaurant. The menu is diverse, as are many other hot dog places, but the staple is a long pork and beef hot dog that is flat gridded in stages until crispy brown on the outside. Customers can specify how crispy they want their dogs. Served on a toasted bun, with mustard, and accompanied by a bucket of sauerkraut, this is one of New Jersey's classic styles.

One of the few hot dog restaurants on the shore (another, The Windmill, is just down the road), Max's is a destination for people who grew up in the area and parts of Northern New Jersey. Any day of the week a visitor will meet senior citizens who talk about the many years they have been coming to Max's, what happened there, whom they knew, and what Max's means to them. Madeleine and Jennifer are always on hand, chatting with customers, and encouraging exactly the kind of nostalgia that keeps Max's immensely popular.

Abe "Flukey" Drexler was the son of a greengrocer who operated a cart along Chicago's Roosevelt Road in the 1920s, and likely before that. The area was in the heart of the city's "Jewish ghetto," famously known as Maxwell Street. According to Drexler family lore, father Jake converted his cart to hot dogs and gave it to his teenaged

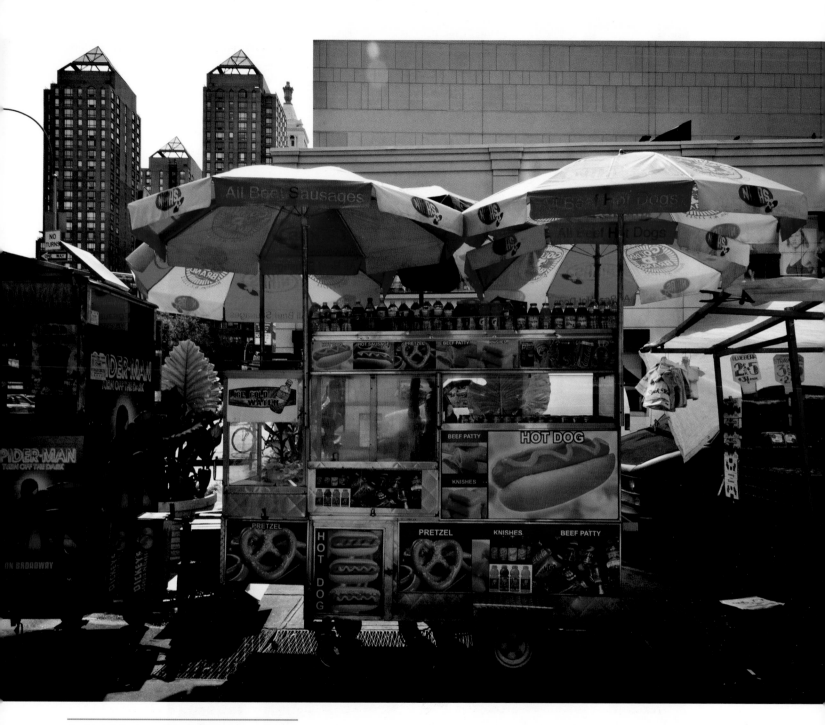

A CLASSIC NEW YORK CITY CART

son to operate in 1929. Hard times in the Great Depression meant more cheap food. The late, great hot dog salesman Seymour Lazar remembered: "During the Depression years a woman could buy eight hot dogs, some bread or rolls, she'd make a little potato salad and for sixty cents she'd have a meal. With eight hot dogs she could feed four people. You could open a can of baked beans. When depressions come sausage companies make money."

Hot dog stands could do well. One of them was Flukey's. The result was the classic Chicago "garden on a bun style." A water-bathed hot dog, eight or ten to the pound, with a heated bun, relish, and maybe pickles, onion, sport peppers, and tomatoes. Accounts of what went on the first hot dogs vary, but they were "dressed" and sold for a nickel. Whether Abe Drexler invented the style during the Great Depression or it grew from diverse vendors, the style is associated with all-beef hot dogs made and sold by Jewish vendors.

After World War II people were really on the move, and not just across country. With moneys saved during the years of rationing, employment rising, and funds being poured into building America's transportation infrastructure, the automobile industry boomed. Growing suburbanization spread populations out from old neighborhoods into new ones in ever-expanding circles. Fast food places grew rapidly along the road systems, in and near the suburbs, and even within cities themselves. In Chicago, for instance, there are barely a handful of hot dog stands that predate the 1950s. In 1948 Chicagoan and World War II veteran Maurie Berman and his new wife, Florence (Flaurie), decided to open a small hot dog stand in the Norwood Park neighborhood. It was only a summer business while Maurie finished his business degree at Northwestern University and Flaurie had summers off from her Chicago Public School teaching job. What they built became an icon among American hot dog stands, Superdawg. The small stand was a drive-in with carhops taking orders and delivering food on trays attached to the sides of customers' cars. Superdawg has become legendary for its hot dogs served with a round, pickled green tomato, an item from Jewish delicatessens that was sold out of barrels, along with sour pickles, and its distinctive crinkle-cut French fries. Most distinctive of all are the twelve-foot hot dog figures that stand atop the restaurant. Naturally, called Maurie and Flaurie, Maurie is dressed in a Herculean lion skin, Flaurie is a winsome girl in a short, flared skirt with a bow on her head, posing demurely, and both have blinking lights for eyes. The effervescent Maurie Berman says that the idea came from the hero comic books of the era, with a dose of classical mythology. As such the figures are a link between an early pop culture generation where Superman and Captain Marvel reigned supreme to today's action characters who have leapt from the page to screens of all kinds.

Pink's in North Hollywood, California, is at the same level of celebrity as Nathan's Famous on America's other coast. It was founded by Paul and Betty Pink in 1939 as a pushcart selling steamed hot dogs and tamales. According to their daughter, Beverly Pink Wolfe, her father, whose original surname was likely Pinkovitz or a variant, came to Los Angeles from Minneapolis not long before. Betty's family had immigrated directly to the city from Lithuania. They worked hard in various small enterprises and knew enough people so that when Paul was looking for an opportunity, a clothing store owner friend asked him if he would like to operate a cart next to the store. He had never been in the food business and needed a fifty-dollar loan from his mother-in-law to

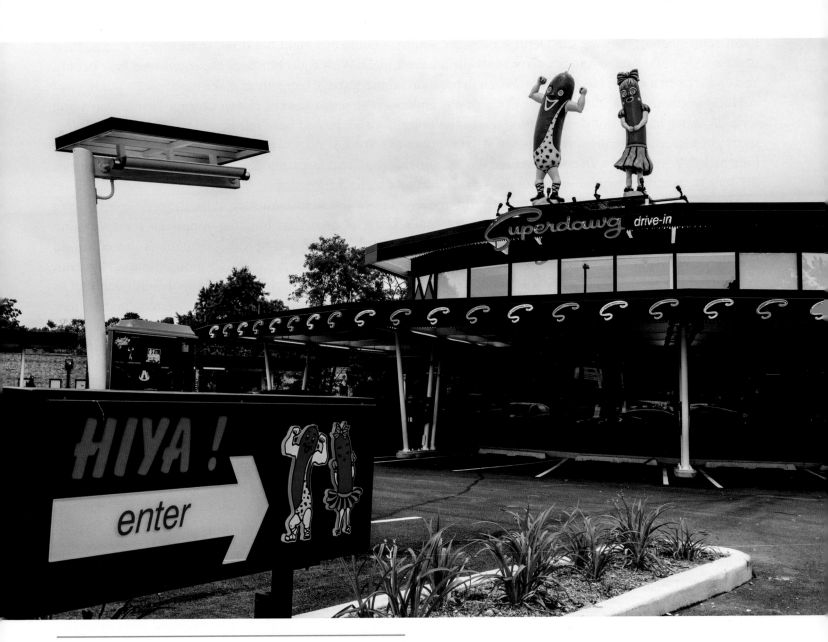

THE NEW SUPERDAWG WITH MAURIE AND FLAURIE

get started. At the time, the whole neighborhood was filled with orange groves, and Pink's pushcart was one of those wayside places travelers might stop at for a snack. Eventually, business was good enough to set up a small permanent stand, for which they got a loan from a Bank of America branch. They had no collateral, but the bank took a chance on them. How fortunate we were, says Beverly, that we became successful.

Today Pink's is featured as a great success story in Bank of America television advertisements, but it did not come quickly. For twenty years Paul was content to run the stand while his wife ran a flower business and worked at the stand. The whole family did. In the later 1950s the Pink family began to market the stand by appearing on radio programs, working benefits, and catering. They also maintained the original concept: a lot of food— seven- to nine-inch hot dogs with lots of toppings—family-run business, and fast service. The place bustles as the food preparers, many having been employed there for years, work fast to serve the long lines of customers. As Beverly says, her parents came from hard times—in Europe they had very little, and growing up during the Depression they had even less—and they knew what work meant. Its rewards were a rich family life and a well-loved institution that reflects the values of its founders and current operators.

Greeks had no dietary restrictions. Super salesman Seymour "Swifty" Lazar commented: "When I was growing up there used to be Greeks on the corners with pushcarts. They served a hot hot dog bun. I don't know what kind of hot dog they used, but it wasn't that expensive. The wholesale price for hot dogs was eighteen to twenty cents a pound. They put condiments on it. In those days they put the cucumber, they didn't use sauerkraut, they used cucumbers, tomatoes, all the garden on it." Lazar was talking about Chicago in the 1920s and 1930s, but Greek influence on American food has been great. The comic caricature of a Greek hamburger joint in Chicago (actually Billy Goat Tavern) on television's *Saturday Night Live* tells us how ubiquitous certain kinds of Greek-owned restaurants are.

Although some Greeks arrived in the 1880s and immediately set about making money to send back home, the heaviest Greek immigration fell between 1900 and 1920. The largest numbers came from the Peloponnesus, the earliest from Laconia in the south, and later arrivals came from the north in the vicinity of Tripolis and Patras. The north is a hardscrabble region, the classic dry, rocky landscape of goat herders living in small villages. It is not a part of the world famous for its culinary treasures, and it is precisely for these reasons that so many newly arrived Greeks got into the fast food business. As always, cheap food was one of the entry points into the American economy. How they became pushcart vendors was a matter of family networking. A vendor from the Greek island of Mathraki whose family worked New York City carts in the 1960s and 1970s put it this way:

Mathrakians remained with the hot dog carts. The ten-twenty people whom we found here they had carts nobody had businesses, restaurants/diners, in which they could put their relatives to work. That's why we got involved with it . . . we found this job because of kinship, one brought the other and the old ones told them to get a cart out in the street . . . and those years there was much more money to be made with a cart in one day than to be a dishwasher in a restaurant . . . so since we started with this work and we learnt it we remained there . . . not everybody, but most of the people have. [The] hot dog business is the only job in which you don't have any overheads and that's why I went into this business.[9]

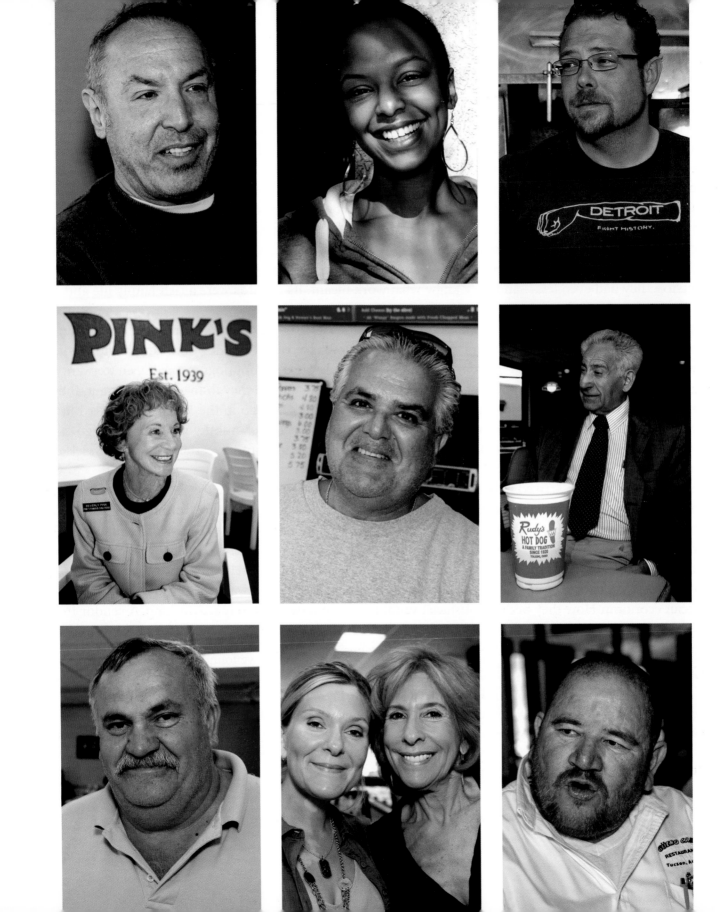

A story in a 1913 issue of the Atlanta, Georgia, *Constitution* reported on this very thing. From the backwaters of Mississippi to modern Atlanta, the author states, the "hog fruit" had taken hold in the hands of Greek hot dog vendors. Peachtree Street for whites and Decatur Avenue for African Americans—vendors were as thick as fleas on a dog. The air, writes the author, was filled with the succulent smells of water-bathed dogs, cooking onions, and sauerkraut. The dean of vendors, "Old John" Salas, had been at it for fourteen years in New Orleans during Carnival and Atlanta during the rest of the year. From the nickels made from his cart, he was able to buy property of considerable value. A ten-dollar stake to start a business, no overhead, and low costs meant enough money to establish oneself in the city. Higher up the food chain, as it were, Carl Holzheimer owned several stands and was a wiener manufacturer. Carl Witt was even wealthier, one of Atlanta's most prominent citizens, who had sold the first hot dog there and "by rare luck and enterprise, put the taste in the mouths of Atlantans."[10]

Germans started the hot dog business; enterprising Greeks followed and expanded the direct sales end. Similar stories are found across the United States. In the factory cities of southeastern Michigan, Greek and Balkan immigrants created the hot dog style most closely associated with the region, the coney. By repute, brothers William and Constantine "Gust" Keros founded what became American Coney Island and Lafayette Coney Island (they stand side by side in downtown Detroit) in 1914 or 1917. The name "coney" comes from Coney Island in New York, either because the hot dog's fame there, or more likely, because of Coney Island's reputation as a place of fun where the street food was just great. So it should be in Detroit. Research shows that a couple of coney stands preceded the Keros brothers' arrival and that those first stands date to 1923. No matter, these two had been goat herders from a poor Peloponnesian village named Dara, Gust coming to Detroit to sell popcorn from a wagon and shining shoes.[11] American Coney Island is still owned by the Keros family, Lafayette was sold to its employees, but the rivalry begun by the brothers some eighty years ago remains as an element of Detroit's cultural history.

What makes a coney unique is the sauce, often called "chili." It is not chili, though it is often sold in separate bowls and labeled as such. Rather it is a tomato-based meat sauce with flavoring reminiscent of Greek tomato sauces used in meats and familiar to many Americans in moussaka. Almost all such sauces are laced with cinnamon, oregano, and paprika, among other seasonings. Former employees of Lafayette, American, and other early coney places spread out to other towns, taking the sauce with them. Various versions exist in the many coney stands of Michigan and beyond, each according to the owners' tastes and thus causing many an argument among devotees of one place or another.

Just up the road from Greece, so to speak, are the Balkans, whose citizens also left for better lives in America over the course of the twentieth century. Slavic-speaking Macedonians and Albanians made their ways to southeastern Michigan to work mainly in the automobile industry and to enter the food business. There they met Greek hot

dog people and German sausage makers. Flint is a stronghold of Macedonian-owned coney places, but they are supplied by Flint's premier sausage house, Koegel Meats. The company was founded by a young Bavarian master sausage maker, Albert Koegel, who left home to see the world just after the turn of the twentieth century and in time to miss service in the kaiser's army in World War I. After Koegel spent time in Minneapolis, where he owned his own meat market, a sales manager for Armour suggested that he move to Flint, then the hottest city in the country because of the new automobile industry. According to his son, Albert, he did, opening a butcher shop with living quarters above it. His products became so popular that in 1932, one of the worst years of the Great Depression, he obtained a loan to build a processing plant in downtown Flint. The company prospered in general and began to supply Flint coney stands as early as 1919, if the Original Coney Island on Saginaw Street was the first stand. Certainly, Koegel sold pork and beef coney sausage from the 1920s on with no competition for their products after 2003. Sauce makings were and still are mainly from Abbott's Meats, a Flint company founded in 1907.

The Koegel family still runs the business with Al, now mostly retired, as the senior expert on Flint coneys. He says that he was raised on them, eating them after school when growing up and working in the plant during summers from the age of twelve. After a stint in the army during the Korean War, Al graduated with a business degree from the University of Michigan (he bleeds maize and blue) and expanded the business to the point where they now sell a quarter of a million pounds of meat products a week, frankfurters and coney dogs among them. During his time at the company, Al dealt with all the stand owners, and there is not a coney place where he is not warmly welcomed. He says that the Macedonian owners are among the hardest-working people he knows and are proud that they not only invented the coney tradition, but keep it going within their families.[12]

Most of the Flint coney stands are owned by Slavic-speaking Macedonians who came from a village originally called Bouf, now Akrita. Because that part of Macedonia became Greek in 1913 after the Balkan Wars, there was still tension between Slavic speakers and the Greek government, leading to emigration to America. Once one family came, other members followed, forming a kind of village in the new land.[13] Tom Zadarovsky of Tommy Z's points to a mural on the wall of his restaurant that shows Sam Branoff's (changed to Brown by some family members) family in a small car, saying that he was the founder of the coney tradition. In fact Paul Brown and Simeon Brayan were likely the earliest of the coney men. Other family members are the cheerful Popovs who own the Starlite Grill. Children, cousins are all in the business. Newer arrivals, like Tom Z (1975), had to work their way up from dishwashing and onion peeling—Tom says that he did this for years at Angelo's, once the most famous of all Flint places. In this way, everyone who remains in the business replicates the experiences of the forebears.[14] Tom puts it succinctly:

You remember, the table back there where everyone was chopping onions and drank cups of American coffee. I never drink American coffee before because in Macedonia we drink Turkish coffee. I come in there and he gave me sugar, I didn't know how to use the sugar shaker, so I opened the top and I put a spoon in there and took out sugar. And they started laughing on me, so I said why are you laughing on me. So I got up and I went to the restaurant and I looked around and I saw all the people eating, and I said, someday I want to own a restaurant like this. Well, my wish coming

true, I did own the place. I work seven days a week from six o'clock in the morning till six o'clock at night, then I go home, then I come back at nine o'clock at night and grind all the meat. I do this for seven years and I saved up my money and I bought the restaurant—my wishes coming true. And afterwards we got a bad partner, but that's okay. But I have the best partner now, her name is Eva, my wife.

Other Greek entrepreneurs opened hot dog stands at about the same time as their fellow countrymen did in Michigan. According to family history, immigrant Chris Economou opened a coney restaurant in 1919 in McKeesport, Pennsylvania. His small hot dogs were dressed in a sauce similar to other iterations, a Greek-style meat sauce and chopped onions. After some success, Economou sold it and moved on to other cities, finally ending up in Tulsa, Oklahoma, where he opened the Coney Island 5 Cent Hot Weiner Shop in 1926. Over time, other coney stands were established, some by Economou's former employees, and Tulsa became a coney town. Whether Economou saw the name "coney" in other establishments, or passed through Michigan where he picked it up, is not known. Greek-owned hot dog stands on the East Coast did not use the name. Whichever the case, Greeks have spread the idea of a sauced hot dog to the middle parts of the United States.[15]

Toledo, Ohio, is a place where one family established a near monopoly on hot dog stands and created their own style of service. Rudy's began as the Coney Island Hot Dogs stand in the gritty industrial city on Lake Erie. The dapper seventy-eight-year-old Harry Dionyssiou says that his father and uncles were working on railroads in Minnesota when a cousin who worked in a Toledo factory wrote to them that a food stand there would be a good business. They came in 1920 and, naturally, started making hot dogs with a Greek-style sauce. The family split up, other locations were set up, uncle Rudy founded a small stand where the main Rudy's is now located. It was the uncles who created the sauce recipe, one that defines Toledo coneys. It is full of vegetables, says Harry, and is the reason why he looks so much younger than his years. Other coney stands have opened in Toledo, but none lasted. Longevity and customer familiarity with the long-serving staff—ranging from twenty to forty years of service—is one reason, taste is another. When Rudy's celebrated its ninetieth birthday, in 2010, the main restaurant served sixteen thousand hot dogs to customers who lined up from morning to late at night as testimony to the power of local hot dog tradition.[16]

Rhode Island's Greek-influenced hot dogs are called New York System, the best-known being Olneyville New York System in Providence. Although the hot dogs are smaller than in other parts of the country, the spiced meat sauce is similar and of Greek immigrant origins.[17] It has been said that Greek sauced hot dogs called "Texas Wieners" originated with Patterson's Texas Hot Weiners that began sometime in the early 1920s as a stand on Patterson Street.[18] Barry Popik has discovered an earlier use in Altoona, Pennsylvania. Why the name "Texas" is a mystery, but it might have come from Western movies that were so popular at the time or it might mean "big," as in Texas big. The meaning is the same as "coney"; hot dogs are fun food. In 1936 an employee named William Pappas started the popular Libby's Hot Grill in an industrial part of the city. From there, similar Texas grills spread out across northern New Jersey, the most popular being the Hot Grill in Clifton. Although the Hot Grill follows the Greek-American original, it was begun by two Italians, Carlo Mendola and Dominic Sportelli, in 1961. Ethnicity and enterprise mix easily in the world of quick service and street foods.[19]

Different immigrant ethnic groups living side by side in urban settings created hot dog traditions. Jimmy Buff's is center for the iconic Italian hot dog. Jimmy Racioppi's grandfather James "Buff" Racioppi, from Naples, worked in a Newark factory for thirty dollars a week in the late 1920s. On his Sundays off, grandpa and his friends played cards, and when they got hungry his wife made sandwiches with a twist: hot dogs in a special bun with fried potatoes and green pepper slices. After a while, the Racioppis asked their friends to chip in a nickel for the food. That led to a Newark hot dog stand in 1932 that made three hundred dollars a week. In Depression years that was a lot of money, and Jimmy Buff's distinctive sandwiches quickly became a full-fledged style. The hot dogs are all-beef because, as affable grandson Jimmy says, a Jewish stand called Syd's was nearby and customers visited both places. Jewish delis were also common, so the all-beef hot dog just seemed to be the right choice at the time. Out of that first stand, and others that followed, the children went to college, some going into other professions, others remaining in their family business. Here is a classic example of a petty entrepreneur growing into an established cultural entity.[20]

Others happily remain closer to hot dog origins. Dee's is one of the few pure hot dogs trucks left in New Jersey and is operated by an ever-cheerful Dolores Ranieri on Fatout Street in Roselle Park. Serving classic New York dirty water dogs, she has been parking at the same location for almost fifty years. Her grandparents emigrated from Calabria to work in the factories of northern New Jersey, and her father had been in the scrap iron business for some time when he decided that a hot dog truck would be a better business. Dolores helped out after school and took over the business when he retired. It is a year-round, one-woman operation that she hopes will remain in the family. Dee's is a case where a single truck does well enough with local residents and as a destination as to not need to change into a permanent restaurant.[21]

Dee's has a commonality with even newer newcomers in hot dogs, Mexicans in Tucson, Arizona. In the 1950s bacon-wrapped hot dogs with toppings reminiscent of Mexican tacos and similar street food appeared in southern Arizona. Made and sold by Mexican food cart owners from the adjacent state of Sonora, they are called Sonoran hot dogs. From Tucson, the style has spread across Arizona, into California and other parts of the country. No one is certain who began the first stands, but they are examples of the ongoing process of using cheap food to enter the greater economy. Along with BK, Daniel Contreras's El Güero Canelo (a comment on Daniel's shocking sandy-red hair color) are the best known. Contreras, a native of Magdalena in Sonora, says that contrary to most people's impressions he started out with a carne asada stand in 1993. Locally, he says, that is what he is known for, but nationally and internationally, it is the Sonoran hot dogs. These were added to his first food truck simply as an alternative to the popular Mexican grilled meat dish. El Güero Canelo, then, originally catered to the large Mexican community in Tucson and to Anglos who like Mexican fare. With the hot dog, Contreras leapt across cultural boundaries into mainstream American fast food. That Mexican cuisine was growing rapidly in popularity and this was in the Southwest where there has long been culinary intermixing aided the process.[22]

Daniel Contreras has become a celebrity and outgrown his original food truck. Others in Tucson and elsewhere are more elemental. Los Michoacanos is one of two trucks run by Egla Guttierez; her husband runs another. With her little son at her side, Egla explains that the couple decided three years ago that the kind of blue-collar jobs

they were doing did not give them enough economic opportunity. Sonoran hot dogs and "raspados"—shaved and flavored ices—would. Located along a highway that served construction and other workers, the neat little stand has been reasonably successful, in part because it is not near other stands, and the products are good. She says that they just have to keep working, making a living even if, like Dee's in New Jersey, the family has but one or two owner-operator stands. Egla speaks for multitudes of stand owners down the years.[23]

In New York City, hot dog cart central, the ethnic composition has changed dramatically. According to New York's Urban Justice Center, many of the city's three thousand or so street food vendors are from the Middle East and Bangladesh. That much is apparent from changes in food served from the carts—a growing number make kebabs, for example. These vendors are as hopeful as those who came before them. Money is to be made in hot dogs, but not all is as easy perhaps as Sabrett suggests. From the beginning, carts have been subject to regulations by authorities, if not outright hostility. In Toronto, the street vendors association headed by Marianne Moroney does battle with city authorities who want hot dog vendors moved to different locations (special districts where various and healthy street foods would be sold), to regulate what they serve even further, and to impose more taxes on them. Similar tensions between vendors and city officials have gone on for years in cities across America. Chicago has few hot dog carts, the result of regulations, especially in the 1960s, that have made licensing and location finding very difficult if not impossible. Los Angeles, Seattle, San Francisco, and other cities have varying degrees of regulatory strictness.[24]

In New York the situation is long-standing. Sociologist Daniel M. Bluestone, citing an 1899 report on street vendors, put it this way:

> The ease of entry into pushcart peddling certainly did not match the conditions of the work. An 1899 observer remarked succinctly, "It is a hard life." The men and women who peddled worked very long days in the most adverse weather conditions—"under broiling sun, in torrents of rain, in desperate cold, and in the midst of swirls of snow . . . For what? For the most beggarly pittance—not enough, scarcely, to live on." Besides difficult weather and modest compensation, peddlers found themselves enmeshed in an official legal system shot through with potential for corruption and exploitation. The city licensed push cart peddlers and then made it illegal for them to stand at single locations where they found a ready market; this opened the way for property owners and the police to extort money from the peddlers as the price of not being hauled into magistrate's court, where they could be fined or deprived of time for selling their goods.[25]

Matt Shapiro and his colleagues at the Urban Justice Center consider the opportunity for street vendors to make a living, or not, a matter of social justice. Other groups around the country, such as in Chicago, think the same. Among the obstacles with which vendors must contend are that they must remove their carts each day and store them and get a decent site to attract customers. Many streets are off limits, and a good many buildings and stores do not want vendors in front of them. Vendors can be fined for the slightest infraction to the tune of one thousand dollars at a time. It is hard for a vendor to move if there are many others in the same location, as is often the case. Nor do people with little capital find it easy to obtain a cart and license. The numbers of licenses in New York is capped at three thousand. A number of license owners lease out their carts and licenses on a kind of black

market, so that a vendor using them must pay unspecified moneys to the owner. Under these circumstances it is difficult to get ahead of the game, as Shapiro puts it. The Urban Justice Center has programs to fight excessive fines and to give microloans to potential street sellers, but their best-known program is the annual Vendy Awards. For seven years food trucks from around the country have competed for the "best of" award, given by celebrity and food writer judges, with large crowds attending. The money raised goes to the Street Vendor Project, and that money goes to microloans, lobbying for favorable legislation, and legal fees. To date no hot dog vendor has won the top prize, but there is always hope.

Within the realm of hot dog business some are successful, others not. A former hot dog stand employee in Berwyn, Illinois, talking about a failed stand, said that "hot dogs are fairly simple once you have a system, but you have to pay attention to detail, you have to know what you're doing. The one I worked at, the owner goofed off, gambled at the track, and what could have been success was a failure. It wasn't the employees."[26] Successful operations depend a great deal on employees, and here lies an important part of the world of hot dog business. It is nothing like the realm of corporate fast food where turnover is high and staff not as cheerful as they might be.

Some, maybe most, of the iconic hot dog places have employees of some longevity. The Windmill in Long Branch, New Jersey, is run by Mike Nolan. He has been in business for twenty years, making him "a lifer," he says. The preparation area in the scenic restaurant is small, and the half-dozen food preparers work a kind of choreography, each knowing exactly where to move, which griddle or fryer to work, and all of them surprisingly pleasant—it is hot work in close quarters. Nolan says that most have been there more than a few years, like him. He and his team know many customers: "Dale, he's a psychologist who comes here three times a week. He orders two dogs, one for him and one for his ninety-five-year-old mother—she's in a nursing home." Nolan tells him not to worry about getting a dog with lots of chili and toppings for his mom because "the best food in the world is the food you wear."[27] This kind of joviality is a genuine part of the hot dog world and translates to customers. As many have observed, people who go to hot dog stands are always happy to be there.

Pink's in Los Angeles, Capital Coneys in Flint, Rudy's in Toledo, Jim's Original and Jimmy's in Chicago, Pete's in Birmingham, Alabama, the Varsity in Atlanta, Georgia, and a host of others are similar. Customers see familiar faces, the atmosphere familial even in a huge restaurant like The Varsity, and are happy. It is the nature of the product and the places, and these are reasons why hot dogs are embedded into communities and American consciousness.

EXPERTS

Along with purveyors and customers, experts and enthusiasts are significant in making hot dog culture. Among them are those who pose questions about sausage production and, beyond the technical, what sausages mean in both business and general culture. Jordan Monkarsh is the person behind Jody Maroni's colorful hot dog stand on Los Angeles's Venice Beach, and a pioneer in changing ideas about hot dogs. A native Angelino whose parents emigrated from Poland, Jody grew up working in his father's butcher shop in the Studio City area,

but was not a sausage maker. That art and craft was in the hands of specialized sausage men who, Jody says, made the shop's specialty, sweet Italian sausage. In the early 1970s in college at Berkeley, he found a developing fancy food universe. "Charcuterie, cheese, wine, the whole culture was much stronger in Berkeley. It had a little radical edge, a community edge," he says. In those days, he says, there were more good restaurants in Berkeley than in all of southern California, and it had an effect on him. What else would a comparative religion and history major do but get into fine foods? Thinking that he would turn his father's grocery store into an upscale food emporium, he schooled himself in the industry. Then he saw a street hot dog cart in downtown Los Angeles and everything changed.

Carts, Jody explains, should have a sheet of metal with Sterno heaters underneath and hot dogs with lots of grease cooking and when the cops come, you run. That is the real hot dog business, maybe not hygienic, but there is an immediacy to it that is compelling. It is the direct relationship of the seller to the customer that can never be recreated in corporate feeding places. In 1979, with that in mind, he set up a hot dog cart on Venice Beach that sold the sweet Italian sausage that he made in his father's shop. Why this area, famous for surfers and hippies? Because it was and is an artistic community, and that is the way that he was coming to view sausages. The stand was a success, but not with the authorities, because they did not want to "Manhattanize" the area with food carts. Having been taken to court for not changing his stand, Jody says he saw really hardened criminals. "That's not me," he said, and then built his now-landmark stand in 1984. It was then that he began to develop other sausages, analog sausages he called them, replacing pork with chicken, for example, and adding other seasonings. Although not the first to work on these kinds of sausages, his friend from Berkeley days, Bruce Aidells (now a brand-name sausage company), had been doing the same. What Jody did was to make new and interesting sausages available to a broad public and opened new vistas in the hot dog business.

"My idea is to reach the public—I like the public forum. Originally I really wanted to make sausages no one else made," Jody explains. Hot dogs are sausages, he says, but most people think of them differently. They are different in a technical sense because hot dogs are fully emulsified and that covers a number of sins. Hot dog makers might be able to have one or two flavor profiles, but for coarser-grind sausages the maker can develop a succession of tastes. Sausages of all sorts are "hermetic" in the sense that within an encased meat product flavors can go from a beginning-opening flavor or texture, as in "snap," to a middle and then a finish that, like wine, has a late-developing flavor on the palate. That is the art of the sausage maker, and that is what he wanted to do: to bring elements of fine dining to hot dog stands but without the stiffness, the snobbery, of fine dining. That is to say, he wanted to democratize sausages.

Jody Maroni's was really at the beginning of the fine sausage trend in American hot dog places, but it has always been with an understanding that he is a hot dog man catering to people who want hearty, good food at reasonable prices. Always, the emphasis at the stands (he has several at airports and was also a purveyor at Dodgers' Stadium) is the meat, not the toppings. He says, "I'm selling the sausage, I'm not selling myself as a saucier. I'll put on what you want but that's not my core idea what is sausage." The philosophy differs from that of most other hot dog retailers, who use a manufactured sausage that may be widespread in their area but change toppings

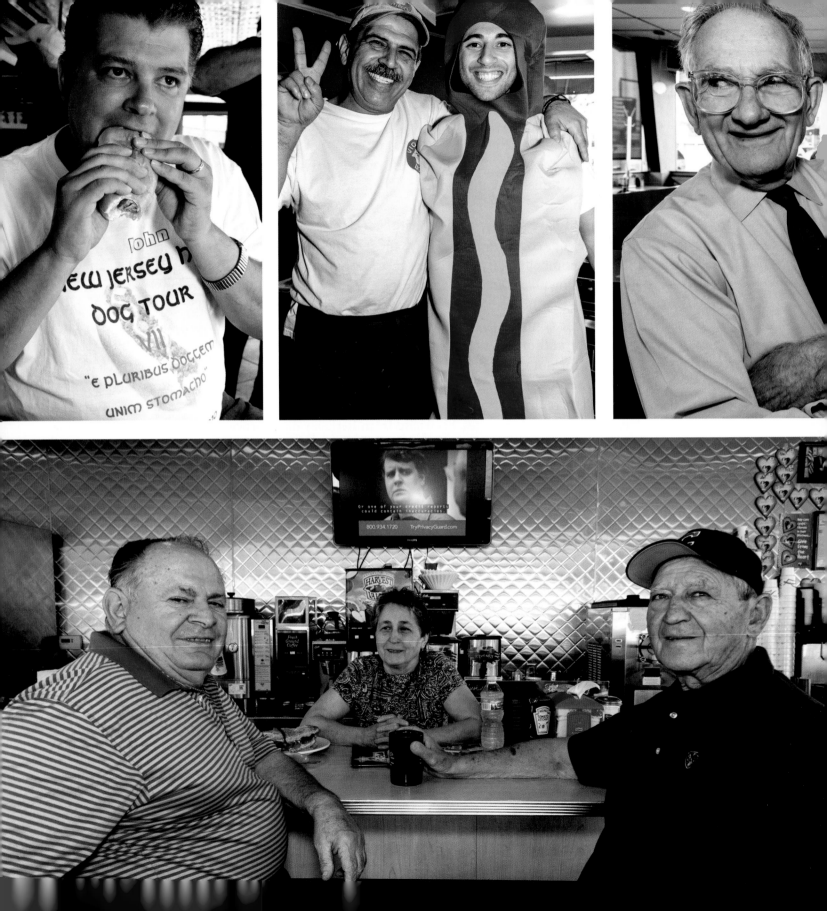

to differentiate their offerings. Jody allows his customers to choose from a variety of toppings because, he says, people are idiosyncratic about what they want on their dogs. Besides, the core idea of a stand is democratic in the sense of freedom of choice.[28]

Many of Jody's ideas have been incorporated in newer hot dog places such as Hot Doug's in Chicago, which uses varieties of sausages, as well as Chicago hot dogs. But he is still unique when compared with places like the well-reviewed Crif in New York City that uses an excellent hot dog dressed in varieties of hearty toppings.

Who says what a hot dog style is and where are the best places to go? Websites and bloggers about hot dogs abound. The redoubtable team of Jane and Michael Stern picked up on food guides such as Duncan Hines, whose 1935 "Adventures in Good Eating" became a model for finding good and authentically regional food across America. Their *Roadfood: The Coast-to-Coast Guide to Over 400 of America's Great Inexpensive Regional Restaurants All within 10 Miles of a Major Highway* (1978)[29] set the stage for many more books and, eventually, a website, www .roadfood.com, that invites participants to join with the team of experts to add reviews to the site. Ed Levine's site, www.seriouseats.com, covers similar territory. Hawk Krall, a self-described Philadelphia-based illustrator "who has a serious thing for hot dogs," has done illustrated guides to American regional hot dogs with commentary on the best.[30] Regional Chowhound sites and Chicago's LTHForum also provide reviews and comments from their community members. Local styles are also covered on sites such as West Virginia's http://thehotdogblog .wordpress.com/2010/02/11/hot-dog-blogs/, and a very good compilation of review sites, manufacturers, and other items of interest is Margarita Will's, http://margaritawill.com/hotdogs/#hot_dog_forums.

Of all hot dog review websites, none are as influential as www.hollyeats.com. Hollister Moore is a veteran of the food industry who knows a great deal about fast food and has a special love for hot dogs. The name Hollister comes from relatives who had been on the vaudeville circuit in its heyday, something that may have influenced the young man, whose first job was at the Cedar Point amusement park in Sandusky, Ohio. Now hooked on restaurants, Moore received a degree in hotel and restaurant management from Cornell University and immediately plunged into the corporate food world with McDonald's. Stints with Burger King and Dunkin' Donuts followed, along with others. He says that during a period in Wisconsin he got into bratwurst culture and came to know Usinger's sausages, still his favorites.

Greatly disliking corporate life, Moore ended up in Philadelphia, where he owned a restaurant-café. He also wrote reviews for Philadelphia's *City Paper* for some years and has done radio and television work in his favorite field, local quick service restaurants and stands. Interested in travel, Moore says that he read writer Calvin Trillin's work, pored over Jane and Michael Stern's *Road Food* books, and was converted to exploring local, often out-of-the-way food places, hot dog places in particular. He finds them fascinating: "you always feel good in hot dog places where you feel good eating them and so do the people making them." That, he says, is the history of the hot dog, in stands and at the ballpark: it is food for everyday life, not intimidating and open to all. Thinking about his

discoveries and developing preferences, Moore says that he has come to dislike hot dogs loaded up with all kinds of things. A purist, he likes the minimal sausage, because he doesn't think that "mixtures of flavors ought to be forced on a beautiful hot dog." That is, the true hot dog is the product itself; the fancy ones he finds inauthentic. Why stand owners do this is for several reasons, he opines. "One is that toppings can drive-up the check so that you can sell a three dollar hot dog for five with junk on top of it. Second, the owner is not confident in just the hot dog and thinks that they have to do more to get any sales."[31]

Reading Holly's reviews, it is apparent that he has a keen interest in local hot dog culture. He comments that "hot dogs are regional and must fit into local tastes. Other regional hotdogs forced into the area probably will not do well." He, and other "experts," whether professionals or self-educated, are interested in "authenticity." The meaning of the term is much discussed in culinary academic circles, mostly in regard to national and regional cuisines. What Moore and so many other hot dog commentators seem to mean by this is "[peasant food] . . . authentic (ethnically pure, honest, simple, or healthy), as well as tasty, is representative of a broader process whereby (food) fashion continually recycles a seemingly inexhaustible number of (culinary) traditions, [and a] . . . generalized desire for nostalgia, [and] tradition." Most hot dogs are commodity products, the Jody Maroni's of the world excluded, only adapted by local people to their own preferences and conditions.[32] A "gourmet" hot dog sold from a modern restaurant is not authentic by these lights; a grungy place doing, maybe, hot dogs grilled on a sheet over Sterno heaters, as Jody Monkarsh puts it, is.

When Holly Moore walked into Charlie's Pool Room in Alpha, New Jersey, he was immediately recognized by the owners Joe and John Fencz from a television show Holly had done and because someone tipped them that he was coming. There are few more authentic, if grubby is in the definition, than Charlie's, nor are there many more eccentric. Moore's enthusiastic review put them on the hot dog map, as loquacious Joe and John say with great enthusiasm. Their restaurant in an out-of-the-way former industrial town is now a destination for hot doggers and on the well-known New Jersey hot dog tour.[33]

Hot dog aficionados are everywhere, from Internet blogs to newspaper and magazine writers, and the eating class. Some have developed such passion for the topic that they have schooled themselves into expert class. Foremost among all is a New Jersey postman named John Fox. He is the go-to expert for print and on-air media about the complex world of New Jersey hot dogs and has organized and led the actual New Jersey Hot Dog Tour for eight years. Jolly and earnest about hot dogs, Fox says that he grew up in North Jersey towns and with hot dogs, but was only a casual eater. After getting his business degree, he worked for a bank, mainly servicing loans. Eventually, he found himself in the car repossession department, not the happiest of situations, he says, because he did not like being shot at. When a job came open with the U.S. Postal Service, he quickly took it and has been there for a quarter century. Asked how he became so deeply immersed in New Jersey hot dog culture, Fox says that it was an accident of marriage. His future wife took him to Galloping Hill Inn in Union on their first date. They married, moved to Union, and the place became a favorite—the mild, very Viennese-style hot dogs are just right. A few years later a newspaper listed the ten best hot dogs in New Jersey, among which was Galloping Hill. Curious about the other "best" John visited them . . . and was hooked. He traveled all over the state, posted his

comments mainly on the Road Food site, became widely known, and then started his hot dog tour. Today, John is often reported in the press, judges contests, and is widely acknowledged as the guru of Jersey dogs and beyond.

Like others, John's main criterion for quality is the sausage itself. Toppings are well and good, interesting except for onions (he does not eat them at all), but, as he says, "it is the meat itself." This is actually a culinary theory that goes back to Archestratus, the ancient Greek gastronome, to whom the chief good in cuisine is the flavor and texture of the prime ingredient. Down the ages theorists have said much the same thing; a sauce, for instance, in good French cookery, is meant to enhance the meat, fish, or vegetable it accompanies. So it is with hot dogs, since they can differ greatly in manufacture and certainly in preparation and saucing. Also like other hot dog purists, John is an originalist. In a Road Food post about a sixty-nine-dollar hot dog, he opined: "You don't buy a hot dog called a 'haute dog' and you don't get it from a fancy chef. You get it from a guy in a tank top with hairy arms who is probably named Nick or Vinnie. Guys like this have sense enough not to use white truffle butter and duck foie gras."

If the sausage counts most in a sandwich, then John researches its provenance and the nuances of the sausage business. When discussing a deep-fried hot dog style called "rippers," he confides:

> You have to have a special dog to do that—they have ingredients that allow them to withstand the higher heat. That is textured soy protein and semolina. This causes them to puff up. Rutt's Hut has this. Thumann's does this. They have three kinds. An all beef dog, a dog made for the griddle made of pork and beef, and then they make the Ripper. People think you can take a regular hotdog and make a Ripper, but you can't. The original, and I got this from a relative of the original Rutt family, they used the beef and pork sausage from a local butcher store. The owner of the place where they got their hotdogs was dying. Mr. Rutt went to him on his deathbed and asked for the formula. He refused and wouldn't even pass the recipe on to his family. He died and the recipe died with him. So the Rutt's went to Thumann and Schickhaus—they were the first to make deep-fried hotdogs. Thumann copied the concept, the plant manager told me that.[34]

This is the very stuff of the hot dog aficionado, in the same way that any gastronome wants to know the secrets of this or that dish or wine. Fox is not professionally trained, but he is not just a fan; in his enthusiasm, he is a supreme hot dog detective.

Hot dog culture is an invented tradition, consciously developed for commercial reasons or not, and it is the practitioners at all levels who keep it vital. The process is a product of interaction among professionals, critics, knowledgeable people, and, perhaps the final arbiters, customers who make and break those in business. It is also the means by which regional hot dogs styles exist.

Hot Dog Emporia: Signs and Meanings

*H*ot dogs are not only something to be eaten, they also are consumed by other senses, namely sight and smell. Restaurateurs know a lot about smell. It is the reason why the odor of baking cinnamon buns permeates the air in malls and airports, drawing in customers like dogs to butcher shops. Visual symbols are even more important to hot dog makers and sellers because every visual presentation is meant to draw people in.[1] Structures, signage, pictures, billboards, television advertising—by definition—all have meanings built into them. Scholars of these things, semiologists, call them "signs." Some signs are more obvious than others: the standard picture of a hot dog in a bun with a strip of mustard on a food stand means that hot dogs are served there. To the viewer who knows what a hot dog is, this means something quick and simple to eat at this place. Put lots of toppings on the hot dog and the sign means "really good to eat, with lots of flavor." In terms of taste the potential customer should know something about the flavors of each topping, but a deeper message is equally simple: lots of food at a cheap price. Beneath these lie cultural assumptions: abundance, Americans' right to it, and, likely, our democratic impulse to eat rudely among our fellow citizens. These are foundations for the feeling of authenticity, something that is important to hot dog culture.

In commercial contexts signs are marketing tools, advertisements for products. Marketing must draw on ideas that already exist in people's minds, even though advertising's goal is to influence them one way or another.[2] Putting company logos on stands, carts, and umbrellas, as we have seen, establishes a brand as a desirable product, but also makes it *the* established brand and tradition in an area. Vienna Beef in Chicago and Sabrett in New York are prime examples. In New Jersey hot dog sellers are at pains to say that their products come from Schickhaus, an old New Jersey producer, even though the company has changed hands several times and is now owned by Armour Eckrich, a division of John Morrell, now wholly owned by Smithfield Foods. The name means tradition and quality. Others companies try to do the same.

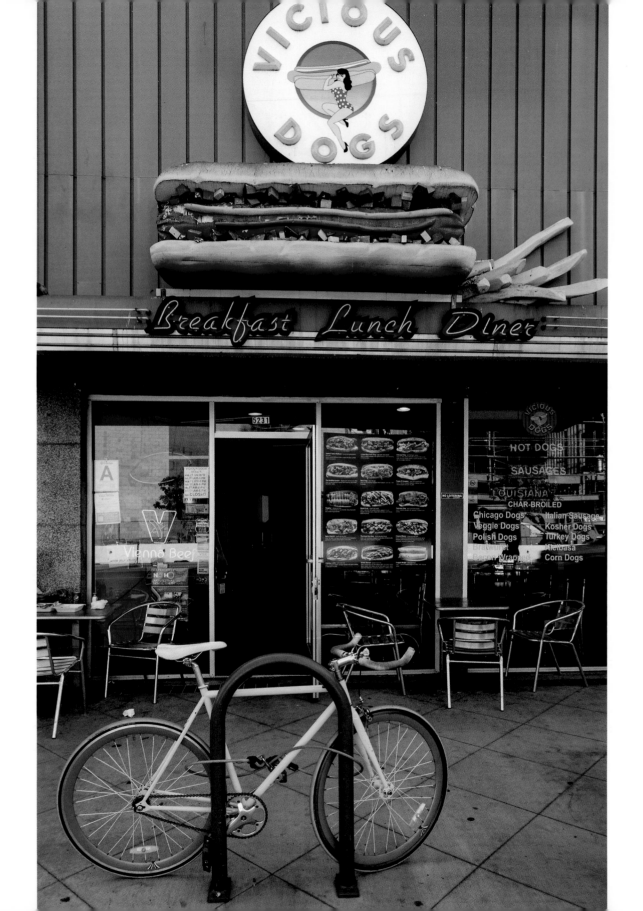

Signage becomes part of a stand, cart, or restaurant. That may be corporately designed—many companies have colorful posters for just that purpose—or homemade. The latter usually represent the small entrepreneurs who cannot afford fancy signs, people who are located within their communities (unless they are cart operators), and are thus more authentic than their manufacturer-supported counterparts. In either case, the overt messages are the same—eat hot dogs here—but the subtext is not the same. The "better"-decorated structures are a relatively superior class; they are in the process of moving upward. Their poorer brethren may not make it, even though they may be more genuinely "folksy." Picking up on that theme some newer hot dog sellers use décor of the poorer sort for marketing. The upscale Crif in New York City is in a small, dark basement space, and Los Angeles's District 13 garage style are two examples of what might be called "retro grunge." It is manufactured authenticity.

Structures themselves follow the same pattern and may be related to the locations in which they are set. From street carts to local stands, from the modernist cantilever-roofed Shake Shack to the nostalgia-themed Portillo's chain, the architecture varies according to the audiences being addressed and their cultural values. A handmade stand like now defunct Matty's in Chicago catered to passers-by in the down-at-the heels, if beloved by ordinary folks, Maxwell Street area. Dee's hot dog truck is one of this type. Rutt's Hut, although a good-sized restaurant, retains its unadorned, utilitarian standlike qualities. The professionally designed Shake Shack caters to long lines of younger, more affluent customers in Madison Park (among others), an area that the parent company helped gentrify.[3] Portillo's restaurants are stand-alone buildings in or near shopping malls, most of which look like diners and are decorated to appeal to suburbanites. Décor, class, and neighborhoods together with cultural assumptions go to make the visual hot dog landscape. And like all else in life, culture is composed not only of everyday things but of memory. How else would anyone know or feel about anything unless past experiences acted as a template against that which is seen is set? Hot dogs, and the vehicles by which they are distributed, are particularly given to remembrances of things past. Generations of families visiting the same hot dog stands are testimony.

What follows are some of the ways that the physical aspects of hot dog eateries and décors speak to us about America's popular culture.

Design

First there is the design of the food itself, the hot dog: the slang phrase "tube steak" has more meaning than a joke about cheap meat. On one level, the shape is handy, literally. It is easy to hold in one hand, even loaded with toppings, and is almost always eaten that way. The sausage in its simplest form is meant to slide into the mouth, just as FDR told Queen Elizabeth to do. Small ones can be loaded onto an arm, as in Rhode Island's New York System. Impaled on a stick, a hot dog can be dipped and hand carried easily. In the hot dog, form follows function, unlike almost any fast food.

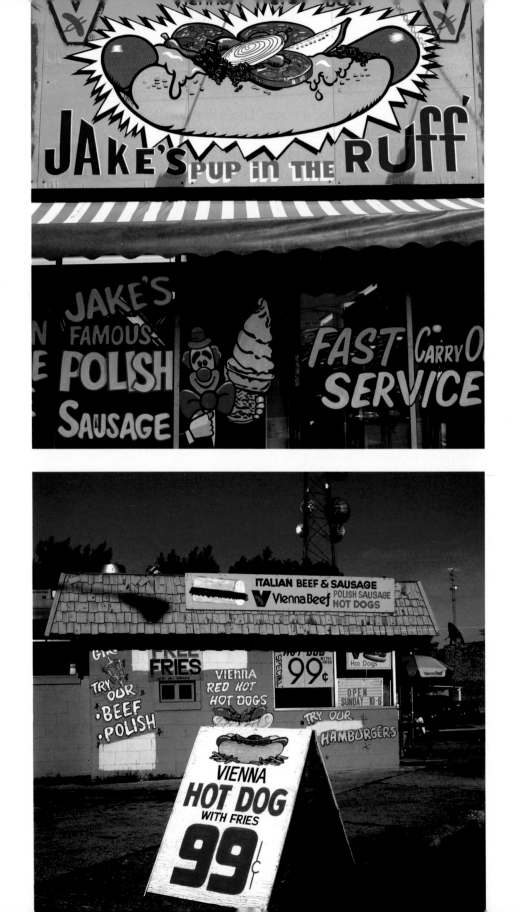

On another level the shape is modern and has been since the appearance of machines such as lighter-than-air ships and artillery shells. It is a compelling image to us and not necessarily for Freudian reasons, either. Therefore, the gently curved tube shape appears in all sorts of hot dog art, advertising, and structures themselves. It is organic and completely natural—an irony considering the way that hot dogs are made.

One meaning, as we will see, is absurdity. Graphic designs, illustrations, and photographs that are ubiquitous in popular culture often depict hot dogs in ridiculous ways. Hot dogs can be dressed in human clothing, shown as performers on stage or screen, morphed into heroic figures, made into real dogs—and vice versa, turned into buildings or carts, impregnated with sexual innuendos, and loaded with colorful ingredients so that the hot dog turns into pure design, like a piece of avant garde art. In purely physical terms, just eating a hot dog, or watching people eat them, is farcical. Like King George, we shove an overflowing tube into our mouths, eyes wide with the effort, like a comedian pulling funny faces. The humor in these acts runs through all of hot dog history and affects all depictions of the thing to be eaten.

LITTLE BOXES

The original hot dog cart was a pushcart, simply a heating box on wheels. Walter Scott, a "lunchman" in Providence, Rhode Island, is a model for the mobile vendor. Though he did not sell hot dogs, in the 1870s his lunch cart became popular in the downtown area. By the 1890s he had a full "cabinet" that was able to heat and cook food on the spot.[4] Carts like these may descend from mobile peanut and popcorn machines invented by Chicago's Charles Cretors in 1885. Similar devices populated the streets of New York and are the ancestors of today's numerous pushcarts. There were no signs, only the peddler; like others, he called out his wares just as is done in ballparks today: "hot dogs, hot dogs, get yer red hots." The stand was a stationary version of the pushcart. Service from the cart meant a vendor reaching into the box, creating the hot dog sandwich, and then reaching across the cart to the customer. The simple stand is a box with a cut-out window. The vendor remains inside and pushes the product out through the window. The methods of selling reflect differences in culture. The street cart stands in the open, the seller hawking his product, a part of the street crowd. It is the oldest form of selling, and the roughest.

The stand purveyor, to the contrary, is sheltered from the crowd, almost anonymous within his dark box. Shielded and permanently fixed, the stand owner's status in these lower reaches of the economy is greater than that of the street hawker. The barrier between seller and customer adds to a sense of ownership and pride of place. This begets art, and so stands are decorated in bright colors and plastered with colorful banners to mark them as special locations within their communities.

Many such stands are examples of vernacular architecture. That means buildings made by amateurs, usually out of local materials, usually in keeping with local buildings, and with not much regard for the profession of architecture. Of course, local building and sanitation codes should be observed, at least nominally. The décor in such places follows suit.

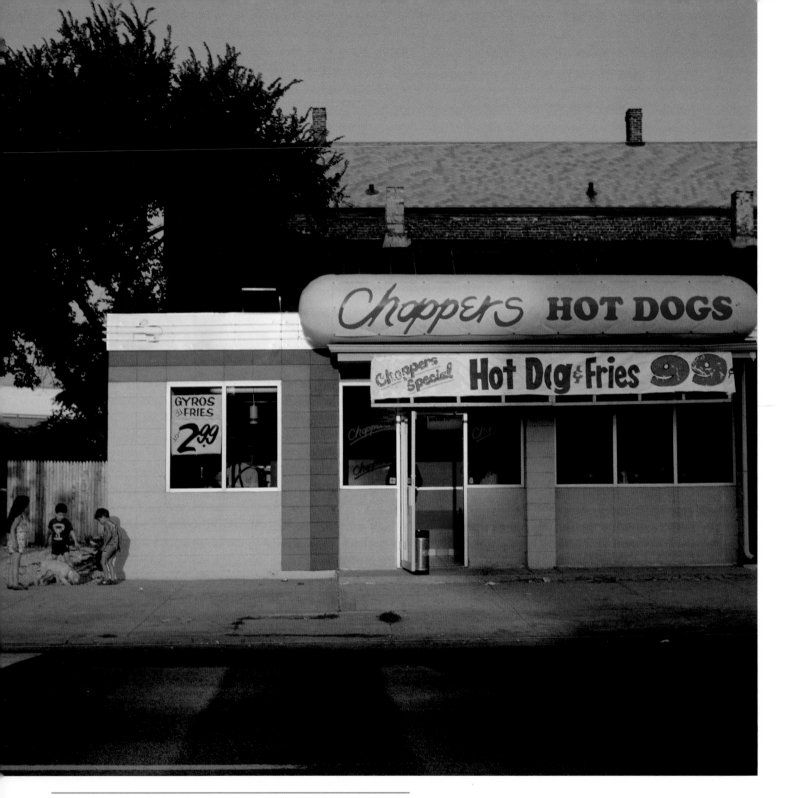

CHOPPERS. VERNACULAR STREAMLINED HOT DOGS.

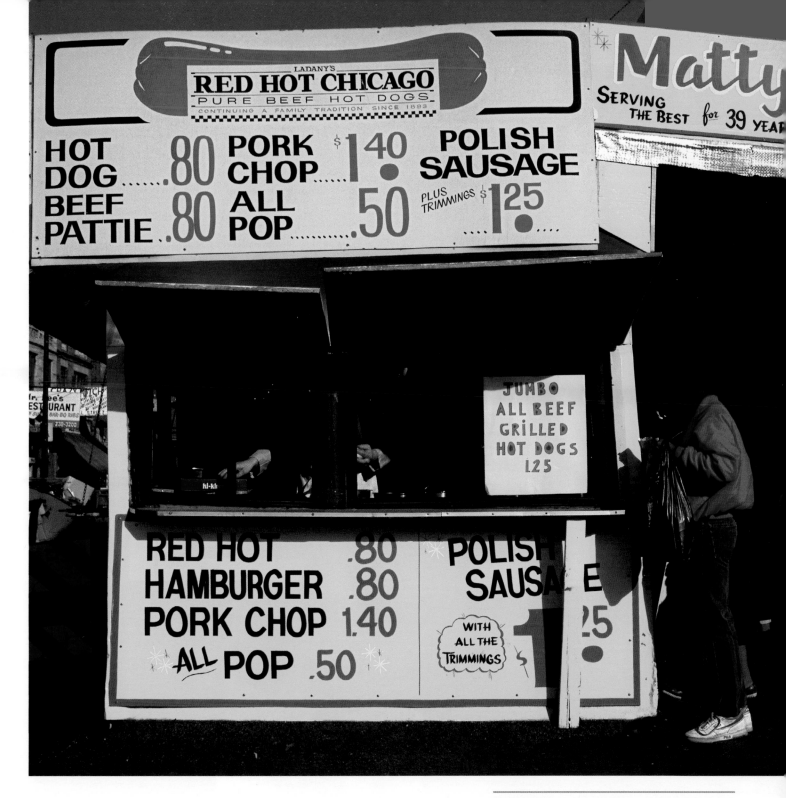

MATTY'S. A CLASSIC CHICAGO BOX

The earliest stands were simple, often striped affairs sporting the generally acknowledged hot dog colors, red and yellow. Oscar Mayer may have popularized the color scheme beginning in the teens of the twentieth century. Red means red meat and red hot dogs, while yellow is an accompanying color. Oscar Mayer's yellow band on each hot dog indicated its "handmade" quality. Soon the company began advertising campaigns that told customers to "look for the brand with the yellow band," and in this way yellow and red, stripes and otherwise, became hot dog colors. As the science of color shows, red on white stands out brilliantly, and yellow has similar properties. Blue, in contrast, is an appetite suppressant—except when it became a synonym for cheap restaurant special dinners in the 1920s called "blue plate specials." Hot dog stands come in all colors, but red stripes are common. Perhaps they suggest the circus, places where one has fun.

INTERNAL EXPANSION AND BOUNDARIES

In the nineteenth century when peddlers filled important economic niches, they always went to where the business was. Those who catered to rural communities traveled well-established routes. In cities, where life moved faster, street vendors had to move quickly. Any public gathering in a park, or a crowd exiting a public event, would attract street sellers. Food carts were always one of the businesses, but business at the margin of economic and social power.

In places where food stands were the rule, the same pattern holds. Where there is a vacant space, where business might be done, is a place that an entrepreneur can set up a stand. In earlier years, before cities established strict building codes, before city governments put food stands in "appropriate" locations, stands could be found in even the most unlikely places. Trolley and railway cars could be hauled to a spot and became instant restaurants. Empty lots, public squares, commercial streets, even highways . . . they are at the edges of formally established business and residential areas—always at the edges of formal life.

Earlier cities, or cities with dense, usually ethnic enclaves, could accommodate the barely formal businesses. Modern city planners could not because they wanted "a *clean space* (rational organization should eliminate all physical, mental, and political pollution)" and to overcome the stubborn resistance of tradition.[5] In popular culture, hot dogs are not rational. Certainly they are, in the main, industrially produced, and stands use logical systems to cook and serve them swiftly, but the effect, or emotion, is not. Hot dog stands are more authentic to customers than sterile streets and squares for several reasons. One is that they are one-on-one, personal interactions—the same holds for hot dog stands and restaurants where operators and customers interact as familiar friends. Memory and yearning for the familiar are others. Perhaps, as much as anything, most people dislike vacant space, as in the law of physics "nature abhors a vacuum." Monolithic lines and sharp angles of the planned city, soaring dark glass rectangles of buildings, call for filling in with "stuff," colorful stuff. The carts and stands themselves and the décor on and within them is this idea carried out physically, and, again, that is partly what makes hot dogs fun.

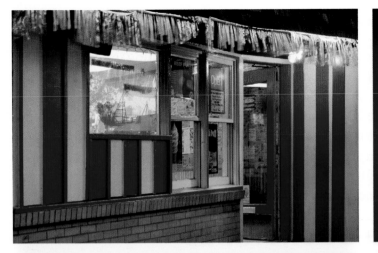

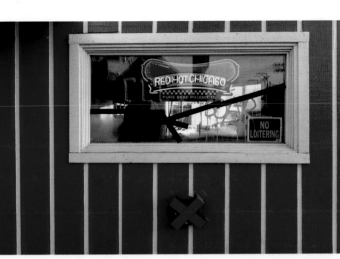

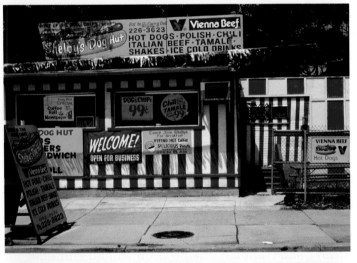

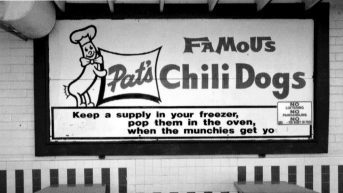

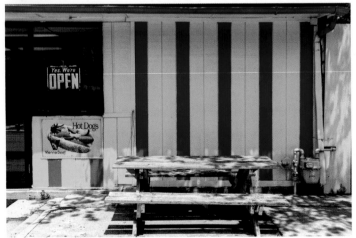

STRIPED STANDS

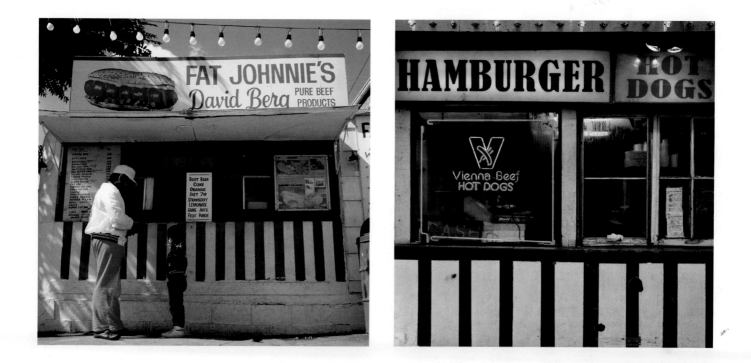

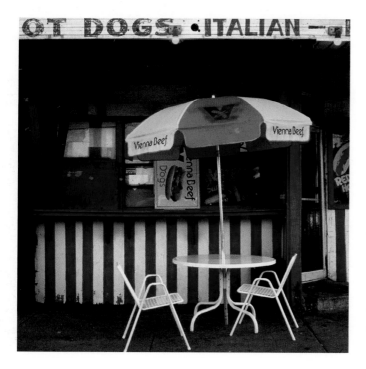

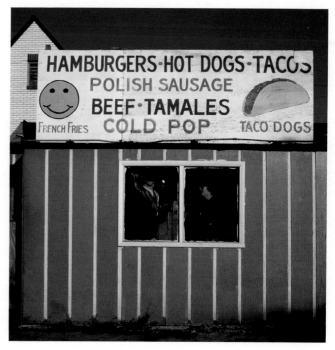

MORE STRIPED STANDS

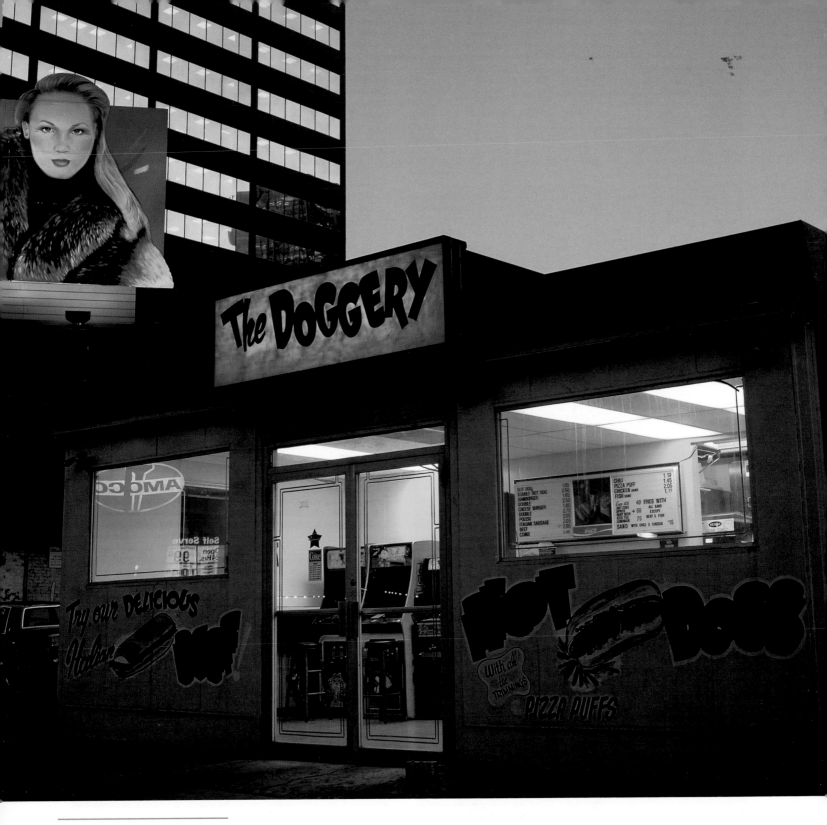

THE DOGGERY, CHICAGO

Opposite: **CHICAGO SCENES**

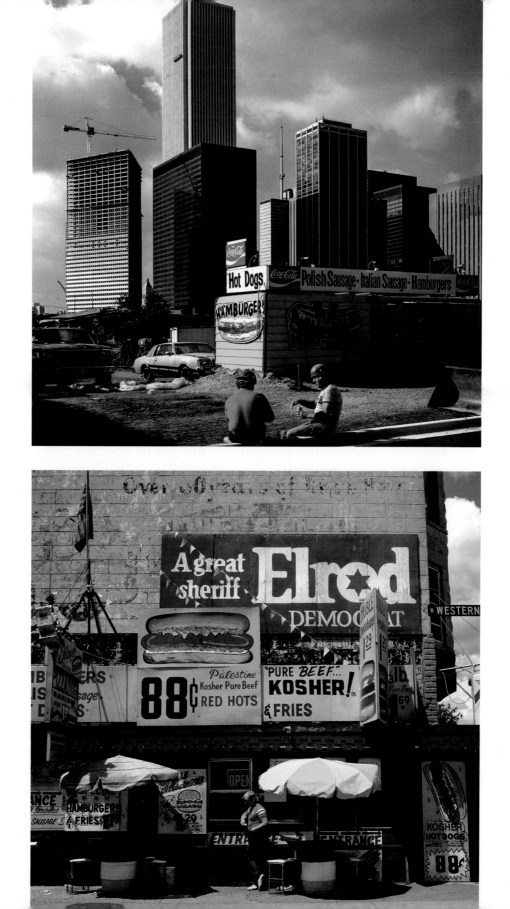

How do we know what the social/economic class or ethnicity of a neighborhood is? Literally we know by its signs. Everyone knows what a fancy, expensive store looks like and something about the people who patronize it. Urban neighborhoods tell us who lives in them by signage on shops and public buildings. Chinatowns, Polish, Hispanic, and other ethnic neighborhoods direct customers to stores by signs in their respective languages. Naturally, hot dog stands are included. The food sold might also change with additions of this or that favorite "ethnic" dish. Tacos are a prime example, though they have become national in scope. Signs also tell us more than ethnicity. Economically poor neighborhoods, where food stands are more ephemeral, often have handmade signs and décor that might be seen as hopeful of success, yet also forlorn because the chances of doing so are not great.

The core of any culture is the family, its internal ties and connections to the community. In traditional cultures families live in close quarters, and they extend into space and time. Living members are nearby, and so are the departed ones. And if we no longer believe that the spirits of the ancestors hover near the living, then they remain in memory. Family and memory always have locations. Homes, neighborhoods, towns, public places are all parts of family experiences and memory. Hot dog stands and other purveyances are features of memory's landscape. In Chicago, hot dog stands are symbols of time and place, where one-time children recall their family and friends. Nathan's on Coney Island is a public place that resides in the folklore of times past and present. For Detroit and Flint, it is coney stands, Max's in Long Branch, New Jersey, and in Los Angeles, Pink's. All have an antique quality about them, just as old neighborhoods that reside in memory.

Once upon a time America was proclaimed to be a great "melting pot" of immigrant peoples. Now it is better described as a cultural (and economic) stew pot. It is in cities that such creations come about. Peoples of differing religious, social, linguistic, religious, and economic backgrounds live side by side. The boundaries, both physical and invisible, may be hard and fast, or they may blur.

Terry's (on Chicago's North Avenue, east of Halsted) marks distinct social territories. On one side stands public housing, blocks of red brick. On the other are the newly made houses of redevelopment. Terry's is itself a solid red rectangle, with heavy wire-guarded windows and chain link fence. It is as if to say, at the intersection of two communities, it reflects the mentalities of both—guarded, wary, and the model of a prison block. Yet, boundaries have been and are crossed all the time. When people live together in similar environments, distinctions blur around the edges. As we have seen, the process of spilling over boundaries is the way that ethnic foods became part of America's mainstream eating habits. Greek-inspired gyros, tacos, "Italian beef," hoagies, and many other foods have been added to the vendors' repertoires, sometimes all served from the same vehicle—in themselves cultural stews.

Boundary crossings take two forms. One is composed of cultural-ethnic-economic elements. The hot dog itself represents this. To reiterate it is an industrially made product—a commodity—and cheap. On this simple Central-Eastern European product is loaded other cultures. In Chicago, it is Italian–Latin American tomatoes, British piccalilli (relish), pan-European yellow mustard, German–Jewish sour pickle slices, Italian–Latin American hot peppers and pickled peppers, and perhaps a staple of nineteenth-century American cuisine, celery (in the form of salt). All are loaded onto a soft bun, European in origin, American in execution. In Arizona and California, bacon, beans, and chili sauces are among the toppings. Many variations, many culinary-cultural practices, are poured onto the hot dog.

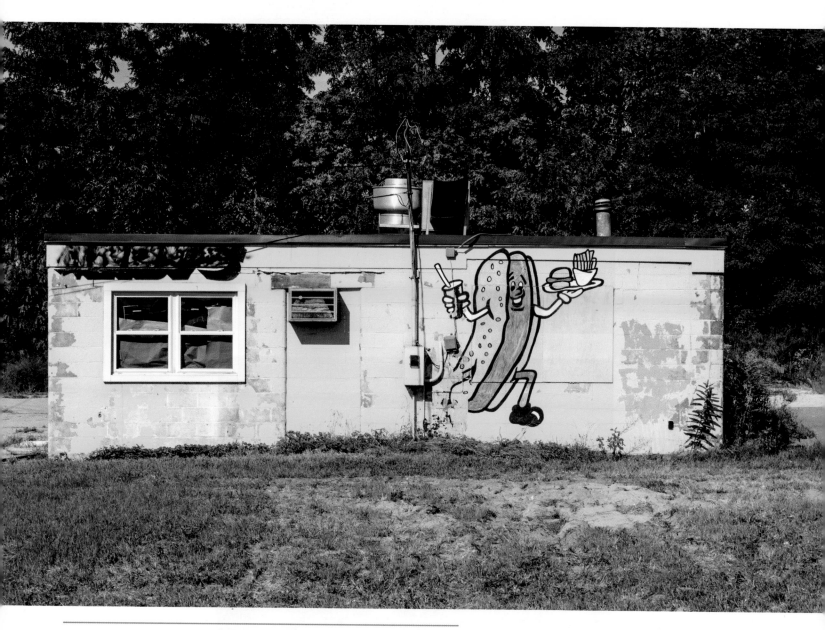

ANDY'S, NORTHWEST INDIANA. NOT EVERYONE MAKES IT.

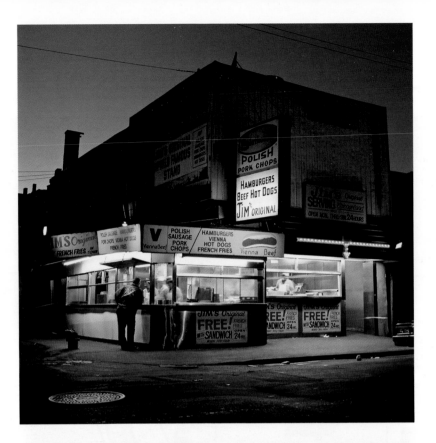

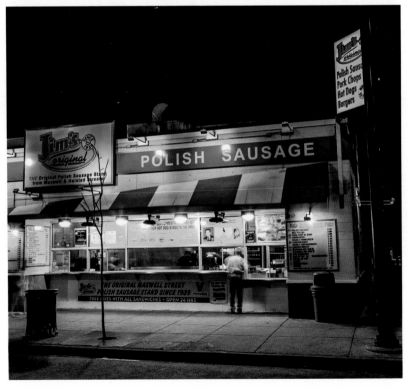

JIM'S ORIGINAL OLD AND NEW. A NEIGHBORHOOD PLACE RENEWED.

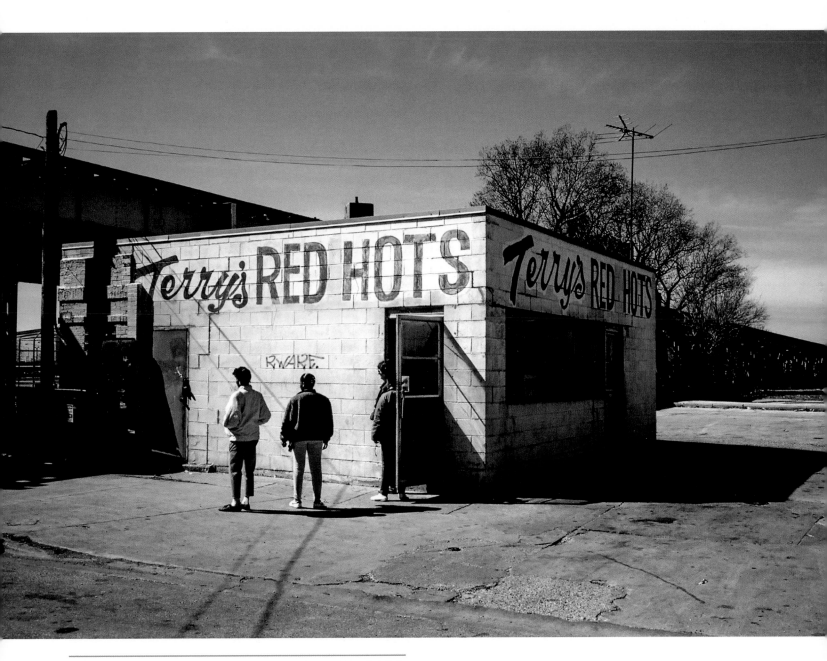

TERRY'S CHICAGO. DEFINING NEIGHBORHOODS.

Ideology forms the second boundary crossing. From their introduction to publics outside their original ethnic boundaries, at fairs, amusement parks, and ballgames, hot dogs became the food of all Americans. They cut across class lines as well, and that is how, in short, hot dogs became the democratic food.

Yet another boundary has been crossed with the growth of American suburbia and the road systems that they engendered and grew from. Dramatic changes took hold of America after World War II. A booming economy and a massive rebuilding of America, the rapid growth of suburbs, construction of a high-speed national road system, internal relocation of many Americans' residences, and the growth of world travel all transformed the country physically and culturally. In a kind of feedback system, cultural changes had their physical manifestations, and the new physical environment affected cultural forms. New buildings, cars, and many goods became the symbols of the new. For example, suburban shopping malls replaced old urban markets and stores, and with these came "mall culture," with malls as both object and symbol.

Many hot dog purveyances transmogrified themselves to enter this new world of signs. The product may have been the same, but the selling vehicles took more modern forms. Drive-in restaurants were one change that reflected a newer age of automobiles (the first was in the 1920s). In others shape indicated the new. Lucky Dogs carts, although hot doggy in shape, are really modern streamlined missiles, much as they are supposed to look like hot dogs. And after the rise of corporate fast food feeding establishments such as McDonald's, Burger King, and many others, some hot dogs emulated the forms of the new nationwide entities. The rationale may be cleanliness or efficiency, but the underlying motif for dining in them is this: petty food consumption was and is a way of reaching out to a world beyond the localized and now-antique hot dog stand. It is as much a symbolic act as an alimentary one. The venerable Jimmy Buff's are no longer in gritty downtown Newark, but in suburban strip malls and stand-alone diners, with an attempt at 1950's interior design. The same goes for Texas Weiner II and Hot Grill in New Jersey, Coty's and Telly's in Flint, Michigan.

DÉCOR

In the 1890s, mobile lunch wagons were being built by Tom Buckley in Worcester, Massachusetts. Within that decade they had become elaborately decorated, walk-in wagons with some two hundred and seventy five having been set up in towns across the nation.[6] Curlicue leaves, trompe l'oeil pillars, art glass, and more décor imitated fancy restaurants, theaters, and even women's fashions (think large feathered hats) of the time. The original Billy's Lunch Wagon in New Haven, Connecticut, that features in the story of how hot dogs got their name, was such a vehicle. Elaborate walk-in lunch wagons, together with new railway dining cars, affected hot dog eating spots ever after.

One was the dining car/diner restaurant concept. In the 1930s diners of many kinds were widespread across the country, but especially on the East Coast. Few were dedicated entirely to hot dogs, though they were often served. Some were simple, others elaborate, and especially interesting were—and are—those that resembled the streamlined modern design so popular in the 1930s: rounded corners and bullet-shaped railroad engines mirror the industrial hot dog.

Carney's in two Los Angeles locations are the real thing, literally railroad dining cars. Their yellow color attracts attention, while the functional interiors preserve the oldest lunch wagon style—a counter-window over which customers are served and with little seating. Carney's advertising features billboards with the restaurant's logo, a train-crossing sign.[7]

The first elaborated lunch wagons' other important influence was on décor. Nothing can stale the infinite variety of hot dog stands. They come in many sizes, though fairly standard shapes, and have boundless décors. The reasons why, again, vary from personal taste, to how much money the stand owner has available, to perceived demands of marketing. Visible signs are meant to lure customers, for as P. T. Barnum apparently said, "Without promotion something terrible happens . . . Nothing!"

Design for selling lures customers, and many designs are what can only be called "baroque." Utilitarian design, spare and to the point, with simple décor became fanciful and then exploded into baroque artifice. That may mean not elegant décor but "horror vacui"; that is, a desire to decorate every possible vacant space. It is analogous not so much to seventeenth-century European art, the Baroque era, but to the Gilded Age in the nineteenth century. Upper-class culinary tastes reflect the era and its arts: more is better, especially rich sauces and additional ingredients, as opposed to a refined cuisine where the main food is to be enjoyed for its own flavors.

The general idea about why baroque design is popular comes from the idea of *carnevale*. The word means "farewell to meat," and comes from the religious observance of Lent, forty days of fasting before Easter. That day, called Mardi Gras, or "Fat Tuesday" in French, everyone puts on fancy or grotesque costumes and parties. The "fat" comes from the excess of eating and drinking before the fasting time. In these festivals, the social order is turned upside down and all polite behavior and eating are cast aside. Circuses, booths at fairs, and many a hot dog stand have this idea in mind: bring people into the world of *carnevale* where everything is fantastical and fun, and likely fattening.[8]

Gargantuan-sized other fanciful figures grace many a hot dog place. The lumberjack Paul Bunyan had an outsized appetite and his adventures, such as digging the Great Lakes, make him a carnevalesque figure. It is only appropriate that Bunyan and some of his stories were invented in about 1907, others in the teens and twenties of the century as advertising campaigns.[9] Strange figures, yawning mouths, and especially happy dogs just waiting to be human chow are all of a piece. As P. T. Barnum knew, the stranger an exhibit is, the more attractive it will be.

Perhaps nothing says baroque more than fairs and festivals. Like circuses they are cousins and brothers to carnivals, whose purpose is to give attendees as much pleasure as they legally can. Rude food is a central element in these places. Advertising at some state fairs, such as the gigantic Minnesota State Fair, brags about the artery-clogging items sold there. It is as if to say that maybe once a year one can forget all dietary rules and simply "pig out." Deep frying is king here. Elaborately decorated food stands say this and, naturally, deep fried dogs are integral. The Illinois State Fair must be corn dog central since it is in Cozy Dog territory, itself lying in the center of America's cornlands.

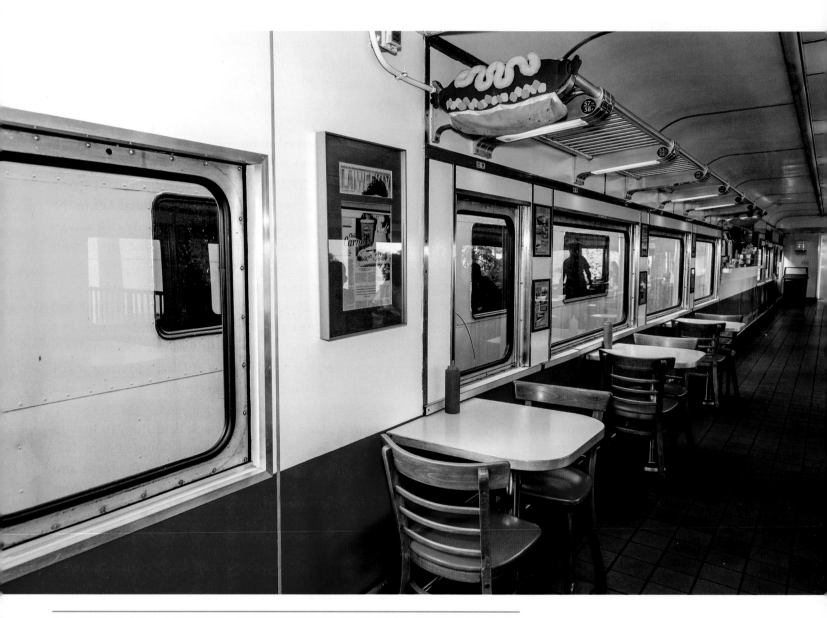

CARNEY'S, LOS ANGELES. GENRE DINING IN A REAL RAILROAD CAR.

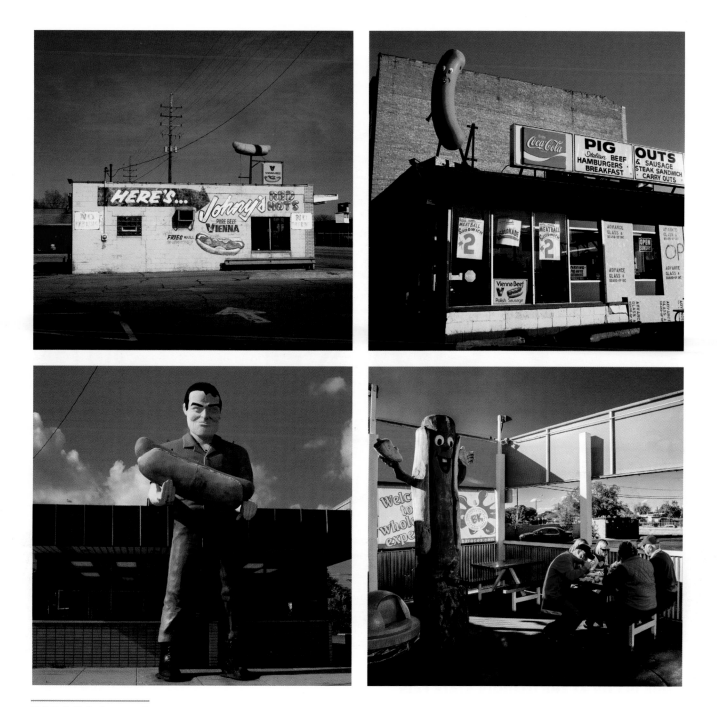

HOT DOG STYLES

BAROQUE DÉCOR AT THE ILLINOIS STATE FAIR

Signs that show huge hot dogs loaded with toppings are one form of baroque. Places that are festooned with pictures, posters, tchotchkes—giveaway items—every bit of counter or wall space covered are another example. This has been called "the baroque drama, the representation of uselessness."[10] It is not. A restaurant so stuffed is meant to overwhelm diners. When the pictures are of celebrities and laudatory articles, they give authoritative witness to the quality of the place. Maybe diners are meant to share their good taste with celebrities. More likely this is all a celebration of the carnevalesque sense of just sheer color and quantity of ornamentation as fun. Hot dog creations such as Vicious Dogs' massively loaded ones decorated with cream squiggles are nothing less than baroque to the mouth. America has many more such grotesque fantasies.

Out and out vernacular art can be original. Most people find folksy painting and signage charming, in the same way that other forms of folk art are. We love the naïve quality of it. Part of the appeal is that art of this kind has roots in the past, in memory. Retro is a common word for some of it, but there is a fine line between the naïve and kitsch. Kitsch is usually defined as decorative objects that are tasteless, usually sentimental, based on more original and authentic art or ideas. Kitsch has been said to be the linking of formal innovations to humane sentimentality; that is, avant garde (modern mass production) techniques can be wedded to familiar objects.[11] Mass-produced paintings of children with huge eyes, and almost any portraits of cute dogs, are examples. Depictions of dwarves and elves from Germanic mythology painted in pastels at Usinger's factory store are another example. So is the Usinger elf that leads an annual sausage parade in Milwaukee. All are fanciful, but sentimentalized, as well. Hot dog stands and carts that are deliberately decorated as throwbacks to another era latch onto this popular sentiment. In contrast, collections of hot dog memorabilia rise above kitsch level to be resources for hot dog culture, and they are often amusing at that.

Hot Doug's in Chicago is one restaurant with a more sophisticated sense of baroque décor, complete with an archaic, museumlike case. That puts the restaurant into the world of artifact collectors. Frank "Uncle Frank" Webster's collection at http://thehotdoghalloffame.blogspot.com is one of several "Halls of Fame."

There are gradations of quality between the poles of good art and bad kitsch that pull upon hot dog culture. Much of the debate about the matter comes down to a sense of authenticity. Many a modern stand draws upon its local culture and history. Ben's Chili Bowl, in Washington, D.C., for instance, has a wall of fame with photographs of famous visitors, as does Pink's in Los Angeles. Ben's is a kind of history of African Americans' achievements in Washington, D.C.; Pink's is about Hollywood celebrities. Both designs are authentic in that they represent each place's clientele and the cultural geography in which they exist.

Other restaurants turn to nostalgic themes in a more deliberate way and out of context. These differ from straight-out modern designs such as Shake Shack. Wood-lined walls, brass railings, old-fashioned tiled floors on new buildings in shopping malls are clearly meant to make customers feel comfortable. Considering the historical fears about hot dogs, one can see the point, especially for older customers. Others of these kinds of places, such as ones with 1950's or 1960's designs, usually with Elvis pictures on the walls, are what night be called faux cute, much like paintings of dogs with big, soft eyes. Faux cute is kitsch—commercial appeal to sentiment—but even more cynical than that because it is not rooted in an authentic time and place.

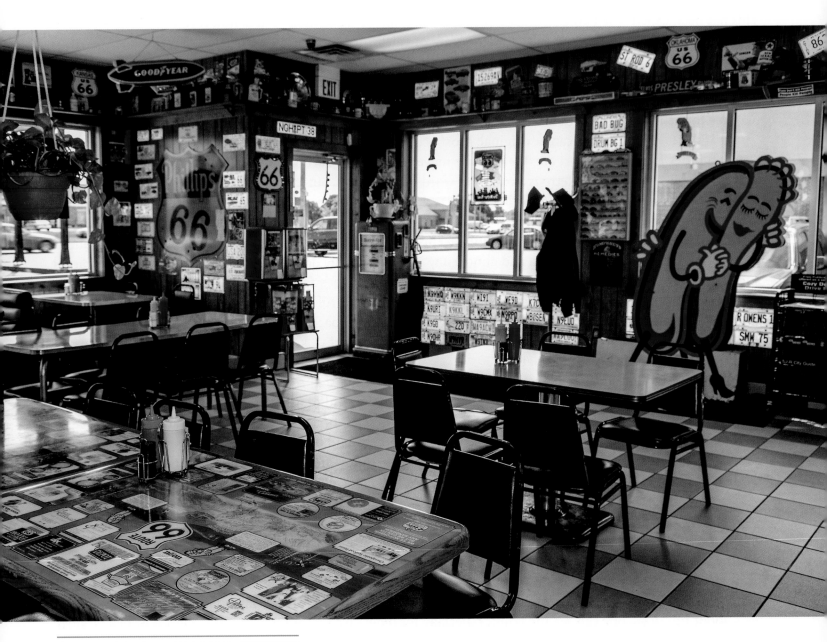

COZY DOG, SPRINGFIELD, ILLINOIS

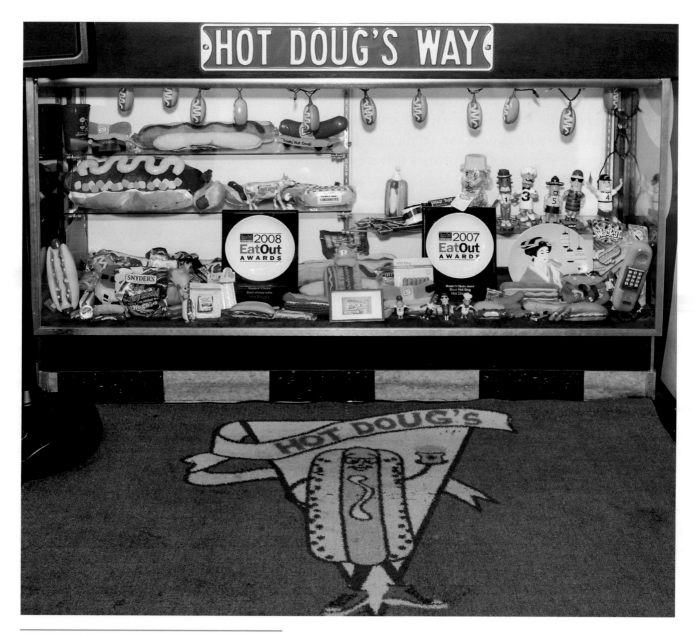

HOT DOUG'S DISPLAY CASE, CHICAGO

Some kitsch is authentic because of naïveté. T. J.'s in Detroit has a design unlike any Opposite: **STANDS** other hot dog stand. It could be called Neo-Minoan, but that's not what owner Pete Makkai says. He had been in Las Vegas—America's kitsch central—and liked the sand colors and designs that he saw. T. J.'s reflects his vision, and besides, it looks like the gentlemen's club adjacent to it. Just down the street another coney stand has been remodeled in very much the same colors. Before long, this might become the dominant Detroit coney stand style and, after more time, a tradition.

The retro designs of the manufactured authenticity varieties mentioned are also meant to appeal to younger customers who have little sense of history, but know a lot about recent popular culture. Rock band members dressed in hand-me-down duds, or worse, set the tone for this kind of aesthetic. As more than one commentator has observed, these are examples of an America that is entirely invented for commercial purposes. And that, itself, is a kind of authenticity that has moved across the world in fast food outlets.

• • •

Hot dog places can be deliberate works of art. Interior designs can be sophisticated with clean and even witty designs. The Dog Joint is a case in point with its muted colors, tastefully placed wall art, and 1970's R. Crumb–inspired graphics. Others are pieces of architectural art when seen at night, and deliberately lit. Wiener Circle is a well-known late-night eatery in Chicago whose lights draw customers of all kinds, not just bar goers, and Pat's in Tucson is an institution that draws University of Arizona students and citizens like moths to a nightlight. Golda's was built as a functional piece of art, interactive art since it was a restaurant, from its core building to the brilliant sign. It no longer exists, but it lingers in memory as a great hot dog stand.

Last, many a hot dog place has taken its design from food chains and standard designs created by restaurant consultants and builders. Although we have said that hot dogs resist modernity, the theory of petty consumption assumes that many entrepreneurs want to participate in the greater economic world around them. Their stands are built in imitation of corporate restaurants. Lifted, as it were, from the neighborhoods, such stands now are returned in beautified and sanitary forms. Neon, shining chrome, large windows, fern plants, gleaming tile, and sanitary plastic trim replace the handmade. Such is the power of uniform corporate culture. However, beneath this veneer of modernity lies the ancient, rude hot dog, compelling as ever.

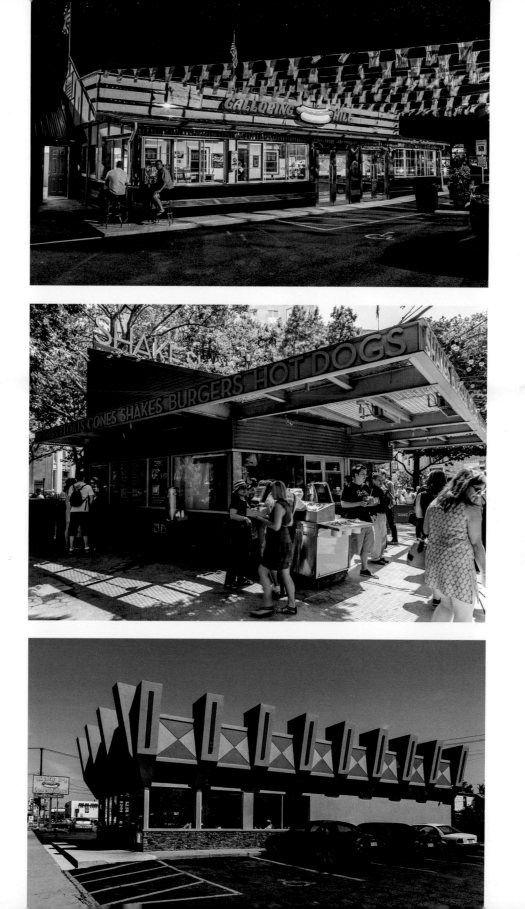

5 *Doggie Styles*

*O*ne of the best-known features of American hot dog culture is its varied regional styles. As if in an endless loop, these are routinely discussed in print, on air, and online media. The same material is repeated in Wikipedia, the National Hot Dog and Sausage Council website, and many other websites, where they discuss the variations and by so doing reinforce the idea of normative hot dog versions that hot dog explorers can expect to find on their travels. There is certainly truth in the idea of a standard style, but within each of them variants exist. Some come from individual preferences; others from innovations that arise from hot dog restaurateurs. Ketchup on hot dogs is a good example of the first. "Never put ketchup on a hot dog," the saying goes in Chicago. By and large that imprecation holds in traditional hot dog stands, one of them, the extremely popular Gene and Jude's not even having packets of the condiment available for their French fries.[1]

When this taboo began is an open question, though the ketchup phrase probably became popular in the 1950s and 1960s and is one of Vienna Beef Company's unofficial slogans. Nevertheless, younger customers use ketchup (as elder diners look on with disgust) because many have been raised on fast food hamburger fare and supermarket hot dogs made at home. Traditional diners also choose which of the seven condiments go on their dogs because, as sausage-maker Jordan Monkarsh says, diners are idiosyncratic.

New York hot dogs often come with a red onion sauce made of chopped onions, tomato paste, and olive oil. Before 1964 some version of this condiment was made by each vendor, the best-known being Gus Poulos at Papaya King. In that year, Gregory Papalexis of Marathon Foods (now the parent of Sabrett) asked food scientist Alan S. Geisler to make a standard sauce. He did, and the two formed Tremont Foods to bottle and sell it. Now, Tremont's sauce is the standard for New York's hot dog stands and has become a tradition.[2] Very much the same thing can be said for all the sauced hot dogs found throughout the country, under names like "coney" or Texas Red Hots. Virtually all date to the 1920s and define some important regional styles. The question might be put

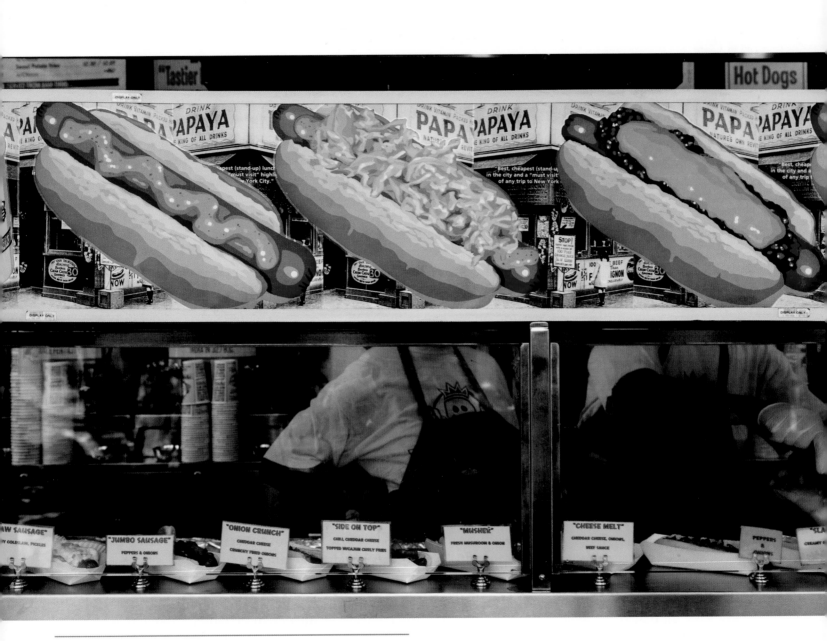

HOT DOG STYLES AT PAPAYA KING, NEW YORK CITY

this way: How long does an ingredient or style have to be in a place before it becomes a "tradition"? Clearly, traditions are invented and changeable.

What follows are some of the American regional hot dog styles both older and newer. It is not exhaustive because within each style are the kinds of variations mentioned above and because of the sheer number of hot dog eateries in America. Further, few hot dog stands/restaurants serve only the namesake sandwich. Over the course of the last century, stands have taken on other dishes. As more than one owner says, they have to change with the times, with new tastes, and have to compete with fast food restaurant chains. Food processors, as well, introduce new quick service all the time in often bewildering numbers. Many of the non–hot dog items reflect the neighborhood's tastes, tofu and chicken breast–based dishes in body-conscious places like Los Angeles, knishes in New York City, and nationally many more burritos and tacos than ever before.

NEW YORK STYLE

For years American television viewers could, and still can in reruns, tune into the show *Law and Order*. In many an episode Detective Lennie Briscoe (played by the late Jerry Orbach) and his partner grab a hot dog from a street cart. Briscoe was a quintessential New Yorker, from accent to jaded, gruff manner, and he snacked on the street out of hand—hard to imagine him with a knife and fork. The nineteen hundred or so carts, sporting umbrellas, are symbols of the city, and considered by many as cultural treasures. Mainly, street carts serve natural-casing (this might also mean collagen casing) sausages held in hot water baths, hence the slang term "dirty water dogs." To serve them, the vendor removes each hot dog with tongs, places it in a bun that is also held in a heated bin, sets it in a sheet of waxed paper, and adds condiments, also held in cooled tanks, as the customer requests. Tremont onion sauce is very popular here. Many of these hot dogs are small and cheap, so that customers often buy two or even three at one time.

Although the mainly garlicky flavor of the New York–style hot dog remains about the same in various iterations, the water-bathed dog has a particular texture that differs from the flat-griddled product. With toasted exteriors the latter have more crunchy exteriors. It is possible that water-bathed dogs are in decline as griddling becomes more popular on carts. Vendors from the Middle East and South Asia are familiar with griddling methods, using them to make kebabs, kofta, falafel, and even eggs on street carts.[3] But the "dirty water" dog is still the traditional pushcart style—until fully displaced.

The classic New York–style hot dog is represented by America's most famous hot dog stand, Nathan's. Most New York–style dogs are also made with natural casings, made from lamb, though true kosher sausages cannot be made with intestines. Nathan's griddles their hot dogs on thick sheets of metal with heating elements beneath them. There are two grills, one to start and hold rows of hot dogs, then a hotter one to finish them. The cook rolls the hot dogs back and forth with a flat spatula with gentle pressure until the sausages are browned all over, thus adding to the crisp snap when eaten. Flat griddling is labor intensive, so Nathan's hot dog stand always had plenty of workers and countermen ready to serve the thousands of customers it had from the 1920s until the present day.

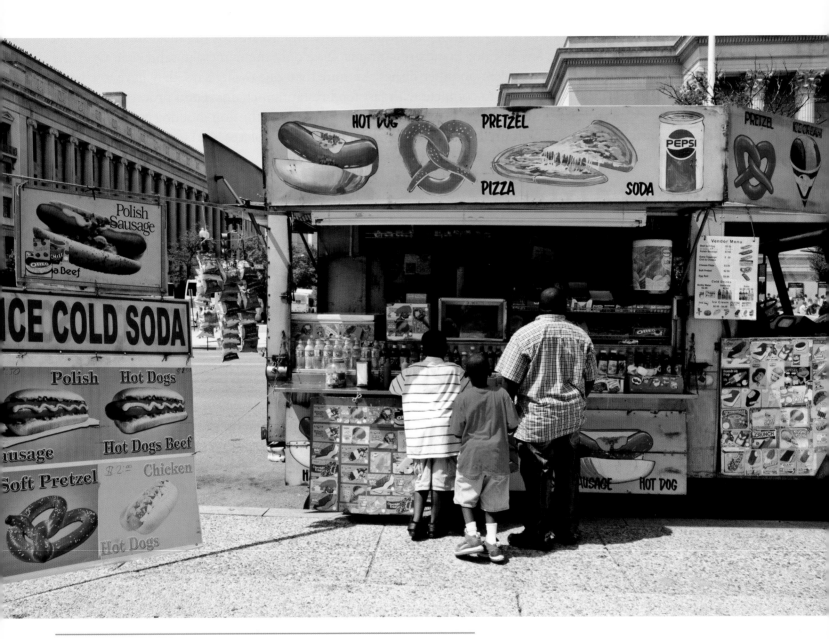

WASHINGTON, D.C., STAND. HOT DOGS ARE A FAMILY AFFAIR.

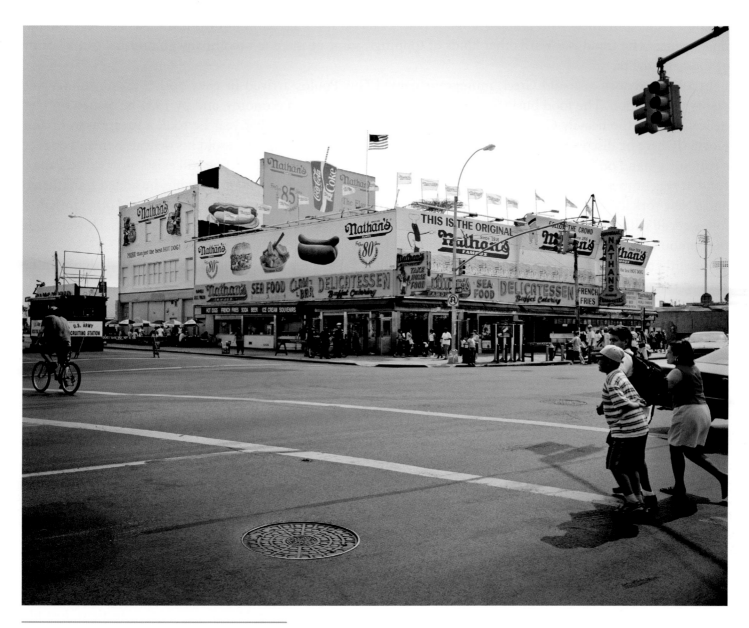

NATHAN'S, CONEY ISLAND, NEW YORK

The classic New York toppings are yellow mustard and griddled onions. In the Nathan's version, white onions are chopped and lightly cooked at one side of the flat griddle. They are placed on the hot dog in the bun after a strip of mustard is laid on the dog. Customers can also add condiments, usually more mustard or sometimes ketchup, from containers with pumps. In many places sauerkraut is also common, as is the classic sweet tomato-onion sauce. The trend is toward other kinds of toppings, some of them to accompany an unusual combination of food and drink.

In 1923 a sixteen-year-old Greek immigrant named Gus Poulos arrived in New York with no money and plenty of ambition. The food business was his way into the American economy, and by 1931 he owned his own delicatessen in the heavily German Yorktown section of Manhattan. In that year he took a vacation to Miami, Florida, where he discovered tropical drinks. On returning to New York, Poulos sold his delicatessen and opened a fruit juice stand on 86th Street, naming it Hawaiian Tropical Drinks. The building still exists, now called Papaya King. It was immediately popular. In the mid-1930s, this being in very German Yorkville, he added frankfurters and a New York icon was invented. In the 1970s a former partner opened a rival, Gray's Papaya, and other imitators followed, all with Papaya in the name. Poulos's model was cheap hot dogs and excellent fruit drinks. However odd the combination may seem, the formula has worked.

Recently remodeled by new owner Wayne Rosenbaum, Papaya King retains its original stand design with no seating, only counters to lean and eat on. The basic all-beef hot dog is the same, but new toppings give the menu greater variety. Some of these are takes on other regional styles, namely a meat sauce, a chili, and a slaw dog—all with homemade toppings. Rosenbaum, a young veteran restaurateur, points to the lines of customers, saying that this is the scene from morning till night.[4] Papaya King, Gray's Papaya Drinks, and others are examples of how one innovation spawned a style by imitation. It is a story common in the hot dog world, just as it is in local markets in lesser-developed countries from whence the hot dog stand ultimately descends.

The name "hot dog" may have originated with sausage wagons in the 1890s, so it's appropriate that Greater New York also has hot dog trucks. Two of the best known are in Rego Park in Queens and in Newark, New Jersey. The half-century-old Dominick's and D'Angelos are trucks owned by the same family and usually parked close to one another. Local business people, police officers, and drivers and passengers from stopped cars are major patrons. One truck sells natural casing hot dogs that are steamed, not hot-water bathed, then topped with chopped onions and sauerkraut, while the other grills the sausages and smothers them with grilled onions and sliced sweet peppers. The peppers are characteristic of Italian American preparations and are reminiscent of New Jersey's Italian hot dogs.[5]

NEW JERSEY

Nowhere in the United States are there more varieties of hot dogs than in New Jersey or Connecticut. Just like "Hot Dog Morris" in Paterson, the original carts and stands served plain sausages on buns with mustard and perhaps chopped onions and sauerkraut. In the past century, northern New Jersey was a concentrated industrial

PAPAYA KING, NEW YORK CITY

center with dense, ethnically diverse, urban populations in places like Newark, Patterson, Passaic, and Elizabeth, to name a few. Out of this milieu came varieties of hot dog styles plus a degree of connoisseurship matched in only a few areas of the country.

TEXAS WIENERS

Surprisingly, the Texas hot dog, also called the Texas wiener, is from New Jersey and Pennsylvania, not Texas. In and around Paterson, New Jersey, and west, across the Delaware River around Altoona, Pennsylvania, there are dozens of places specializing in this unique dish.

Texas wieners are made with deep-fried or flat-griddled pork-and-beef-mixture sausages, set in regular buns, slathered with a spicy mustard and—what makes them special—a tomato-based sauce made from "secret recipes." Chopped onions top the sandwich. The sauce is called "chili" but, as we have seen, it is not made like the original Southwestern American varieties. Rather, it is made with ground meat cooked in a tomato base and seasoned with cinnamon, cumin, allspice, cayenne pepper, and cloves. The result is a fragrant spicy-sweet sauce that closely resembles those used in some Greek and Balkan dishes that have roots in the old Ottoman Empire. Once one or two of these sellers began selling "chili dogs" like this, everyone else had to do it and the style was set. Wherever Greek and Macedonian "hot dog men" went, they brought some version of sauces like this with them. One of them, no one knows who, gave the name "Texas" to the hot dogs as a marketing device before 1919. By then Texas chili was well known, and Western movies were very popular (in fact, the first "Western" movie, Thomas A. Edison's the *Great Train Robbery*, was filmed a few years earlier in northern New Jersey). The name has stuck and become part of local culture.

John Fox, the New Jersey hot dog guide, says that there are two styles of Texas wieners/hot dogs, each with its own geography. Hot dog places around Paterson, such as the always-packed Hot Grill in Clifton, Libby's Lunch in Paterson, and Goffle Grill in Hawthorne, use a deep-fried Thumann dog with a thinner sauce. Flat-griddled Schickhaus dogs are featured at Texas Weiner II, now owned by the Popov family, with a thicker sauce. In upstate New York, Heid's (dating to 1917) of Liverpool (near Syracuse) serves both Texas and other styles. In Watervliet, New York (near Albany), Gus's Hot Dogs are quite small and coated in a Greek-themed paprika-laden sauce.

RIPPERS

Among the best-known New Jersey hot dogs is "the ripper." Instead of griddling or hot water bathing, a specially made (with grain fillers) natural-casing hot dog is put into hot oil, the same kind of oil and fryer as used in French fries, and quickly cooked. The name "ripper" comes from the fact that when cooked to 310° F in hot oil, the skin bursts, crackles, or "rips." There are several grades of hot dogs cooked this way: "rippers," in which the skins merely cracks; an "in-and-outer," indicating a sausage barely cooked through; a "medium," meaning medium cooked; the "wellers," a very well done dog; and the "cremator," whose skin and body are well done to the point of burning. Each version is placed in a bun and served with mustard, or a mild yellow chili sauce. Likely the originator of this

TEXAS WEINERS II

style is Rutt's Hut in Clifton, New Jersey. It was founded in 1928 by Royal Rutt and his wife, immigrants from Germany. No one knows exactly when Rutt began to deep-fry his products, but by the 1950s the style spread to other places in New Jersey, such as Hiram's Roadstand in Fort Lee. Rutt's serves a famous sweet-sour mustard-colored relish composed of onions, carrots, and chopped cabbage. Rutt's is always crowded, partly because it is a community center, maybe because they have a liquor license and an attached bar. Although Rutt's has had a Greek owner for some years, the German-based relish remains a distinguishing feature of this "ripper" place.[6]

ITALIAN HOT DOGS

New Jersey is home to "Italian" hot dogs, found almost nowhere else in the United States and never in Italy. The sandwich is made from a round of "pizza bread." This bread is local to New Jersey and is a large, thin round of bread, about ten inches in diameter, made in the shape of a doughnut—with a hole on the middle. The bread is cut into quarters, each piece split in half and then stuffed with a lightly deep-fried hot dog, or maybe two of them, griddled or fried onions, strips of fried sweet green peppers, and pieces of fried potatoes. Depending on the stand, potatoes can be thin slices that are deep fried and crunchy, or thicker wedges, soft inside and crispy on the outside. Mustard is the preferred condiment, but some use ketchup as well.

As mentioned, Italian hot dogs were invented in the Italian American community of Newark, New Jersey, in the early 1930s. By repute, the first were served by James Racioppi's grandmother, and now morphed from an original Newark location to several across the state. This hot dog tribute to Italian American cuisine has its roots in southern Italy, where potatoes, green peppers, and onions appear in many dishes. One of the most famous of these in the United States is chicken Vesuvio, said to have been invented in Chicago in the 1920s. Italian hot dogs are, therefore, really part of an immigrant community's food culture. Today, there are a number of places that prepare Italian hot dogs, each somewhat different from the others. Jimmy Buff's in several locations near Newark, Dickie Dee's in Newark, Charlie's Famous in Kenilworth, Jo Jo's in Toms River, and Tommie's Italian Sausage in Elizabeth are among the best known. As John Fox says, the Jimmy Buff's in Scotch Plains is owned by James's cousin and is notable for its very greasy creations. Each style has devoted fans, and never the two agree.

NORTHEAST

The Northeastern states have numerous hot dog variations, many of them very local. Outside of New York City there are some famous stands and regional styles. Walter's Hot Dog Stand, in Mamaronek, Westchester County, New York, has sometimes been called America's best hot dog stand. Founded in 1919, the current Chinese-style building dates to 1928. The hot dogs are made to Walter's own specifications, composed of pork, beef, and veal. The hot dogs are flat griddled (New York style), cut in half, brushed with a butter sauce, then griddled again so that they are very crispy. When put into a bun, the sausages (they can be doubled) are topped with a mustard-relish sauce that is unique to Walter's. Splitting and grilling hot dogs is common in home barbecue grilling, but

in most hot dog stands that is done to large-diameter sausages such as Polish. Cooking in butter or putting butter in a split dog also appears in parts of New England, especially Connecticut and Massachusetts.

Connecticut is home to a number of different hot dog types. Most use Hummel Brothers products. They range from "dirty water dogs" to New York–style griddled sausages, some deep fried as in New Jersey, and others chargrilled. Rawley's in Fairfield serves a deep-fried hot dog that when given "the works" is covered in brown mustard, relish, sauerkraut, and crisply fried pieces of bacon. Blackie's in Cheshire dates to 1928 and makes deep-fried hot dogs that burst open and are then served to customers, who add the condiments. Most notable is a hot pepper relish that is so popular that is it bottled and sold at retail as Blackie's Hot Pepper Relish. Super Duper Weenie in Fairfield began as a motorized hot dog wagon serving varieties of American regional hot dogs. The truck is still used, but there is a permanent location in Fairfield. They are most famous for their own meat chili sauce, red onion sauce, and hot relish. Danny's Drive-In in Stratford combines a Southern style with Northeastern sausages—a spicy chili sauce and a creamy slaw to form a heaping hot dog dish. One special is also found along the industrial corridor running up through Hartford, the Georgia Red Hot; it is basically a Southern hot link, most often supplied by Flamingo Smoked Meats in the Bronx, New York. This one is served with sauerkraut and relish.

RED HOTS AND WHITE HOTS

Upper New York State has various styles, three in particular: white hots, red hots (both often called simply "hots"), and Michigans. White hots, or "porkers," are special to the region of Rochester-Syracuse-Buffalo, New York. They are sausages made from pork, beef, and veal mixtures that are not smoked, unlike red hots or most other hot dogs. To remain white, powdered milk might be added to them, along with mustard and other seasonings. White hots were originally made from leftovers from meat butchering in the 1920s and were known as "poor man" hot dogs. Today they're made with the same meats as others and are more expensive than their red-colored cousins. White hots are grilled then topped with fiery sauces made from onions, molasses, vinegar, and hot peppers, among other ingredients. The major manufacturer of Rochester "Hots" is Zweigels, while in Buffalo Sahlen's and Wardynski's hold sway, and Syracuse regards Hoffman's as its brand. These three producers have been in hot competition for many years. The best-known Rochester stands include Schallers, LDR Char Pit, Bill Gray's, Don's, Mark's, and Tom Wahl's.

Red hots, known also as "red," or "Texas," are more like regular hot dogs; that is, smoked in the production process. In Buffalo, at Ted's Hot Dog (founded by Theodore Spiro Liaros in 1927 as a shack) they are cooked over hickory wood fires until the exteriors burst and crack. When served with everything the dogs are covered in "Mustard, Ketchup, Relish, Homemade Hot Sauce, Onion, Dill Pickles, Lettuce, Tomato, Mayo, Cheese, Chili, Sauerkraut, and our delicious Peppers and Onions."

In the north of New York State, near the Canadian border, the city of Plattsburgh is home to regional hot dogs called "Michigans." The basic Michigan is a steamed hot dog, set in a firm bun, with mustard (on top or underneath the dog), a special meat sauce, and coarsely chopped onions. The sauce is somewhat like other

"chili" sauces served in the Northeast, with a little cinnamon and other spices. The best-known Michigan place is Clare and Carl's in Plattsburgh, where the buns are closed at each end, resembling a boat, so that the sauce and toppings remain on the sandwich. The name "Michigan" implies that this style originated in the coney stands of the Detroit area, but this has never been proved because the sauce is not the same in both places. Michigans have spread to neighboring areas of Vermont and into Canada, where they are served in Montreal, but with a spaghetti sauce instead of the usual spiced one.

Rhode Island has one of the more distinctive styles of hot dogs. New York System, also called "hot wiener," and sometimes "bellybusters," "gaggers," or "destroyers," is a small sausage made of a pork and veal mixture that stands on a hot griddle for a long time before serving. When ordered, the sausage is served on a steamed bun and covered in mustard, a spicy meat sauce that is thinner in consistency than a standard chili, chopped onions, and celery salt. Hot wieners are often served theatrically. The vendor puts a row of as many as twelve buns up his or her arm, adds wieners, and then dresses them. Customers routinely eat two or three at a time. New York System was begun by Greek immigrant restaurateurs probably in the 1920s, who gave the style its name and created the special sauces (there are several styles using more or less spices) used on their creations. Interestingly, the phrase "THEY'RE HOT—RIGHT OFF THE IRON. THE NEW SYSTEM. TEXAS HOT WEINER SHOP" appeared in an Oil City, Pennsylvania, newspaper in 1924, meaning that the idea of a system was in use outside of Rhode Island. The most famous stands are New York System in the Olneyville district of Providence and Cranston, and Original New York System on Smith Street in Providence.

Rhode Island also has its share of stands serving other varieties of hot dogs. Hewtin's is a food truck in Providence that features hot dogs (and fancy sandwiches) with dressings such as pineapple relish, among others. Spike's Junkyard Dogs in several locations sells hot dogs with names like "German Shepherd" (with brown mustard and sauerkraut) and Texas Ranger, featuring barbecue sauce and bacon.

FENWAY FRANKS

Massachusetts' Fenway Franks are the state's best-known hot dogs and are sold at the home of the Boston's beloved Red Sox baseball club. These are steamed sausages (made by Kayem) that are larger than their buns and are served with yellow mustard and ketchup. Unlike in other regions of the Northeast, ketchup may be an analogue to Boston baked beans, a molasses-sweetened dish endemic to the region and sometimes served with hot dogs, known as "franks and beans." Boston baked beans appear as a topping from time to time at other places, for instance, Top Dog in Rockport, where it is called a "Boston Terrier," and Simco's On the Bridge in Mattapan. The classic Boston-area hot dog is served on a toasted bun, but steamed buns are used when toasting is not possible.

RED SNAPPERS

In Maine, there is a hot dog breed called "red snapper." It is a small, natural casing hot dog made mainly with pork that is dyed a bright red. They can be found all over the state, but Flo's in Cape Neddick is the most famous joint,

especially for its chunky sweet sauce. Red-dyed hot dogs were once common throughout the United States, but today are mostly native to the American South, parts of New England, and Hawaii.

HALF SMOKES

In Washington, D.C., and its vicinity, "half smokes" are said to be the native street food. This is a large pork and beef sausage made of coarser ground meat than a regular hot dog, more like a Polish sausage. They are seasoned with hot pepper flakes so that the sausage is mildly hot-spiced and they are smoked like other sausages. Half smokes are heated by vendors either on flat griddles or in water ("dirty water") and served on buns with mustard and onions plus other condiments. Although half smokes are sold from street carts, some near the Washington Mall and the Capitol where government workers often buy them on their lunch breaks, the most famous purveyor is Ben's Chili Bowl. A favorite place for celebrities, politicians, and a business anchor for the African American community, Ben's serves flat-griddled "half smokes" and hot dogs. Ben's is famous for its chili, which is made with tomatoes, ground beef, and spices such as hot chilies and cumin. Weenie Beenie in Arlington, Virginia, makes their half smokes in the older style by splitting them down the middle and then griddling them.

SLAW DOGS

Coleslaw-covered hot dogs are a characteristic of Southern U.S. versions. Of all the states where "slaw dogs" are found, West Virginia is the best known. Here, hot dogs, usually called wieners, are laid on a steamed bun, then coated in mustard, a thin meat sauce, then layered with coleslaw and topped with chopped onions. Because West Virginia hot dog fans are very picky about their coleslaw, the best should be fresh and creamy. Chili sauces are also important, and they vary from thick to thin in consistency, some with more meat than others, and some like thin spaghetti sauces, but more vinegary and spicier (such as Dairy King in Grafton). The most popular chain of stands is called Sam's. It originated in Huntington but has franchises across southern West Virginia into southern Ohio. Sam's is most famous for its spicy chili that was invented in a small West Virginia town.

Southerners—and many other Americans—often use the term "all the way" for a hot dog loaded with all the condiments that the vendor has to offer. One new small chain of hot dog havens is known for this. Hillbilly Hot Dogs in Lesage, and two other locations, serves both griddled and deep-fried hot dogs with various toppings and one extreme hot dog, a huge fifteen-inch one (the Home Wrecker) that is griddled, put in a toasted bun, and loaded with sautéed onions, peppers, mustard, "nacho cheese" sauce, hot peppers, a thin chili sauce, fresh chopped onions, ketchup, shredded lettuce, and West Virginia cole slaw. "All the way" slaw dogs have spilled over the West Virginia borders into Ohio and Virginia. Skeeter's E. M. Umberger Store in Wytheville, Virginia, has similarly laden hot dogs, only in normal sizes. Roast Grill in Raleigh, North Carolina, served hot dogs blackened (they say "burnt") on a grill, topped with chili and a vinegary slaw. Here (as in many other places) ketchup is forbidden, but might be allowed for children.

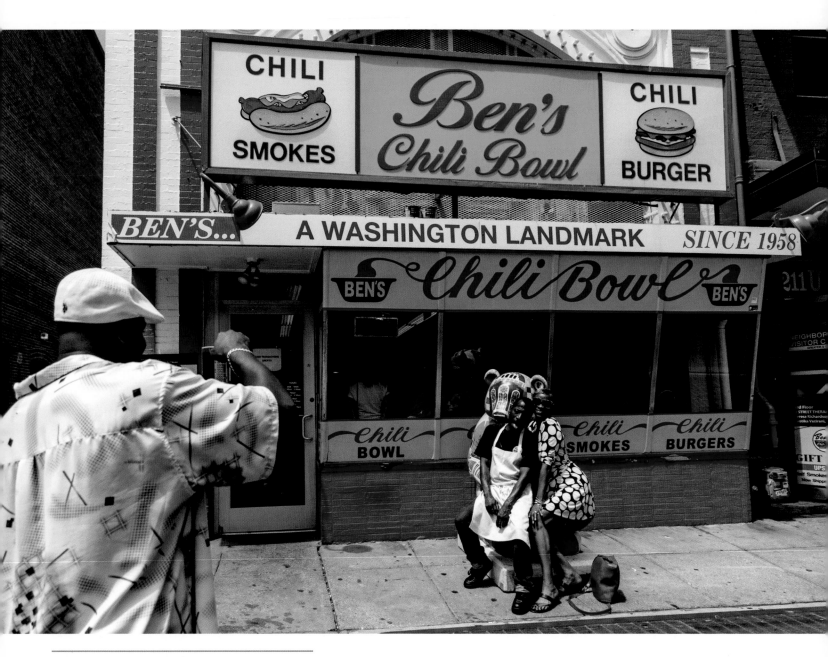

BEN'S CHILI BOWL, WASHINGTON, D.C.

SCRAMBLED DOGS

One local variant of both the chili dog and slaw dog is the "scrambled dog." It is a hot dog that's set in a soft bun, placed in a canoe-shaped bowl, then covered with chili and toppings such as mustard, ketchup, chopped onions, pickles, and, in a later variation, oyster crackers. In many places cole slaw is added. The scrambled dog is usually associated with two Georgia restaurants. One is the Dinglewood Pharmacy in Columbus. Some think that it was invented in that establishment. It was not, but the chili made there by the cook, Lieutenant Stevens, was so famous that the dish is associated with the lunch counter at which he worked for many years.

The other, Nu-Way Weiners (the name is deliberately misspelled), was founded in Macon by a Greek immigrant in 1916, at the very same time that Greek vendors dominated the hot dog cart trade in Atlanta. James Mallis passed the restaurant along to other relatives, and today Spyros Dermatas operates this landmark restaurant. The hot dog here is a beef and pork product that is griddled in the New York way, then served in several ways. When served "all the way" the dog has mustard, onions, zippy chili sauce, and homemade cole slaw. When it is a scrambled dog, the bun is opened, the sausage laid in it, topped with chili and beans and then oyster crackers. Nu-Way is one of the hot doggeries that is nationally known through on-the-road-food television programs. It is certainly an integral element of Macon's local culture.

Scrambled dogs are found mainly in towns between Columbus and Macon and have several variations. One is a simple small hot dog served with chili, mustard, ketchup, chopped onions, slaw, and oyster crackers that is meant to be eaten out of hand. Others use some of these ingredients, but it is the oyster crackers atop the final sandwich that make this style unique.

RED DOGS

Scrambled dogs are usually made with red dogs, and throughout the American South, deeply red dyed hot dogs are especially favored. As made and sold by such packers as Carolina Packers, and many others, these are mainly made of pork and beef mixtures, are skinless, and are bright red. Most hot dogs in the United States and around the world (Denmark is an exception) are natural in color, but not in the South (or in Maine). The tradition is at least one hundred years old, when the term "red hot" meant literally that the sausage had to be red. In the 1950s the U.S. Food and Drug Administration raised questions about the safety of red dye #2, used in hot dogs and other foods, thus endangering the red dog tradition. However, manufacturers substituted red dye #40, the same as used in cough syrup, which is safe, and red dogs remain.

Some of the best-known stands include Shorty's in Wake Forest, North Carolina (dating to 1916), with classic griddled reds covered in mustard and chili. Pulliam's Barbecue in Winston Salem is a hundred-year-old shack known for its "toasted" hot dogs. Neon-red, pork hot dogs are grilled and served on a bun grilled with butter. The dog is topped with mustard, chili, and very white slaw and then doused with a homemade hot sauce. An even more extravagant hot dog is found at Millie's in Smithfield, North Carolina, near Raleigh. It is a red, served with melted cheese, mayonnaise, chili, onions, and mounds of cole slaw.

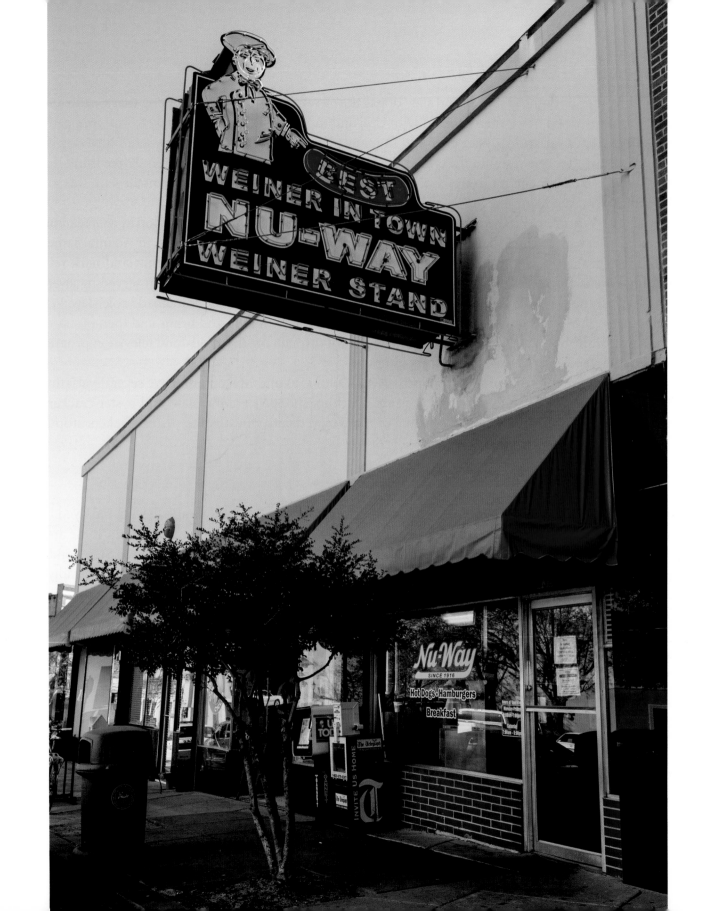

TEXAS PETE

In eastern North Carolina, east of Charlotte, most hot dog places have a bottle of Texas Pete's hot sauce on the table or counter. It's so popular that Carolina fast food is identified by its use. There is nothing Texas about Texas Pete. Originally developed for a barbecue restaurant in the 1930s by the Garner family, it was named after cowboy movies that were so popular at the time, perhaps like New Jersey's Texas dogs. The spicy hot sauce was sold door-to-door at first and eventually became a staple of Carolina cuisine. From its Winston-Salem home, Texas Pete has spread to other areas of the South, so that a well-known place like Rough House in Abbeville, South Carolina, that serves chili dogs is not complete without doses of Texas Pete.

The American South has several other kinds of special hot dog places that are frequently visited by local people and tourists because of their unusual qualities. In Birmingham, Alabama, two restaurants owned by Greek Americans, and that serve similar styles, stand along the same street. Pete's Famous Hot Dogs, now closed due to the owner's death, was a ninety-year-old place that had small, pink dogs coated with mustard, seasoned ground beef, onions, sauerkraut, a special spicy sauce, and hot pepper sauce. Gus's Hot Dog, Pete's competitor, serves almost the same kind of hot dog, and both are considered to be Birmingham's classic hot dogs.

Of all hot dog restaurants in the South, none is more written about and depicted on television programs than The Varsity in Atlanta and Athens, Georgia. Founded in 1928, the Varsity is the world's largest drive-in restaurant: six hundred cars, as many as thirty thousand diners on football Saturdays. Varsity lore is specialized for hot dogs and service and it's most famous call, "What'll ya have?" Varsity dogs range in size, the most common ones being small pork and beef mixtures, served in steamed buns with a fine-grained chili, chopped onions, and mustard. They are quite inexpensive, and diners often order more than one. More than anything, it is The Varsity's atmosphere that draws such huge crowds.

New Orleans is home to the most famous hot dog carts in the United States, next to New York City. Lucky Dogs, founded in 1948 by Stephen and Erasmus Loyacano, is a chain of pushcarts made in the shape of a hot dog. The hot dogs are heated in water and served with mustard, onions, and chili in several sizes. They are not especially distinguished for their flavor, but location means everything. The carts are mainly located in the historic French Quarter, which is also a main entertainment and tourist district of the city. Anyone visiting New Orleans will have seen them, but they have been made more famous in a novel, *A Confederacy of Dunces*, by John Kennedy Toole. In this celebrated novel, the hero is at one point a Lucky Dogs vendor and as such is the center of many painfully funny scenes. Lucky Dogs employs people who often need a boost in the world and so replicate in some ways the original American hot dog vending experience.[7]

CONEYS

Anyone who has visited a hot dog stand or restaurant in the Midwest, and many other parts of the United States, will have encountered "coneys." The name is short for Coney Island, an appellation given to hot dog stands in Jackson, Detroit, and Flint, Michigan. A coney is a griddled pork-and-beef mixture sausage (sometimes all-beef)

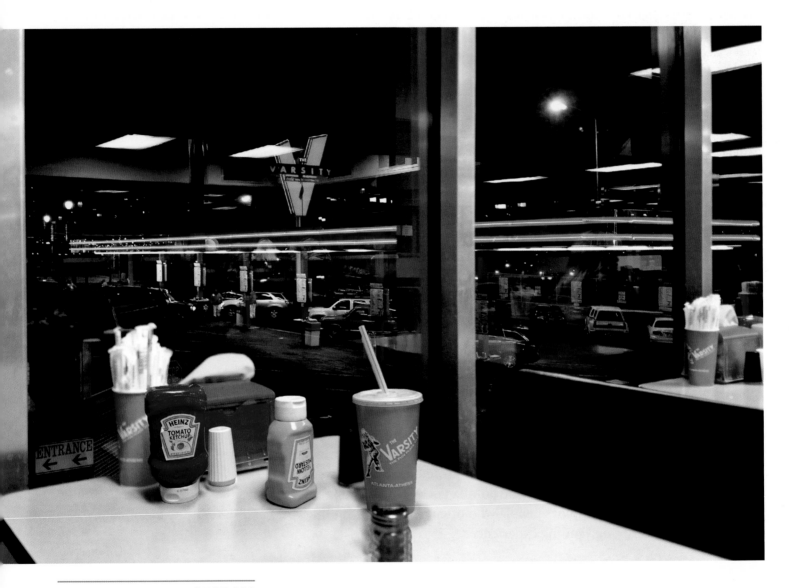

VARSITY, ATLANTA, GEORGIA

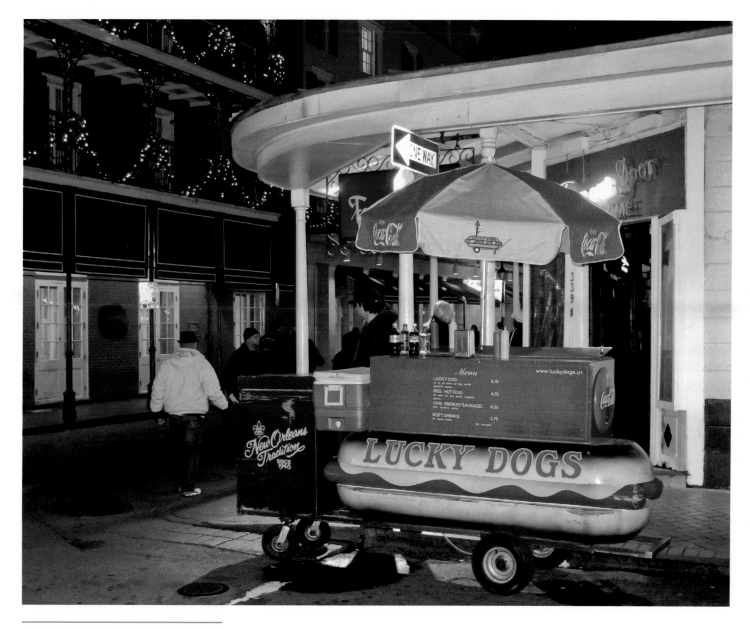

LUCKY DOGS, NEW ORLEANS

that is placed on a steamed bun, then topped with a meat chili sauce, chopped sweet onions, and then a strip of yellow mustard. The difference between a coney and other chili toppings is in the seasoning and texture of the sauce. There are two coney sauce styles. In Detroit, Michigan, the chili is thick, but wet, and heavy on spices such as cumin and chili, with hints of other spices. In Jackson and Flint, Michigan, the sauce is drier, with a texture like ground beef. Made with ground beef hearts, it is less spicy than the Detroit version but with a stronger, "liver" flavor. As seen earlier, coneys were created by Greek and Macedonian immigrants who, along with Albanians, run most of the southeastern Michigan stands. Coneys have spread across the Midwest, though not much into Chicago save for the iconic Leo's of Detroit, and can be found in various styles in many towns and cities.

Toledo and Cleveland, Ohio, have similar Greek family histories, namely sauces laced with cinnamon. As discussed, Red's in Toledo is the hot dog place. In Cleveland, Old Fashion Hot Dogs, alias Hot Dog Inn, founded by Mike Vasiliou in 1928, is probably the best known, though nearby Steve's Lunch and others serve similar dogs. Of course, in Cleveland they all use the local mustard by which many Clevelanders identify their native cuisine.

One coney variation is in Cincinnati, where the "cheese coney" is popular. The two elements that make the cheese coney unique are the chili sauce used and mounds of shredded cheddar cheese atop each dog. Like the "chili" sauces made for Detroit and the East Coast hot dogs, Cincinnati's is nothing like the original from the American Southwest. It was created in the 1920s by Macedonian stand owners, Tom and Michael Kiradjieff, who sold Greek food and hot dogs from their Empress restaurant. The chili is basically the liquid used in their version of Greek lamb stew—ground beef seasoned with cinnamon, cloves, allspice, cumin, cocoa powder, vinegar, cayenne powder, and tomato sauce, among other ingredients. This chili quickly became so popular that today there are some two hundred chili parlors in and around the city. The hot dog is usually a fat pork and beef mixture with a natural casing that's covered with mustard, chili, chopped onions, and masses of bright-yellow shredded cheddar cheese. No one knows whether the Cincinnati coney got its name from the New York amusement park or the Coney Island Park built near Cincinnati in 1887, and still in existence.[8]

CHICAGO

Chicago is a rival to New York City as hot dog central, with roughly twenty-five hundred hot dog places in the greater metropolitan area. The typical Chicago hot dog has a more complex flavor profile than the standard New York style, likely because it was created by a Hungarian sausage maker who came to work for Vienna Beef in the 1920s. Most other hot dogs, such as Red Hot Chicago and Eisenberg, have roughly similar flavor profiles. Chicago connoisseurs know the difference and often reject any other kinds but their own. Many styles of hot dog are available in Chicago, but there is one classic style that is nationally famous. In its best form, it is a natural-casing all-beef sausage, heated in hot water, or steamed, placed on a steamed poppy-seed bun, and then layered with mustard, neon-green sweet relish (originally called piccalilli), chopped white onions, some tomato slices, quartered sour pickle spears along the side, a few spicy-hot pickled "sport peppers," and, if wanted, a sprinkling of celery salt. The whole thing is said to be "dragged through a garden." And, never, ever, is ketchup put on a hot dog.

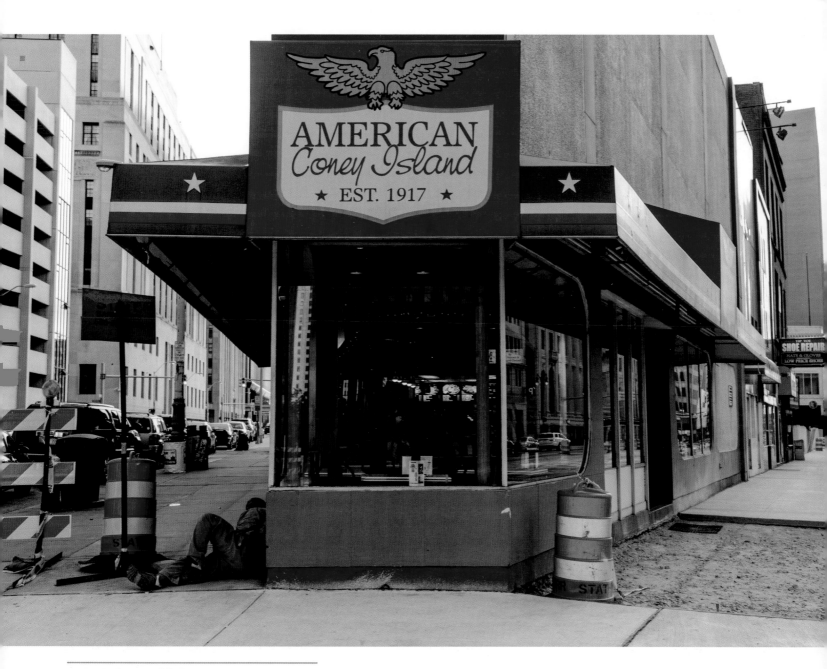

AMERICAN CONEY ISLAND, DETROIT

MURPHY'S, CHICAGO. A MODEL HOT DOG PLACE.

It is hard to classify Chicago hot dog stands exactly because many have always been integral parts of Chicago neighborhoods. Each has slight differences in the skill levels of the vendors making them, or slight differences in what goes on the sandwich. For instance, the elaborated Chicago hot dog is a fairly recent invention, perhaps fifty years old, so some stands make an older, simpler style. This style is sometimes called "Depression dogs," because they lack all the toppings of the standard modern hot dog. Using a plain bun, the toppings are mustard and relish, and sometimes hot sport peppers. So devoted are Chicagoans to the ones that they grew up with that comparisons between different neighborhood stands often lead to heated arguments. There are, however, stands that are universally acclaimed, among them Gene and Jude's, Murphy's, Superdawg, Wolfy's, Gold Coast, Portillo's, Wiener Circle, Jimmy's Red Hots, and many others.

MAXWELL STREET POLISH

Maxwell Street Polish is a form of hot dog special to Chicago. It is a pork-and-beef, or all-beef, coarse-ground sausage, thicker in dimension than a regular hot dog, and naturally cased. Although Polish sausage is based on actual Polish kielbasa (sausage), it is treated as a hot dog and prepared differently than most Chicago hot dogs. Maxwell Street Polish was likely invented by Jim Stefanovic, a Macedonian immigrant, for his stand in 1943. Jim's Original was located on Chicago's famed ethnic street market, Maxwell Street, hence the name. The sandwich is made by flat griddling (or grilled by some other stand owners) a third-pound sausage, setting it on a bun, and covering it with mustard and a thick layer of grilled and caramelized onions. Customers can add the other usual Chicago-style toppings, including hot sport peppers, but never ketchup. Maxwell Street Polish became very popular in the city, and many hot dog stands also serve it. The first to do so was probably The Maxwell Street Express, which stands a few feet from Jim's Original and is owned by Stefanovic family cousins.

KANSAS CITY DOGS

Almost all guides to hot dog styles mention the Kansas City hot dog. It is described as a grilled sausage covered in a thick strip of brown mustard, melted Swiss cheese, and a lot of sauerkraut. The closest sandwich to it is the Reuben, which is made with roast or corned beef and may have been invented in Kansas City, though probably New York City. In reality, there are very few hot dog stands in Kansas City, and not many that sell this kind of dog.

What is more popular is the barbecue hot dog. Kansas City is one of America's great barbecue cities, so it is natural that its characteristic sauce will be put on hot dogs. For such a sandwich, this ketchup-based sweet and mildly spicy sauce is laid on a grilled dog, then topped with cheese. In some versions "burnt ends" are added. These are the well-done ends of barbecued meats that are cut into small pieces, then placed on the hot dog with barbecue sauce. Places like Big City Hot Dogs in Kansas City, Missouri, are well known for this style.

CALIFORNIA

California is as varied in its hot dogs as it is in its people and environments. Next to New York, Los Angeles has the highest rate of hot dog consumption in the United States. If there is a consistent style it is a chili or chili cheese dog, but these are generic national styles. Of all the stands, Pink's is the best example of a kind of non-style and, at the same time, establishes its own identity. The first principle is abundance at reasonable cost. Pink's serves both nine- and seven-inch griddled hot dogs, made by Hoffy's, in a variety of forms, each with identifying names. Some are named for celebrities, others for American places, and others by the nature of the toppings. A Guadalajara is topped with relish, tomatoes, onions, sour cream, and bacon, while a Polish pastrami is just as described. There are bacon burrito dogs, guacamole dogs, pastrami Reuben dogs, millennium dogs—twelve-inch sausages with jalapeno peppers, tomatoes, chili, guacamole, grilled onions and lettuce—and recently a Gustavo Dudamel dog in honor of the brilliant Venezuelan orchestra conductor, now with the Los Angeles Philharmonic. The basic hot dogs are superior, but it is the toppings that catch customers' attention.

Carney's two locations are actually picturesque old railway cars, and they are so very much in the Los Angeles tradition of theme dining. Carney's was founded by John Wolfe in 1975; his son, Bill, says that the original car was a small dining area of five tables, the rest taken up by kitchen. Later, both added separate preparation areas to expand seating, but they are still narrow dining cars. The original menu was hot dogs, hamburgers, and fries, though it has expanded over the years. The hot dogs are seven to a pound, natural-casing, all-beef products that are steamed, though some are split and griddled. Carney's makes its own slaws and other toppings—the numbers have grown over time as the customers' demands change. The hot dogs are made to specification by a local packer, so that the flavor profile and textures remain consistent, but the style is really from New York because of immigration to Los Angeles. Carney's menu is far simpler than Pink's; its staple hot dog is the original with chili, mustard, tomatoes, and onions. Other versions have red cabbage slaw, pineapple, or Asian slaws. Carney's and Pink's represent the two main poles of hot dog culture in Los Angeles, basic and elaborate. Other places have different takes on what hot dogs ought to be.[9]

Wienerschnitzel, founded in 1961, in contrast, is as close to a national hot dog chain as there is in the United States, with three hundred and forty restaurants in ten states. The chain claims to sell one hundred and twenty million hot dogs annually and does considerable marketing, featuring dachshund dogs. Its inexpensive hot dogs come in several versions, the basic one with mustard; others with chili, onions, tomatoes, relish, or sauerkraut; and another with pastrami loaded on it.

Perhaps the closest restaurant group in California to the Eastern hot dog havens is Caspers in the San Francisco Bay area. Begun in Oakland in 1934 by an Armenian family, the company has been making its sausages to its own specifications under the name SPAR since 1985. Its original sandwich, still served, is a steamed natural-casing hot dog that is available with cheddar cheese, sauerkraut, pickles or jalapenos, and a chili dog. Top Dog in Berkeley has been serving fine-quality ethnic sausages since 1966 and has gained a devoted following. While hot dogs are popular in northern California, they do not have quite the cultural cachet as in East Coast and midwestern cities.

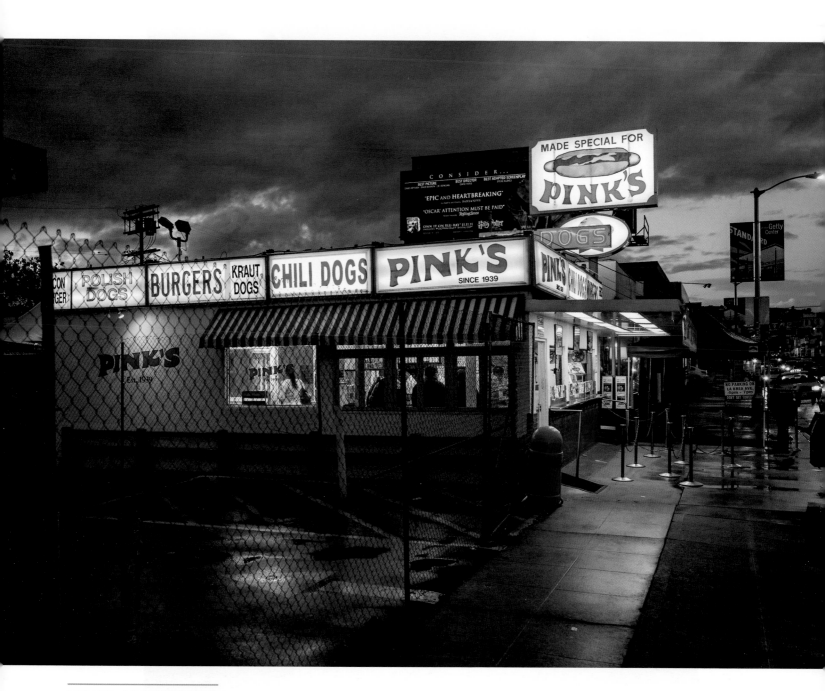

PINK'S, LOS ANGELES

PINK'S AROLDO

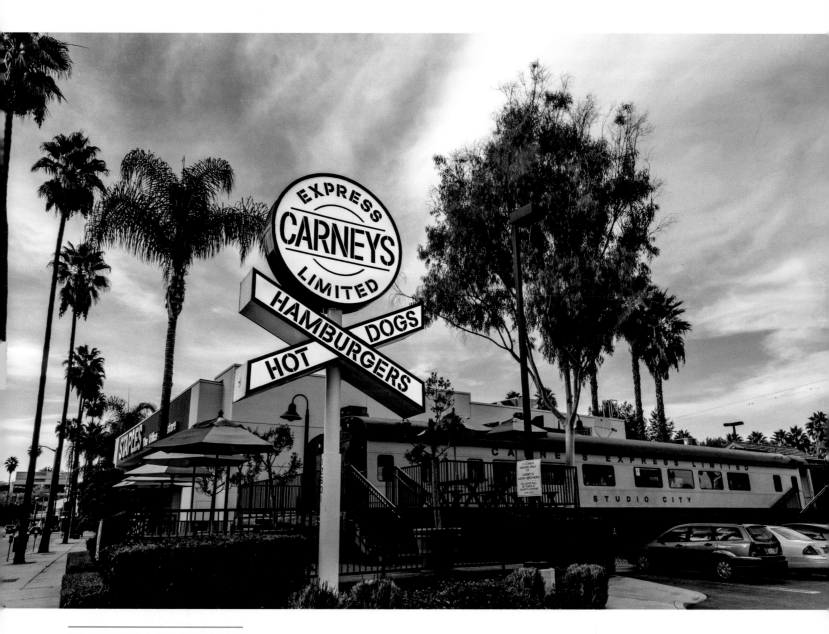

CARNEY'S, LOS ANGELES

SONORA HOT DOGS

In the American Southwest, Arizona in particular, a new style of hot dogs appeared in the 1980s. The Sonoran hot dog is also known as the Mexican hot dog, or Tijuana dog, and even "danger dog" in Los Angeles. When made "all the way" it is a griddled or grilled hot dog, wrapped in bacon, then loaded with cooked pinto beans, chopped onions, chopped tomatoes, mayonnaise, crumbled or shredded cheese, Mexican red or green salsa, mustard, and sometimes ketchup, and can also have sliced radishes or cucumbers and a roasted Mexican pepper and green onion alongside it. The Sonoran hot dog supposedly originated in Hermosillo in the Mexican state of Sonora and crossed the Arizona border in the 1980s. An estimated two hundred Sonoran hot dog carts and stands are to be found in Tucson, Phoenix, and other Arizona cities. Across the United States, many hot dog restaurants that serve different styles from around the country also serve some version of this Mexican American specialty.

The Sonoran hot dog is the classic fusion of Mexican and North American food traditions. Plain hot dogs served with red and green sauces are common in Mexican public events. The beans and cheese (especially melted) are typical of what is called Tex-Mex or Cal-Mex dishes, such as nachos covered in melted cheese. In some places, hot dogs are served wrapped in flour tortillas. One of these is Oki's Dogs in Los Angeles, only here the fillings are two hot dogs, wrapped in pastrami or cheese and served with a more Japanese-style sauce. Like the Sonoran hot dog, this one is a huge amount of food sold cheaply.

SEATTLE-STYLE HOT DOG

Seattle has many hot dog establishments, and carts such as Hot Dog Joe's, found around the city. A number of them serve a newer style unique to Seattle. This is a grilled wiener placed in a grill-heated bun that is coated with cream cheese. Atop that are grilled onions and, optionally, jalapeno peppers, sauerkraut, grilled cabbage, barbecue sauce, or Sriracha (a hot, red, Thai-style sauce).

PUKA DOGS

Hawaii is one of the more interesting hot dog regions of the United States. There they have a local style called the puka dog. The world "puka" in the native Hawaiian language means "hole," and that is how the hot dog is served. A special bun, made just for these sandwiches, has a hole running down its length (very much like the French style). A grilled hot dog is stuffed down the hole and then topped with a special sauce (the recipe is a secret) along with a sweet mustard and tropical fruit relish. A lemon, garlic, and mayonnaise sauce is added at the end. This kind of hot dog, completely wrapped in a bun, is similar to hot dogs wrapped in baked buns. In Hawaii these are called hot dog manapua, and on the mainland United States they are known as hot dog rolls, common in ethnic bakeries such as Czech and Polish ones. These, in turn, have a homemade version called "pigs in blankets," or hot dogs of various sizes baked in a bread or biscuit dough.

ORIGINAL EL GÜERO CANELO, TUCSON

CORN DOGS

The corn dog is one of the most popular ways to consume a hot dog. A corn dog is a hot dog—usually a very cheap, low-quality one—skewered lengthwise on a stick, dipped in a cornmeal batter, and then deep fried. It is often served plain, but it can be dipped in sauces or have mustard and other condiments smeared on it. Not all corn dogs are the same because the cornmeal batters differ in their ingredients, mainly in the amount of sugar put in them. Corn dogs are staples at North American state and county fairs, perhaps the best known being Fletcher's Corny Dogs at the Texas State Fair and Cozy Dog at the Illinois State Fair. In Canada, they are often called "pogos" from a popular brand. There is an argument about who invented corn dogs, but the first machines for making them were invented in the 1920s. A patent for a frying device dates to 1927.[10] Fletcher's first sold corn dogs in 1941 and Cozy Dog in 1947. Today, there are many individual vendors who make and sell them around the country.

Likely the most famous of the breed are made and sold by Cozy Dog Drive-In in Springfield, Illinois. Founder Ed Waldmeier says that he discovered "corn dogs" in Muskogee, Oklahoma, in 1941. They were not the kind that could be made quickly. He told a friend whose family owned a bakery about how good they were and forgot about them. Five years later his friend had developed a batter that would stick to hot dogs and sent him a batch. It worked, and in 1946 Ed opened a small stand in Springfield, calling it Cozy Dog (the original name was "crusty cur"). One stand was followed by another, and then a full-scale restaurant right on historic Route 66. Once a local place, it is now an international destination due to a great deal of publicity in the media. Sue Waldmeier, the former wife of Ed's son Bob, and their sons run the restaurant and say that they see people from across the world while, at the same time, serving the local community—they know many of their regular customers and "have their favorite dishes ready by the time they walk in the door." Cozy Dogs uses Oscar Mayer turkey-pork hot dogs that are impaled on sticks, dipped in a proprietary batter, and deep fried until crusty light brown. Everything is done by hand, a laborious process, especially when selling six to eight hundred items a day. The Cozy Dogs name also appears on stands at the Illinois State Fair, its prestige so great that operators buy the batter mix from them. People may say "corn dog," Sue says, but they are not the same in texture or flavor as a Cozy Dog. Here is a restaurant that has found a real niche in the hot dog world.[11]

Fairs are not the only corn dog venue. Hot Dog on a Stick is a chain of stands selling corn dogs and lemonade that was founded by Dave Barham in Santa Monica, California, in 1946. Known for their colorful uniforms, Hot Dog on a Stick has stands in a number of Western states, mainly California.

BATTER DOGS

Hot dogs on sticks fried in other kinds of battered coatings are also popular in North America and across the world. In the United States, the best-known batter dogs are Pronto Pups, which originated in 1941 in Portland, Oregon. Using a pancake batter, Pronto Pups are used in fairs and amusement parks across the country. The batter is close to one of the original forms of corn dogs, some of them made with waffle batter. The Hawaiian style is called Andagi dog, only this one is dipped in a vanilla-flavored doughnut batter and then fried. Among the

more exotic batter dogs is the Korean version. These are dipped in a thick batter, rolled in small, square chunks of potato, and then deep fried. The final appearance is a lumpy, tubular hot dog set on a long stick. Such hot dogs are commonly sold by street vendors, where they often stand on carts for a whole day. Recently, French fry–coated hot dogs have come to the United States and are sold at some fairs.

TRANSNATIONAL STYLES

Fusion

It has been said that the American hot dog is a platform for culinary cultures.[12] Certainly, American food is a mixture of ingredients and cooking techniques, brought by immigrants of all eras. Sauerkraut, pickles, piccalilli, Greek and Balkan meat sauces, guacamole, carne asada, pico de gallo, hot peppers, and lately ingredients native to Japan and Korea have all been loaded on hot dogs by enterprising purveyors across the country. The result is a fusion of ingredients that seem disparate to traditional culinary ideas. For instance, kimchi, Korean pickled vegetables, may be analogues of sauerkraut, but the flavors differ drastically. The reasons for creating fusion hot dogs are varied and change over time. The first is the age-old "added value" theory. When hot dog sellers are in competition with one another, depending on the business and social environment, then each will try to get an edge on the others. That seems to be the case in Chicago in the 1920s and 1930s when Greek and Italian fruit and vegetable street vendors vied for control of the market. Jewish hot dog sellers in the Maxwell Street area joined in and added more ingredients from their neighbors' stand to their own wares. However, if carts and stands are spaced far enough apart, then a style might remain the same. Traditional New York carts were like this until recently, when they began adding other toppings in response to perceived market conditions.

Old Chicago, Tucson, and Los Angeles, among others, share the same theme, fast food catering to ethnic communities. The Southwest has Hispanic inflections, mainly Mexican or the already creolized Tex-Mex or Cal-Mex. In each of these instances, the toppings are far from the original country's grand culinary traditions. No complex moles in their myriad forms or pumpkin seed sauces or the like are found in hot dog stands. Rather, the additions are more ordinary, day-to-day fare that comes from the owners' and diners' experiences and expectations in quick service food. Hot dogs may be platforms, but not for haute cuisine in most cases.

Added value also goes to the underlying American idea of abundance. Everyone wants value for the money, and the more value the better. Walk into any hot dog place or look at myriad blogs and one of the main topics of commentary will be on how much food is served and at what (low) price. Cheese, among the earliest toppings, chili, meat sauce, bacon, pastrami, potatoes, green peppers, slaw, barbecue sauce, and pulled pork, and others are often pictured by sellers as high-rise sandwiches. The Sonic drive-in chain, or Vicious Dogs in Los Angeles, show massive, gooey creations that seem to demand bibs for eating. In America, more is better.

The second kind of fusion is in stands serving styles of hot dogs from outside their regions. Chicago, New York, Southern-leaning slaw dogs with or without chili-coneys and bacon-wrapped versions are the most popular. America's Dog in Chicago is specifically devoted to this concept, though many other restaurants, like Sonic, do

some versions of it. The idea is a way to draw on the cosmopolitan nature of American hot dogs. In pure gustatory terms, having regional constructions gives a variety of tastes, in the way that a full-service restaurant might add special dishes not integral to its core menu. Crif Dogs in New York City is a good, upscale example. Here Japanese teriyaki-grilled strips of meat in a sweet marinade, or Chihuahua dogs, wrapped in bacon and served with avocado, and the spicy red neck, which features chili, bacon, cole slaw, and jalapeño chilies, are among the varieties. In a crowded market, regional hot dogs are a way to differentiate oneself from competition. Whether a restaurateur in, say, Chicago can convincingly use a Chicago hot dog for Detroit or Flint coneys is a matter for connoisseurs to decide.

Asian styles have become a style du jour in the United States. Lest anyone think that Asian American mixes are new, Nathan's used to make a once-popular chow mein sandwich. It was composed of fried chow mein noodles and chow mein and served in a hamburger bun. Chow mein is another creolized American food, not authentically Asian in history or flavor. Los Angeles has five Kogi Korean BBQ trucks that serve fused Korean and Mexican dishes. Korean and Mexican cuisines are generally hearty, qualities that go well with hot dog concepts. Kogi's hot dogs include versions made with barbecued pork, and some with barbecued ribs and kimchee. New York is also home to newer fusion styles of hot dogs. Many of these have Asian ingredients in hot dog toppings. Two are notable. Asiadog is a portable stand owned by Mel and Steve that started in Brooklyn. They now appear at various festivals around the city and have become popular for their toppings that range from Korean to Thai. One is a barbecued pork belly with scallions and cucumber, another a Thai-style sauce made of mango, onion, peanuts, and fish sauce, among other ingredients. Doggy-Style in Alameda, California, is similar. They use locally made sausages to prepare dogs with wasabi mayonnaise, some with teriyaki, and others with kimchee in addition to American regional styles. Korean toppings are used in several street carts and in the recently closed hot dog restaurant, New York Hot Dogs and Coffee. Bulgogi and galbi, marinated strips of grilled meats, and kimchi, spicy hot pickled vegetables, are among the characteristic Korean preparations put on these hot dogs.

Japanese hot dogs are not Japanese but originate in Vancouver, British Columbia, Canada. Japadog began as a street cart opened by Noriki Tamura, a Japanese chef who had never cooked hot dogs before. His creations meld grilled hot dogs and other sausages with Japanese toppings. These include teriyaki sauce, seaweed, grated radish, plum sauce, bonito (fish) flakes, Japanese mayonnaise, okonomiyake sauce, boiled soybeans, and more. The stand is so popular that Japadogs has opened a permanent location and has opened in New York City. The Hawaiian hot dog musubi, a split hot dog set in sticky rice and wrapped in a sheet of seaweed, is a little like these. Japanese toppings have also become popular in places serving "gourmet" hot dogs.

One of the more unusual fusions is actually very American: African American "soul food" dogs. Though many African Americans own hot dogs stands, there has never been a specific style or black hot dog identity. Soul Dog, founded in 2004 in Poughkeepsie, New York, is one of the few, though the menu is broader than traditional Southern ingredients. Hot dogs here can have "soul sauce," chipotle cream, sloppy joe, cole slaw, and spicy peanut sauce, among others.

More specifically "soul food" is Otis Jackson's Soul Dog in North Hollywood, California. Subtitled "premium hot dogs and soul fixins," this small, new (2011) restaurant was founded by Don and Rasheedah Scott. Don is a Cleveland native whose career is as a writer (he was one of the writers for the movies *Barbershop* and *Barbershop II: Back in Business*). He says that he loved hot dogs growing up in Cleveland and his Mississippi-born mother's Southern cooking. The couple's idea was to serve really good Southern food—they make superb fried chicken and macaroni and cheese—and marry it to hot dogs. Most people think of soul food as slow, Sunday-after-church-type fare, and generally not very healthy, Don muses. Soul Dog hopes to change that perception to the point where people might eat it every day. If theirs is not food that will cause one to lose weight—this is Los Angeles—it is at least healthier than one would ever expect in a hot dog stand.

Rasheedah gave up her professional career, went to culinary school, and then developed the unique toppings for Soul Dog's hot dogs. Some are takes on Don's mother's recipes: a collard green cucumber relish, sweet potato puree, blackeyed pea chipotle mayo, and pineapple bell pepper relish are like no others. The hot dogs are specially made by a local butcher and are all nitrate-free. The hot dogs are large and loaded with toppings. Iterations include The Original Soul Dog, with collard green cucumber relish, sweet potato puree, bacon crumbles, on a grilled bun made especially for them. A What's-Up Dog is made with blackeyed peas; the Short Rib is slowly cooked in red wine, and then the shredded beef rib meat is placed on a bed of romaine lettuce and horseradish sauce. These resemble Korean-flavored hot dogs, only an old American creation. In some respects Otis Jackson's Soul Dog resembles upscale, "gourmet" hot dog places in that the food is refined and unique; it is far earthier than many with that label.[13]

GOURMET HOT DOGS

Hot dog enthusiasts have seen the rise of what have been called "gourmet" hot dogs. The word "gourmet" is loaded with cultural meaning that runs from the appreciation for fresh, well-made foods to snobbery. It may seem anomalous to consider the lowly hot dog as fine food, but it is not. Aficionados abound, many of whom have palates that can distinguish among hot dog types and makers as well as appreciating the craft of good hot dog preparation. Some purveyors fit this category: Otis Jackson's Soul Dog and many a hot dog stand such as New York's Papaya King or Murphy's in Chicago.

Gourmet hot dogs might mean specialty meats that require especially keen taste buds and toppings that are highly refined; that is, made by chefs using costly ingredients and much skilled labor. Theorists might consider these kinds of hot dogging to be an appropriation of a popular culture for the benefit of an elite clientele. Sausage-maker Jordan Monkarsh, who ironically, may have begun the trend, calls them "chefized" and thus removed from real hot dog roots (he has "smoked chicken mole" and "Toulouse garlic," a garlic-infused pork sausage on his menu). Others, people usually called foodies, think of "upscale" hot dogs as interesting experiments in a form of good food. After all, many a fancy dish came from humble roots: shellfish come to mind.

The most famous of these eateries is Hot Doug's, an "encased meats emporium" in Chicago, founded and operated by the very affable Doug Sohn. After slaving as a line cook, and as a Chicagoan, he thought of "hot dogs." As a trained chef, why not experiment? After his successful first place was destroyed by fire, he set up in a nondescript area of the city with very little foot traffic. He need not have worried because the quality of his dishes is so great that there are lines at almost all times of the day, especially on Saturday when his French fries are cooked in duck fat. For example, he serves "Chardonnay and Jalapeno Rattlesnake Sausage with Roasted Yellow Pepper Dijonnaise and Cranberry Wensleydale Cheese," "Lamb and Pork Loukanika with Artichoke Pesto, Kalamata Olives, Marinated Feta Cheese and Lemon-Dijon Foam," and "Foie Gras and Sauternes Duck Sausage with Truffle Aioli, Foie Gras Mousse and Fleur de Sel," to name a few. Foie gras became an ethical and political issue in Chicago, and Sohn was right in the middle of it. What is interesting about Sohn is that he is a Chicago hot dog guy who says that at least his business is serving traditional Chicago-style hot dogs, and very well. That is a given in a city so devoted to its own hot dogs.[14]

Chicago has several other hot doggeries that emulate Hot Doug's. Among them is Franks 'n Dawgs and Chicago's Dog House, both new establishments. Franks 'n Dawgs serves such treats as roaring buffalo chicken (truffle chicken sausage, celery root slaw, blue cheese, and hot sauce), sweet veal (veal sausage, bacon cured sweet breads, pickled chanterelles, pickled corn, and cured egg yolks), and Peking duck (duck and sesame sausage, pickled cucumber, hoisin aioli, scallion, crispy Peking duck skin, and puffed rice), among others. None are hot dogs but instead are interesting sausages. Chicago's Dog House also has variety meat sausages including wild boar, pheasant, smoked duck, and alligator. Their standard hot dogs come in iterations topped with hummus, or Chihuahua cheese and chili, Brie, Grey Poupon mustard, and pears, and other such interesting combinations. Now one of America's great restaurant and international food cities, Chicago and its hot dogs can be transformed in these new styles.

Similar stands have popped up in other cities. New Orleans has the very busy global gourmet sausage place Dat Dog. Their upscale sausages include hot Kielbasa (from Poland), Slovenian sausage (from Slovenia), German smoked bratwurst (from Germany), hot brat (from Germany), Louisiana hot sausage (from Harahan), Louisiana smoked sausage (from Jefferson Parish), alligator sausage (from the bayou), and crawfish sausage (from the swamp). Toppings such as wasabi, Andouille, and homemade chili are all in the upscale category. Upscale hot dogs may be transnational, but as Dat Dawg shows, local flavors are always important.

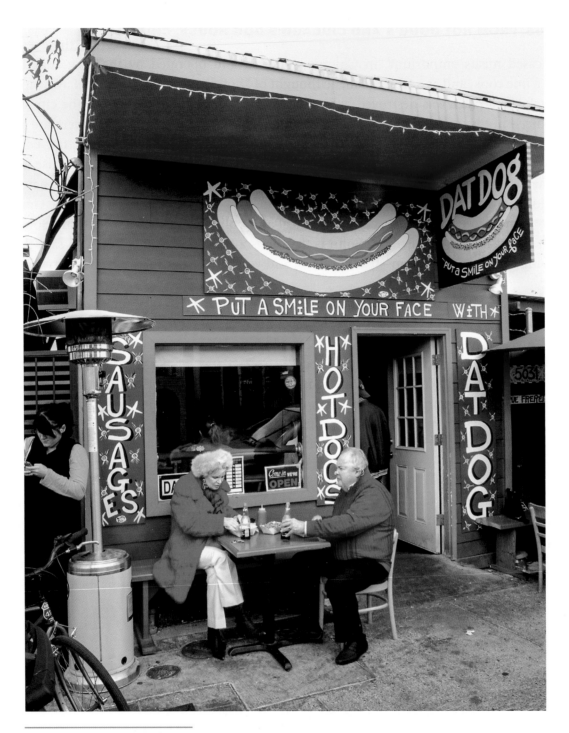

DAT DOG, NEW ORLEANS

Recipes

New York Deli Specials

Once upon a time in New York, Jewish delicatessens could be found in neighborhoods and areas of commerce all over the city. Corned beef, pastrami, chicken soup with matzo balls, knishes, and many other dishes associated with Jewish American cuisine were to be found there. Today, though numbers are reduced, these items can still be found on deli menus. One of them is a simple hot dog–centered dish called a "Special," the nickname for a knockwurst, or kosher (usually) sausage. These are basically stubby, natural casing sausages, four to a pound, and seasoned with lots of garlic. Hebrew National makes the best known of these, though before consolidation of the industry there were many local makers.

Ingredients

2–4 knockwursts

Water for heating

1 16-ounce can vegetarian baked beans

Slices of (Jewish) sour pickles

Yellow mustard

Jewish rye bread

Heat enough water to cover knockwursts to just under boiling. Place sausages in water and heat for about 10 minutes, until heated throughout. Meanwhile, place baked beans in a pan and heat on stove until hot. To serve, place knockwurst on a plate with heated beans on one side and pickles on the other. Place dollops of mustard on the plate, to taste and eat with slices of Jewish rye bread. *Serves 2–4.*

Split Pea Soup with Hot Dogs

Bean soups made with ham bones are a historical American staple. A nice, thick, green or yellow pea soup with hot dogs is a widely used variant. When made with canned soup, it is an early convenience food.

Ingredients

2 tablespoons olive oil or batter

1 clove garlic, minced

1 medium onion, diced into medium pieces

1 medium carrot, diced into small pieces

1 cup split peas

4 cups water

1 bay leaf

1 teaspoon salt

Ground pepper to taste

6 hot dogs, cut into 1-inch rounds

Place oil or butter in a deep pan and heat. Add diced onion, carrot, and garlic and sauté until onion is somewhat transparent. Add split peas, water, bay leaf and salt. Cover pan and bring to boil. Reduce heat and cook for 45 minutes, or until peas are very soft. Remove bay leaf from pan. Using a hand blender or a fine-bladed masher, puree the peas until a thick soup is formed. Add water if necessary. Add salt, and pepper to taste (more is better), and hot dogs. Heat until hot dogs are heated throughout. Serve with good bread. *Serves 4.*

New York–Style with Onion Sauce

Onion sauce is a standard for New York–style hot dogs. Our thanks to Craig "Meathead" Goldwyn, AmazingRibs.com, for his version.

Ingredients

ONION SAUCE

½ cup water

1 teaspoon cornstarch or arrowroot

1 tablespoon tomato paste

1 tablespoon inexpensive balsamic vinegar

1 teaspoon Dijon-style mustard

1 teaspoon brown sugar

¼ teaspoon hot pepper sauce

1 pinch of cinnamon

1 tablespoon olive oil

2 large red onions, peeled thoroughly
 and sliced thin

¼ teaspoon table salt

2 cloves of pressed or minced garlic

HOT DOGS

4 all-beef frankfurters, preferably Sabretts

4 buns

Sauerkraut from the refrigerator section,
 not the can

Spicy brown Dijon-style mustard

About the onions: Red onions often have an extra layer of tough paper under the outer layer. Make sure you remove it.

About the tomato paste: If you want, you can substitute 2 tablespoons of ketchup or a sweet tomato-based Kansas City–style barbecue sauce for the tomato paste.

Combine the water and cornstarch in a bowl and whisk it until there are no more lumps. Whisk in the tomato paste, balsamic, mustard, brown sugar, hot sauce, and cinnamon.

Warm the oil in a large skillet, not a nonstick, over medium high heat. Add the onions and sprinkle with the salt. This helps pull the moisture out. Move them around occasionally with a wooden spoon so they don't burn. Cook until the edges start to brown. Whatever you do, do not let them burn. Add the garlic and cook for another minute.

Add the liquid, stir, and rub the pan with the wooden spoon to scrape up all the flavorful fond, the brown bits on the bottom. Turn the stove to low and simmer with the lid on for 1 hour. Check frequently to make sure it is not burning and the water has not evaporated. Add water if needed.

The final result should be thick, not runny, but not pasty. After an hour, taste and adjust salt and other flavors as you wish.

While the onions are simmering, warm the kraut in a pan or for 15 seconds in the microwave, cook the franks, and prepare the buns. The franks can be cooked on a griddle, on a grill, but most pushcarts make "dirty water dogs" by simmering them in water that has become a rich, flavorful soup after holding scores of franks over the course of a day.

And don't worry, the franks are precooked so they are pasteurized, and the dirty water is hot enough that no germs can survive. As for the buns, some are toasted on a griddle, but most pushcarts store them in a bin where the steam from the dirty water keeps them warm and moist.

Lovingly place the frank on the bun, squirt on the mustard, add the onions, and then the kraut. Hum quietly, "I'll take Manhattan . . ." *Makes 4 hot dogs.*

Sonoran Hot Dogs

Hot dogs can cross cultural lines, the evidence coming from varieties of toppings. Sonoran hot dogs fulfill several much-desired qualities in hot dogs: acceptable ethnic ingredients; varied flavors; and abundance. A Sonoran is the proverbial "gut buster." This recipe does not use made-from-scratch beans and sauces, but all the ingredients are readily available in supermarkets.

Ingredients

4 hot dogs, 6 to a pound are better

4 strips bacon (chicken or turkey bacon are fine)

4 bolillos (Mexican rolls), split

¾ cup refried beans

½ cup prepared guacamole

½ cup shredded quesadilla or other Mexican melting cheese, or Monterey Jack cheese

1 medium onion, finely diced

1 large fresh tomato (or more), finely diced

Mayonnaise to taste

½ cup salsa verde (or more if needed)

Wrap bacon around each hot dog and place on a hot griddle or grill and cook until bacon is crispy. Time will vary with heat of grill.

Meanwhile, place a layer of beans and guacamole on the sides of the split bolillo. Place a cooked hot dog in each bun, settling it in the bean-guacamole mixture. Cover each dog with a layer of shredded cheese, diced onion, and tomato. Smear the top with mayonnaise to taste and top with salsa verde. *Serves 4.*

Note: In Arizona these are served with a grilled güero chile and a grilled knob onion. Güeros are 3-inch-long peppers also called yellow wax. They are mildly flavored and could be substituted with the larger Anaheim pepper. When grilling them, along with knob onions, place on a medium hot grill and cook until they are charred on the outside. Serve with hot dogs.

Korean Barbecue-Flavored Hot Dogs with Kimchi

East and Southeast Asian toppings on hot dogs have become popular with food trucks such as Kogi and Japadog in Vancouver, Canada, and New York City. Rather than go through the process of making kimchi, this calls for prepared product. Purchase bottled kimchi and Sriracha.

Ingredients

SAUCE

¼ cup medium soy sauce

1 tablespoon sesame oil

1 tablespoon brown sugar

¼ teaspoon ground black pepper

1 teaspoon finely chopped ginger

1 tablespoon finely chopped garlic

1 teaspoon crushed hot red pepper

2 tablespoons cooking wine—white or red

1 tablespoon cooking oil

HOT DOGS

6 (1 pound) all-beef hot dogs

6 hot dog buns, split and lightly toasted on the inside

Brown mustard

1 cup kimchi, drained

Sriracha (hot Thai sauce)

Mix very well all the ingredients in a wide bowl, so that the sugar is dissolved. Place hot dogs in the mixture and marinate for 10 minutes.

Heat a grill until hot, place marinated hot dogs on it, and cook until exterior is slightly crispy and browned (not burnt). Reserve extra liquid, if any, and heat in a small pan. Place hot dogs in each bun and top with a strip of mustard and kimchi. Add any extra liquid to taste and Sriracha to taste. *Makes 6.*

Thai Spicy Cucumber Sauce Hot Dogs

Ingredients

1 cup rice vinegar

¾ cup sugar

Salt to taste

1 pound cucumbers, peeled and shredded

1 clove garlic, crushed and finely chopped

6 Thai bird chilies, crushed

¾ cup chopped roasted unsalted peanuts

½ cup chopped fresh cilantro

4 hot dogs

4 hot dog buns

Place vinegar, sugar, and salt in a small pan and heat until the sugar is dissolved. Allow to cool. Place rest of ingredients (except hot dogs and buns) in a bowl, pour cooled liquid over them, and mix together. Allow to stand for at least an hour or more. When using, lift cucumber from liquid, but reserve liquid if more juice is required.

Hot dogs may be cooked by grilling, but hot water bathing is equally good. Place cooked hot dogs in buns and top with cucumber. *Serves 4.*

Adapted from Victor Sodsook, *True Thai*. New York: William Morrow and Company, 1995.

Fettuccine with Sausage, Sage, and Crispy Garlic

Jordan Monkarsh is a sausage doyen. This recipe does not use an ordinary hot dog, but one of his pioneering creations. His chicken sausages are used in the same way at his Jody Maroni's stand on Venice Beach, and so it qualifies as a hot dog.

Ingredients

¾ pound fettuccine

2 tablespoons butter, divided

¼ cup olive oil

8 garlic cloves, peeled, thinly sliced

2 tablespoons finely chopped fresh sage

1 pound (4 links) Jody Maroni's Venetian
 Chicken Sausage, sliced into half-moons

¼ teaspoon dried crushed red pepper
 (optional)

Salt and pepper, to taste

1 cup grated Asiago cheese (about 3 ounces)

Prepare pasta as directed on the package. Meanwhile, melt 1 tablespoon butter with oil in heavy, large skillet over medium heat. Add garlic slices and sauté until light golden, about 45 seconds. Using slotted spoon, transfer garlic to bowl. Increase heat to medium-high; add sage to same skillet and stir until beginning to crisp, about 10 seconds. Add sausage and sauté until browned and crisp in spots, about 8 minutes. Drain pasta; add pasta and remaining 1 tablespoon butter to skillet. Using tongs, toss pasta with sausage mixture. Add crushed red pepper, if desired; season to taste with salt and pepper. Transfer pasta to large bowl. Top with crispy garlic and grated Asiago cheese. *Serves 4.*

With kind permission of Jordan Monkarsh, http://www .jodymaroni.com/recipes.

Froman Mac & Cheese Muffins

Nothing is more American than mac and cheese. In one version it has been made since the eighteenth century, only not with hot dogs.

Ingredients

8 ounces dried elbow macaroni or shells

1 tablespoon kosher salt

3¼ cups shredded cheddar cheese, divided

2 cups heavy cream

2 cups 2% or whole milk

2 eggs, lightly beaten

7 slices American cheese slices, torn into quarters

½ teaspoon kosher salt

4 Gilbert's Froman Sausages (6 to a pound hot dogs)

6 tablespoons Panko bread crumbs

6 teaspoons unsalted butter

Preheat oven to 425°. Spray six 6-ounce ovenproof ramekins with nonstick cooking spray and place on a parchment-lined baking sheet. Set aside.

Bring 3 quarts of water to a boil. Season with kosher salt. Add dried macaroni or shells and cook halfway, or about 4 minutes. Drain, rinse with cold water, and stir to prevent sticking. Toss with ¾ cup shredded cheddar cheese and set aside.

Bring heavy cream and milk to a boil over medium-high heat, stirring often to prevent scorching.

In a large bowl, mix remaining 2½ cups shredded cheddar cheese, beaten eggs, torn American cheese slices, and salt.

Slowly pour the boiling cream and milk over the egg and cheese mixture while whisking continuously to prevent the eggs from curdling. Continue whisking until the cheese is melted.

Cut 2 Froman sausages into thirds and 2 Froman sausages into quarters lengthwise and then into ½ inch pieces. Toss pieces in with pasta and shredded cheddar cheese.

Scoop ½ cup pasta mixture into each ramekin. Insert a third of a Froman sausage into the center of each ramekin. Sprinkle the top with Panko bread crumbs and dot with one teaspoon butter.

Bake for about 20 minutes, or until the top is golden brown.

Cool about 10 minutes. Run knife along sides of ramekin to loosen the muffin. Gently slide muffin out of ramekin and serve with fruit or a vegetable. *Makes 6 muffins.*

Used with kind permission of Chris Salm, http://gilberts sausages.com/recipes.

Barbecue Sauce Hot Dogs

Morrison Wood was a well-known food writer in the middle of the twentieth century. He was a regular columnist for the Chicago Daily News—*Mike Royko's old paper—and wrote wonderful cookbooks: the Jug of Wine series. This recipe dates to 1968 and is of its time.*

Ingredients

1 tablespoon bacon drippings

2 cloves garlic, crushed and finely chopped

6 hot dogs (1 pound), slit down the middle

1 medium onion, finely sliced

¼ cup red wine

8 ounces tomato sauce

⅓ cup molasses

1 teaspoon chili powder

Salt to taste

2 tablespoons Worcestershire sauce

Juice of 1 lemon

Melt bacon drippings in a deep skillet over medium heat. Add chopped garlic and sauté until transparent. Add slit hot dogs and turn in fat. Add onions, cover pan, and cook until transparent. Pour wine into pan and stir to deglaze any sticky bits in pan. Add tomato sauce, molasses, chili powder, salt, Worcestershire sauce, and lemon. Bring to bubbling state, reduce heat to simmer, cover and cook about 15–20 minutes. Check pan and add wine or water if the mixture begins to burn. Serve on bed of rice. *Serves 4–6.*

Adapted from Morrison Wood, "Hot Dogs Can Be Gourmet Eating," *Chicago Tribune*, May 24, 1968.

Since Chicagoans like to think that their city is hot dog central, here is an atypical recipe but one that reflects the city's former meat and potatoes food reputation. Fortunately, the Tribune became far more concerned with modern, good cookery when Carol Haddix became food editor thirty years ago.

Ingredients

6 hot dogs

6 hot dog buns, split

12 ounces tomato sauce, or "spaghetti sauce"

2 cups mashed potatoes

3 slices American cheese cut in half

Preheat oven to 375°.

Place hot dogs in each bun, spread tomato sauce to taste in a strip down each hot dog. Place heaping strips of mashed potatoes on each hot dog and cover each with a half slice of cheese.

Place hot dogs in a heatproof dish, set in oven, and bake about 10 minutes, until cheese becomes really melted. To serve add more tomato sauce as desired. Best to eat with a knife and fork.

Adapted from Carol Rasmussen, "All American Hot Dog Takes New Culinary Twists," *Chicago Tribune*, October 3, 1974.

Hot Dog Polenta

Polenta is a northern Italian dish, though it originated as barley grains. The corn meal used in it came from the Americas in the sixteenth century. James Beard called it simply "mush." Polenta has many variations in the Old World, but not likely one like this.

Ingredients

1½ cups cornmeal/polenta

Salt to taste

4½ cups water

4 hot dogs—the spicier the better, though Jody Maroni's chicken fennel sausage would be good—cut into 1-inch rounds.

¼ cup butter

1 cup, or more, grated Parmesan or pecorino cheese

Place cornmeal in a deep, heavy pan and mix with salt. Turn heat to medium and slowly stir in 2 cups of the water. Stir in the hot dog pieces. Stir in the butter. Add rest of water, slowly, stirring all the while. Cook about 20 minutes until all the water is absorbed and the polenta can be pulled away from the sides of the pan. Make sure hot dog pieces remain distributed more or less evenly. When done, place in a serving bowl and sprinkle grated cheese on it. If you like, add more butter. *Serves 6.*

Hot Dog Rösti (Swiss Hash-Browned Potatoes)

Hashed browns are a staple of diners, just as French fries are in hot dog stands. The Swiss version, probably their national dish, used grated potatoes cooked until crusty brown. This combination marries good old hot dogs and good old fried potatoes.

Ingredients

6 medium potatoes (Russets will make a flakier product; Yukon Golds are smoother, boiled)

Salt to taste

¼ cup olive oil

¼ cup butter

3 cloves garlic, smashed and finely chopped

4 green onions, chopped into small rounds, white parts as well

8 hot dogs, cut into ¼-inch rounds

More butter

Boil potatoes with skins on, until cooked through, but not falling apart. Remove from water and allow to cool to room temperature. Using the coarse side of a 4-sided greater, or a rösti grater if you have one, grate the potatoes. Mix with salt to taste. Heat olive oil and butter in a deep, heavy skillet (a cast-iron pan is perfect) using medium heat. Add the garlic and sauté until transparent. Add the potatoes, moving them around until a thick layer covers the pan. Stir in the rest of the ingredients and press down into the potatoes. Cook until bottom layer of the potatoes is golden brown. If you can manage, turn the whole pancake over and brown the other side. Cut into pieces and serve. *Serves 4–6.*

Adapted from Mettja C. Roate, *The New Hot Dog Cookbook*. New York: Modern Promotions Publishers, 1983 [1968].

Washington State Hot Dogs

Recipes for apples and sausage combinations are common, some more complex than others. They are related to European pork and apple recipes, so one might expect pork-based hot dogs in this recipe, but any good hot dog will do. Washington State is, of course, apple country.

Ingredients

8 hot dogs, 8 to a pound

1 tablespoon (or more) brown or Dijon mustard

3 Granny Smith or other tart apples, thinly sliced—the peels may be left on

¼ cup brown sugar

½ cup coarsely grated cheddar cheese— a Washington State cheese is best

Preheat oven to 350°.

Place hot dogs in a baking dish. Spread with mustard. Spread apple slices over the hot dogs and sprinkle with brown sugar. Bake for about 20 minutes, until apples are tender. Sprinkle grated cheese over top of dish, replace in oven, and bake until cheese melts, about 5 minutes. *Makes 8 hot dogs.*

Adapted from Dorothy Dean, "These Recipes for Hot Dogs May Please," *Seattle Spokesman-Review*, June 20, 1951.

Franks and Veggies Pita Pockets

This "healthy" hot dog creation came from the Bar-S brand kitchens more than twenty years ago. It is an example of changing attitudes toward American food—pita pockets and shredded vegetables.

Ingredients

2–4 tablespoons olive oil

8 hot dogs, 8 to a pound

1 medium onion, sliced into thin strips

1 sweet green pepper, seeded, and cut into thin strips

1 sweet red pepper, seeded, and cut into thin strips

1 zucchini, peeled and cut lengthwise into thin strips

1 teaspoon dried oregano, or 1 bunch of fresh oregano, chopped

4 fresh pita breads, cut in half

Heat olive oil in a deep skillet over medium heat. Add hot dogs, onions, green and red pepper strips, and zucchini. Sauté until vegetables become tender. Sprinkle with oregano and heat thoroughly. Place a hot dog with vegetables in each pocket half. *Serves 8.*

May be served with a dollop of thick yogurt.

Adapted from "Jumbo Frank Recipes Celebrate the Hot Dog as an All-American Favorite," *Lawrence* [Kansas] *World Journal*, June 27, 1990.

Frankfurter Twists

Hot dogs wrapped in dough are an antique recipe, at least in baking-mix-company history. They descend from a long line of stuffed pastries running back into European baking traditions: think four and twenty blackbirds baked in a pie. In a way, pigs-in-blankets are a kind of analogue to the hot dog itself. This recipe is an interesting variation.

Ingredients

2 cups biscuit mix

⅔ cup milk

3 tablespoons chili sauce—not Tabasco or the like, but a tomato or tomatillo sauce

1 tablespoon yellow mustard

1 tablespoon prepared horseradish

12 hot dogs, 2 ounces each

12 skewers

Melted butter

Have a grill heated and ready for cooking.

Mix biscuit mix and milk until soft dough is formed. Roll out on a floured board to a 9×12-inch rectangle. Mix the chili sauce, mustard, and horseradish. Spread over the dough evenly. Cut dough into 12 long equal strips. Skewer the hot dogs and wrap each with the strip of dough, twisting it into a spiral around the hot dog. Lay hot dogs on the board and brush with melted butter. Place on grill and cook until the dough becomes crispy brown. *Makes 12 hot dogs.*

Adapted from Katherine Tromans, "Recipes Turn Lowly Hot Dog into Gourmet Frankfurter," *Sarasota Herald-Tribune*, August 29, 1957.

Corn dogs date to at least the 1920s and are Southern in origin—essentially hushpuppies. They are staples of state fairs everywhere, especially the Illinois State Fair, where Cozy Dogs hold sway.

Ingredients

1 cup yellow cornmeal

1 cup all-purpose flour

4 teaspoons baking powder

1 teaspoon salt

1 tablespoon white sugar

1 tablespoon dried mustard

1 egg, beaten

1 cup milk

12 beef hot dogs, 2 ounces each

12 wooden skewers

Flour

Oil for deep-frying

Mix cornmeal, flour, baking powder, salt, sugar, and dried mustard in a wide bowl. Beat egg in a separate bowl and mix with milk. Pour liquid into dry mixture to make a batter. If necessary, add more milk.

Preheat oil in a deep pan to about 360°. Place wooden skewers into hot dogs. Roll each hot dog in flour, a dusting is enough to make batter stick to them. Dip in batter until well coated. Place as many corn dogs into hot oil as will fit. Fry until browned, not burnt. Remove from oil and drain on paper towels. For remaining corn dogs, bring oil back to 360° and repeat the cooking process until all the corn dogs are done. *Makes 12 corn dogs.*

Sweet-Sour Frankfurters

Chinese-American dishes became popular in the late nineteenth and early twentieth centuries. Variations of standard chop suey and chow mein preparations appeared in cookery books and other media for the rest of the century. Producers such as La Choy made them even easier and inspired many a food writer. This is one. Note that it does not call for soy sauce or any serious spicing.

Ingredients

8 hot dogs, 2 ounces each

1 medium onion, finely sliced

2 tablespoons butter

1 sweet green pepper, seeded and cut into thin strips

¼ cup raisins

1 cup water

¼ cup brown sugar

2 tablespoons cornstarch

¼ cup water

¼ cup vinegar

1 package, 18 ounces, frozen green beans, cooked

Prepared packaged Chinese noodles

Cut frankfurters into 1-inch rounds. Melt butter in a deep skillet over medium heat. Add onions and frankfurters until onion just browns. Add green pepper slices, raisins, and 1 cup water.

Reduce heat and simmer for 5 minutes. Combine brown sugar and cornstarch with water and mix until smooth. Stir into frankfurter mixture. Stir in vinegar and green beans. Stir and cook briefly, until heated through. Serve over Chinese noodles. *Serves 4.*

Adapted from Veronica Volpe, "Hot Dogs Hold High Spot in Popularity, Novel Recipes Are Offered," *Pittsburgh Press*, July 13, 1967.

Chili dogs come in many forms. This one, from our friends at the National Hot Dog and Sausage Council, is more like a traditional chili.

Ingredients

CHILI SAUCE

¾ pound ground beef

1 cup chopped onion

1 8-ounce can tomato sauce

½ teaspoon Worcestershire sauce

¼ teaspoon hot pepper sauce

½ teaspoon chili powder

½ teaspoon salt

¼ teaspoon pepper

1 teaspoon brown sugar

HOT DOGS

8 hot dogs, cooked according to package directions

8 hot dog buns, split and lightly toasted

Cheddar cheese, shredded, optional

In a medium skillet, over medium heat, brown beef and onions, breaking up beef into small pieces. Drain fat from skillet. Reduce heat to low.

Stir in tomato, Worcestershire and hot pepper sauces, chili powder, salt and pepper and sugar. Simmer for about 10 to 12 minutes, stirring occasionally.

Place cooked hot dogs into toasted buns. Ladle ¼ cup chili sauce over each hot dog. If desired, top with cheese.

Courtesy National Hot Dog and Sausage Council: www .hot-dog.org/ht/d/sp/i/37931.

Bratwurst Kabobs

Sausages are ready-made for skewering and cooking over an open flame. This is a simple recipe using bratwurst. It comes from Klements, one of the premier bratwurst and hot dog makers in bratwurst central, Milwaukee.

Ingredients

8 (1 pound packaged) precooked bratwursts

½ cup soy sauce

3 tablespoons spicy mustard

¼ cup apple juice

2 medium red peppers, seeded and cut into
 1-inch pieces

1 medium yellow squash, cut into ½-inch cubes

1 medium yellow onion, cut into wedges

2 tablespoons olive oil

4 metal skewers

In large, resealable bag, combine the soy sauce, apple juice, and mustard; add peppers, yellow squash, and onions. Seal bag and refrigerate for one hour.

Heat olive oil in a heavy skillet, place bratwursts in skillet, and heat. When the brats begin to brown, add a little water so they do not burn. Remove brats from skillet and slice each brat into 5 equal pieces. Thread brats onto skewers, alternating with the vegetables.

Brush brats and vegetables with reserved marinade. Grill over medium heat until vegetables are tender and brats are golden brown, turning and basting frequently with marinade. *Makes 4 kabobs.*

Used with kind permission from Klement's Sausage Company, www.klements.com/ask_patio_daddio/recipes.html.

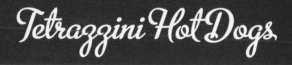

Ingredients

4 tablespoons butter

1 clove garlic, crushed and chopped

8 ounces fresh mushrooms, cleaned and sliced, including stems

2 tablespoons flour

2 tablespoons Hungarian paprika, hot or mild to taste

2 cups chicken broth

½ cup heavy cream

Salt to taste

Ground black pepper to taste

12 hot dogs, cut into ½-inch rounds

12 ounces medium-width egg noodles, cooked al dente

¾ cup grated Parmesan cheese

Preheat oven to 350°.

Melt butter in a heavy skillet. Add garlic and sauté until transparent. Add mushrooms and sauté until slightly browned. Move mushrooms to side of pan and stir in the flour and the paprika. Cook while stirring until mixture bubbles. Stir in the chicken broth, slowly, until mixture is smooth. Stir in heavy cream, salt and pepper to taste. Add hot dogs and cook until the pieces are coated.

Place cooked noodles in a baking dish, stir in the hot dog mixture, and sprinkle Parmesan cheese on top. Set in hot oven and bake until cheese melts, about 10 minutes. *Serves 6.*

Adapted from Mettja C. Roate, *The New Hot Dog Cookbook.* New York: Modern Promotions Publishers, 1983 [1968].

Hot Dogs with Aloo Curry

Indian cuisine is growing in popularity in the United States. It has not been taken up by hot dogs places in a big way. This recipe might be used to replace French fries. Although it does not contain the usual curry powders, it is a curry nonetheless, whose flavors should not overwhelm the hot dog.

Ingredients

2 tablespoons cooking oil

1 large onion, finely chopped

3 plum tomatoes, chopped

4 red chilies—Mexican arbol would be good,
 seeded and chopped

1 teaspoon cumin seeds

Salt to taste

½ cup water

1 pound Yukon gold or similar thin-skinned
 potatoes, cut into ¼-inch dice

½ cup water, or more

Cilantro leaves, chopped, to taste

6 hot dogs, 2 ounces each

Hot dog buns, toasted

Heat oil in a deep pan over medium heat. Add onions and sauté until slightly browned. Add tomatoes, chilies, cumin seeds, and salt to taste. Pour ½ cup water in pan and cook, stirring until water disappears. Place potatoes in pan and add another ½ cup water. Stir well. Cover pan and cook over low heat until potatoes are just tender. Remove from heat and set aside to cool. Just before serving, garnish the potato mixture with chopped cilantro.

Cook hot dogs to taste, either griddling or hot water bathing—the latter is better for this topping. Place a hot dog in each bun and top with Aloo. *Serves 6.*

Adapted from Sri Owen, *Curry Cuisine*. New York: DK Publishing, 2006.

Hot Dogs with Cilantro Chimichurri

This garnish is the standard condiment in Argentina, but this one adds a lot of cilantro. The fresh flavors go well with a crisply grilled hot dog.

Ingredients

½ cup of olive oil

2 cloves of garlic, crushed and finely chopped

A good handful of flat-leaf parsley ripped from a healthy bunch, finely chopped

A good handful of cilantro ripped from a healthy bunch, finely chopped

2 teaspoons of hot red pepper flakes

1 teaspoon of salt

¼ teaspoon of pepper

4 tablespoons of red wine vinegar

4 hot dogs, 6 to a pound

Crusty rolls to fit hot dog, Italian or French, split

Mix the olive oil, garlic, parsley, cilantro, red pepper flakes, salt and pepper, and vinegar together in a bowl. Let the flavors combine for a couple hours before serving.

Cook hot dogs on a griddle. Place in rolls and cover each with chimichurri sauce.

Adapted from Marcela Mazzei's recipe for *Encyclopedia of World Street Food*. Santa Barbara, CA: ABC-CLIO, 2013.

A picture of this recipe graces the cover of the Nathan's Famous Hot Dog Cookbook *by Murray Handwerker. Other pictures of the dish are spread across the Internet as an example of disgusting food. Not so fast and not so bad. Try it and judge for yourself.*

This recipe was created by Catherine Lambrecht of the Greater Midwest Foodways Alliance.

Ingredients

Two pounds frankfurters (12 large ones)

1 tablespoon butter

1 large onion, medium diced

1 tablespoon salt

½–1 cup sauerkraut, lightly drained, plus extra
 for decoration

1 cup grated Swiss cheese

SPAETZLE

2 eggs

½ cup water

1½ cups flour

½ teaspoon salt

¼ teaspoon baking powder

Preheat oven to 350°.

In a frying pan set on medium low, melt butter then add onions. Allow to cook slowly to caramelize, which may take 30 minutes.

Fill a 6-quart pot with water, add a tablespoon salt, and bring to a boil.

Meanwhile, prepare your spaetzle batter. In a medium mixing bowl, beat together eggs and water. Sift together flour, salt, and baking powder, then add to the eggs and water. Stir together until incorporated.

If you do not have a spaetzle maker, you can spread spaetzle batter on a plate or cutting board, then use the tip of rubber spatula to cut off bits of batter into the boiling water. Alternatively, you can use a wide-holed grater or colander to press batter with your rubber spatula into the water.

Opposite: **ROAST CROWN OF FRANKFURTERS**

Spaetzle in boiling water cooks very quickly, only needing a few minutes per batch. Lift cooked spaetzle from the boiling water, place into a colander, and allow to dry.

In a large bowl, mix together spaetzle, Swiss cheese, caramelized onions, sauerkraut, and any sliced trimmings from the frankfurters assembly.

TO ASSEMBLE:

Line up frankfurters on a cutting board with the tips lined up against a large knife. If these sausages have a curve, then nestle them together where they match curves, if possible.

Measure off butcher's string about 50 percent longer than the frankfurters lined up, then string it through a trussing needle. Your trussing needle should enter the frankfurter about an inch below the upper tip, then slowly make your way through. Repeat this process on the bottom edge of your frankfurters. If your frankfurters have uneven lengths or you want to shorten the roast, you may trim these sausages an inch below the bottom string's location. Any sliced trimmings may be added to the spaetzle mixture.

Once strung together, gather your strings and tie the bottom and top edges. Arrange this frankfurter crown on a baking pan. Lightly fill center with your spaetzle mixture with any remaining spaetzle, spreading it in the pan around the frankfurters.

Bake for 30 minutes. *Serves 6–8.*

Notes

INTRODUCTION

1. See David Zirin, *A People's History of Sports in the United States*, on why baseball as a democratic sport is a myth, not reality.

CHAPTER 1

1. www.barrypopik.com/index.php/new_york_city/entry/shaggy_dog_frito_chili_pie_hot_dog/
2. www.fsis.usda.gov/factsheets/hot_dogs/index.asp; see also, Hurley, Jayne, and Liebman, Bonnie, "Lower-Fat Hot Dogs, Bacon, & Sausage, The Best of the Wurst," Nutrition Action Newsletter, July/August 1998—U.S. Edition (www.cspinet .org/nah/7_98meat.htm).
3. Tofurky franks label.
4. *Consumer Reports*, "Hot Dogs without (Too Much) Guilt," July 2007: www.applegatefarms.com/uploadedfiles/resources /news/consumerreports0707.pdf; see critique of this report: www.seriouseats.com/2007/06/consumers-reports -doesnt-know.html.
5. These were not the first tuna hot dogs. The earliest seem to have come from the Davis Brothers Fisheries Company of Gloucester, Massachusetts, which in 1949 marketed them to Catholic patrons as "Friday franks." They failed. "Tuna Fish Hot Dog—'Friday Franks'—Hits Retail Market Today," *Wall Street Journal*, December 2, 1949, 10 (see www .foodtimeline.org/foodlobster.html#fridayfranks).
6. Engler, Peter, on the mother-in-law: www.lthforum.com/bb/viewtopic.php?t=3932, and personal communication; see also the story on NPR: www.npr.org/templates/story/story.php?storyId=10279183.
7. Sullivan, Louis H., "The Tall Office Building Artistically Considered," *Lippincott's Magazine* 57 (March 1896): 403–09: www.giarts.org/article/tall-office-building-artistically-considered-excerpt.
8. *Chicago Daily Tribune*, November 1, 1884, 12.
9. The phrase might date to a baking company in 1914 but was used in the 1930s by the Q-tips cotton swab company, the American tobacco company, and famously by New York City's Chock full o'Nuts sandwich chain.

10. Douglass, Mary, *Purity and Danger: An Analysis of the Concepts of Pollution and Taboo*. London: Routledge (New edition), 1984.

11. Scott, Herbert, *Groceries*. Pittsburgh: University of Pittsburgh Press, 1976, 17, 18.

12. Norat, Teresa, Chan, Doris, Lau, Rosa, Aune, Dagfinn, and Vieira, Rui. "The Associations between Food, Nutrition and Physical Activity and the Risk of Colorectal Cancer," WCRF/AICR Systematic Literature Review Continuous Update Project Report, October 2010 (www.wcrf.org/cancer_research/index.php).

13. "Petition for Rulemaking to Modify the Standards of Identity for Ground Beef, Hot Dogs, and Sausages," Submitted by the Center for Science in the Public Interest, November 16, 2004 (www.cspinet.org/new/pdf/lowerfatmeatpetition .pdf).

14. Szabo, Liz, "Pediatricians Call for a Choke-Proof Hot Dog," *USA Today*, February 22, 2010 (www.usatoday.com/news/ health/2010-02-22-1Achoke22_ST_N.htm). In reality, perhaps fifteen children a year are reported to have died from asphyxiation from a hot dog; other foods, such as popcorn, were more culpable. See www.fsis.usda.gov/factsheets/hot_ dogs/index.asp. See Ferrières, Madeleine, *Sacred Cow, Mad Cow: A History of Food Fears*, translated by Jody Gladding, New York: Columbia University Press, 2006. This book discusses terrors about various food, especially meat.

15. The National Sausage and Hot Dog Council, www.hot-dog.org/ht/d/sp/i/1683/pid/1683. Mass market "all meat" franks have even more. Oscar Mayer "fast franks meat wieners" contain "turkey, pork and chicken, mechanically separated turkey, pork, mechanically separated chicken, water, contains less than 2 percent of salt, sodium lactate, flavor, corn syrup, sodium phosphate, dextrose, sodium diacetate, sodium erythorbate (made from sugar), sodium nitrite, bun, enriched wheat flour (wheat flour, niacin, reduced iron, thiamin mononitrate [vitamin B1], riboflavin [vitamin B2], folic acid), water, soybean oil, high fructose corn syrup, yeast, salt, mono and diglycerides, enzyme modified soy lecithin, guar gum, methylcellulose, calcium propionate as a preservative, sodium stearoyl lactylate, xanthan gum, wheat grits, defatted soy flour, whey, enzymes, sorbitan monostearate, artificial flavor." See also www.labelwatch.com.

16. See Dalby, Andrew, and Grainger, Sally, *The Classical Cookbook*. Los Angeles: J. Paul Getty Museum, 1996.

17. De Voe, Thomas Farrington, *The Market Assistant, Containing a Brief Description of Every Article of Human Food Sold in the Public Markets of the Cities of New York, Boston, Philadelphia, and Brooklyn*. New York: 1867, 102.

18. "Meat for the Multitudes," *The National Provisioner* 185(1), July 4, 1981; 185(2): 108. See also, Horowitz, Roger, *Putting Meat on the American Table: Taste, Technology, Transformation*. Baltimore: Johns Hopkins University Press, 2006, 85.

19. www.hobartfood.com.au/company_history.asp

20. Horowitz, 85.

21. Interview with Edward Slotkin, formerly of Hygrade Company, March 1990.

22. *Jonesboro Gazette and Egyptian Vindicator*, Jonesboro, Illinois, November 10, 1865.

23. www.welcoa.org/freeresources/pdf/ted_townsend_interview.pdf; Miller, Stephen, "Inventor Had Relish for Hot Dog Making," *Wall Street Journal*, April 11, 2011 (http://online.wsj.com/article/SB10001424052748704843404576251132711301702.html).

24. "Edward C. Sloan," Wisconsin Meat Industry Hall of Fame (www.ansci.wisc.edu/Meat_HOF/2003/sloan.htm).

25. www.marel.com/systems-and-equipment/further-processing/Sausage-Making/MasterTwist-Pro/275/default .aspx?prdct=1

26. Marianski, Stanley, and Marianski, Adam, *Making Healthy Sausages*. Seminole, FL: Bookmagic, LLC, 2008. See also the patent for hybrid collagen-alginate system by Peter R. Visser, www.faqs.org/patents/app/20090061051.

27. Horowitz, 87.

28. Interview, Murray Handwerker, son of Nathan Handwerker, March 1990.

29. Interviews, Dr. James Klement, Klement's Sausage Company, September 2011; interview Frederick "Fritz" Usinger, March 1990.

30. U.S. Food and Drug Administration, Code of Federal Regulations, Title 9, Volume 2, Revised as of January 1, 2003, 9 CFR 319 (Definitions and Standards of Identity or Composition). From the U.S. Government Printing Office via GPO Access (www.fda.gov/Food/FoodSafety/RetailFoodProtection/FoodCode/FoodCode2001/ucm092709.htm).

31. Food and Agriculture Organization of the United Nations, FAO Corporate Document Repository, "Meat Processing Technology for Small- to Medium-Scale Producers" (www.fao.org/docrep/010/ai407e/AI407E05.htm).

32. Interview, Jody Monkarsh, owner Jody Maroni's Sausage Kingdom, November 2011.

33. U.S. Food and Drug Administration, Code of Federal Regulations, Title 9, Volume 2.

34. Knipe, C. Lynn. "Meat Emulsions," Meat Export Research Center, Iowa State University, n.d. (http://meatsci.osu.edu/archive/meatemulsions.htm).

35. See Bellwood, Peter, *First Farmers: The Origins of Agricultural Societies*. Oxford and Malden, MA: Blackwell Publishers, 2005; Smith, Bruce D., "The Origins of Plant Husbandry in Eastern North America," in C. Wesley Cowan and Patty Jo Watson, editors, *The Origins of Agriculture: An International Perspective*. Washington, DC: Smithsonian Institution Press, 1992; and Fussell, Betty, *The Story of Corn*. New York: Alfred A. Knopf, 1992.

36. See Pollan, Michael, *The Omnivore's Dilemma: A Natural History of Four Meals*. New York: Penguin, 2007, and *In Defense of Food: An Eater's Manifesto*. New York: Penguin, 2009.

37. Smith, Andrew F., *Eating History: Thirty Turning Points in the Making of American Cuisine*. New York: Columbia University Press, 2011; Watts, Alison, "The Technology That Launched a City: Scientific and Technological Innovations in Flour Milling during the 1870s in Minneapolis." *Minnesota History* 57(2) (Summer 2000): 86–97. See also www.naturesownbread.com/nat_allaboutbread/breadhistory/index.cfm. See www.aibonline.org/resources/booklistings/bakinghistory.html for a good, if dated, bibliography on baking history.

38. As discovered by Barry Popik, a major authority on hot dog history and nomenclature: www.barrypopik.com/index.php/new_york_city/entry/hot_dog_polo_grounds_myth_original_monograph/

39. "Milk Rolls" appears in Lea, Elizabeth E., *Domestic Cookery, Useful Receipts, and Hints to Young Housekeepers*. Baltimore: Cushings and Bailey, 1859 [1845], 38; Unknown, *365 Foreign Dishes, A Foreign Dish for Every Day in the Year* (1908), www.gutenberg.org/files/10011/10011-h/10011-h.htm, where buns are called Vienna Milk Rolls.

40. For a good overview of mustard history, see Man, Rosamund, and Weir, Robin, *The Mustard Book*. London: Grub Street Cookery, 2010.

41. www.frenchs.com/products/History.

42. Skrabec, Quentin R. H. J., *Heinz: A Biography*. Jefferson, NC: McFarland, 2009, 72–73.

43. Trollope, Frances Milton, *Domestic Manners of the Americans*. London: Whittacre and Treacher & Co, 2nd ed., Vol. II, 1832; Chevalier, Michael, *Society, Manners and Politics in the United States: Being a Series of Letters on North America*. Translated from the third Paris edition. Boston: Weeks, Jordan and Company, 1836, 287; Charles Dickens, *American Notes for General Circulation*. New York, Harper & Brothers, 1842; Levenstein, Harvey, *Revolution at the Table: The Transformation of the American Diet*. Berkeley: University of California Press, 2003, 8 (original quote from Arthur Meier Schlesinger, *Paths to the Present*. Boston: Houghton Mifflin, 1964, 227).

44. Morton, Mark, "Bread and Meat for God's Sake," *Gastronomica* 4(3) (Summer 2004), 6–7. See *Oxford English Dictionary*, "Sandwich," for etymologies and 1762 reference by Edward Gibbon.

45. Wilson, Bee, *Sandwich: A Global History*. London: Reaktion Books, 2010, 16–35.

46. Wilson, 77; Leslie, Miss [Eliza]. *Directions for Cookery, in Its Various Branches, Tenth Edition, with Improvements and Supplementary Receipts*. Philadelphia: E. L. Carey & Hart, 1840. http://digital.lib.msu.edu/projects/cookbooks/html/books/book_12.cfm.

47. *San Jose (CA) Mercury News*, "The Wienerwurst: The Man Who Sells the Delicious Morsel," July 11, 1887, 4. Found by Barry Popik, "The Big Apple": www.barrypopik.com/index.php/new_york_city/entry/hot_dog_polo_grounds_myth_original_monograph/.

48. Whitlock, Craig, "Germans Take Pride in the Wurst; 1432 Decree Shows Thuringian Sausage May Have Been Nation's First Regulated Food," *Washington Post*, December 2, 2007.

49. See "Glossary of Sausages and Prepared Meats," National Hot Dog and Sausage Council, www.hot-dog.org/ht/d/sp/i/38586/pid/38586.

50. "'Dear Julia': Letter from Cincinnati Written in 1870," *Bulletin of the Historical and Philosophical Society of Ohio*, 18 (April 1960): 105–15. And Musselman, Barbara L., "Working Class Unity and Ethnic Division: Cincinnati Trade Unionists and Cultural Pluralism," *Cincinnati Historical Society Bulletin* 34 (Summer 1976): 121–43.

51. Snow, Richard F., *Coney Island: A Postcard Journey to the City of Fire*. New York: Brightwaters Press, 1984, 56. Discovered by Barry Popik and cited in Gerald Leonard Cohen, Barry A. Popik, and David Shulman, *The Origin of the Term "Hot Dog."* Rolla, MO: Gerald Cohen, 2004, 269–70.

52. Immerso, Michael, *Coney Island: The People's Playground*. New Brunswick, NJ: Rutgers University Press, 2002, 130.

53. *Brooklyn Eagle*, February 9, 1886, 2, discovered by George Thompson, No. 11, 2003 and cited in Cohen, Popik, and Shulman, 275.

54. *Brooklyn Daily Times*, March 2004, 2, col. 4. This, and many other items detailing the true history of the term "hot dog," have been uncovered by researcher Barry Popik, cited in Cohen, Popik, and Shulman, 233.

55. See Cohen, Popik, and Shulman for versions of the story, especially pp. 279–80; also "Hot Dogs—History and Legends of Hot Dogs," in http://whatscookingamerica.net/History/HotDog/HDIndex.htm.

56. Mencken, H. L., *Happy Days, Mencken's Autobiography 1880–1892*. Baltimore, MD: John Hopkins University Press, 1996 [1936, 1937, 1939, 1940], 58–59.

CHAPTER 2

1. Geertz, Clifford, "Deep Play: Notes on the Balinese Cockfight," in *The Interpretation of Cultures*. New York: Basic Books, 1973, 414–53.

2. Interview, Beverly Pink, Pink's Hot Dogs, November 2011.

3. See Fischer, David Hackett, *Liberty and Freedom: A Visual History of America's Founding Ideas*. New York: Oxford University Press, 2004.

4. Lears, T. Jackson, *Fables of Abundance: A Cultural History of Advertising in America*. New York: Basic Books, 1994. See also the pioneering study, Potter, David, *People of Plenty: Economic Abundance and the American Character*. Chicago: University of Chicago Press, 1954.

5. Zeldes, Leah, "Chicago's Schmidt the Real Mr. Footlong Hot Dog Inventor," Dining Chicago.com: www.diningchicago.com/blog/2010/07/27/chicagos-schmidt-the-real-mr-footlong-hot-dog-inventor.

6. O. Henry, "Whistling Dick's Christmas Stocking," *McClure's Magazine*, December 1899, 138–46.

7. Mercuri, Becky, "Hoagies," *The Oxford Encyclopedia of Food and Drink in America*, vol. 1. Edited by Andrew F. Smith, 677.

8. Kasson, John F., *Rudeness and Civility: Manners in Nineteenth-Century America*. New York: Hill and Wang, 1990, 186.

9. Kasson, 12–13.

10. Bremmer, Jan N., and Roodenburg, Herman, *A Cultural History of Gesture.* Ithaca, NY: Cornell University Press, 1992, 88.

11. Curry, Pamela Malcolm, and Jiobu, Robert M., "Big Mac and Caneton a L'Orange: Eating, Icons and Rituals," *Rituals and Ceremonies in Popular Culture.* Edited by Ray B. Browne. Bowling Green, OH: Bowling Green University Popular Press, 1980, 247–57.

12. Barry, Dan, "Ambassador Hot Dog," *New York Times,* June 6, 2009: www.nytimes.com/2009/06/07/weekinreview/07barry .html.

13. See Gabaccia, Donna R., *We Are What We Eat: Ethnic Food and the Making of Americans.* Cambridge, MA: Harvard University Press, 1989, for an excellent study of the process.

14. See Coe, Andrew, *Chop Suey: A Cultural History of Chinese Food in the United States.* New York: Oxford University Press, 2009, the best book yet on how food from one small area of China came to dominate Americans' idea of a whole cuisine.

15. Mencken, H. L., "Victualry as a Fine Art," *Chicago Daily Tribune,* June 13, 1926, E1.

16. Kessler, Roman, "The Craze over Currywurst," *Wall Street Journal,* August 27, 2009, this on the opening of Berlin's currywurst museum—and many other sources. The sauce is made from ketchup, Worcestershire sauce, and a packaged curry powder.

17. Trachtenberg, Alan, *The Incorporation of America: Culture and Society in the Gilded Age.* New York: Hill and Wang, 2007, 88.

18. Levine, Lawrence W., *Highbrow/Lowbrow: The Emergence of Cultural Hierarchy in America.* Cambridge, MA: Harvard University Press, 1988, 177.

19. Fields, Armond, *Tony Pastor: Father of Vaudeville.* Jefferson, NC: McFarland, 2007, 96.

20. Kersten, Holger, "Using the Immigrant's Voice: Humor and Pathos in Nineteenth Century 'Dutch' Dialect Texts," *Melus* 21(4), *Ethnic Humor* (Winter 1996): 3–17; see *Carl Pretzel's Komikal Speaker; A New Collection of Droll, Whimsical, Laughable and Odd Pieces for Recitation, in Schools, Exhibitions, Young People's Societies, and Parlor Entertainments. Prepared Expressly for This Series.* New York: Beadle And Adams, Publishers, 1873 [Beadle's Dime Speaker Series, No. 15]; *Carl Pretzel, Vedder Brognostidikador Almineck Kalinder, 1872.* Robert M. de Witt, Publisher, 1872.

21. Ashby, LeRoy, *With Amusement for All: A History of American Popular Culture since 1830.* Lexington: University of Kentucky Press, 2006, 123–27.

22. Reynolds, Quentin, "Peanut Vendor, and Father of the Hot Dog," *Collier's,* October 19, 1935. See also Popik, Barry, "Hot Dog–the Polo Ground Myth." www.barrypopik.com/index.php/new_york_city/entry/hot_dog_polo_grounds_myth_ original_monograph/

23. "'TAD,' CARTOONIST, DIES IN HIS SLEEP: Thomas A. Dorgan, Famous for His 'Indoor Sports,' Victim of Heart Disease. WAS A SHUT-IN FOR YEARS Worked Cheerfully at Home in Great Neck on Drawings That Amused Countless Thousands. Took up Drawing after Accident. First to Say 'Twenty-three, Skidoo.'" *New York Times,* May 3, 1929, 21.

24. Rice, Grantland, "The Sportlight," *New York Sun,* May 5, 1943, 34. Cited as the definitive, to date, work on the subject: Cohen, Gerald Leonard, Popik, Barry A., and Shulman, David, *The Origin of the Term "Hot Dog."* Rolla, MO: Gerald Cohen, 2004, 372.

25. ". . . Bacon, ham, sausages." *Chicago Daily Tribune* (1847–1858), June 10, 1857; *National Police Gazette,* March 20, 1886, pg. 2, col. 2, cited in http://listserv.linguistlist.org/cgi-bin/wa?A2=ind0008A&L=ADS-L&P=R5917&I=-3.

26. The folk song is "'Z' Lauterbach hab Ich mein Strumpf verlor'n," or "I Lost My Socks in Lauterbach." http://www .library.upenn.edu/collections/rbm/keffer/winners.html.

27. Cohen, Popik, and Schulman. See entries on the history of the name.

28. Zimmer, Ben, "'Hot Dog': The Untold Story," http://www.visualthesaurus.com/cm/wordroutes/2847/, May 13, 2011. See also Wilton, David, *Word Myths: Debunking Linguistic Urban Legends.* New York: Oxford University Press, 2008, 57, on possible 1880's usage of the term, citing Farmer, John S., and Henley, William E., *Slang and Its Analogues Past and Present.* London: Harrison and Sons, 1891.

29. Cohen, Popik, and Schulman.

30. Zwilling, Leonard, "A TAD Lexicon." *Etymology and Linguistic Principles* 3. Rolla, MO: L. Cohen, 1993.

31. Interview, George Krueger, Krueger Sausage Company, Chicago, January 1990.

32. Interview, Gregory Paplexis, president of Marathon Enterprises, May 1992.

33. Interview, Sheldon Davis, son Henry Davis, January 1990.

34. Interview, Murray Handwerker, son of Nathan Handwerker, March 1990.

35. Abelson, Jenn, "Winning Season and Seasoning for Local Frank Maker at Fenway," *Boston Globe*, April 1, 2009: http://www.boston.com/news/local/massachusetts/articles/2009/04/01/winning_season_and_seasoning_for_local_frank_maker_at_fenway/

36. Interview, Carl Gylfe, vice president of marketing, Ball Park Franks, April 1990.

37. Fujinaka, Mariko, "Plump When You Cook 'Em Campaign," http://www.jiffynotes.com/a_study_guides/book_notes_add/emmc_0001_0001_0/emmc_0001_0001_0_00139.html#PLUMP_WHEN_YOU_COOK_EM_Campaign

38. Interview, Oscar G. Mayer, March 1990. For a brief history of the Oscar Mayer company see Kraig, Bruce, *Hot Dog: A Global History.* London; Reaktion Press, 2009.

39. For a take on how marketers use symbols and repetition to condition consumer's minds and habits, see Duhigg, Charles, "Can't Help Myself," *New York Times* magazine, March 9, 2012, and his new book, *The Power of Habit: Why We Do What We Do in Life and Business.* New York: Random House, 2012.

40. Cain, James M., *The Magician's Wife.* New York: Dial Press, 1965. Quoted in Dingley, Robert, "Eating America: The Consuming Passion of James M. Cain," *Journal of Popular Culture* (Winter 1999) 33(3): 63.

CHAPTER 3

1. James M. Cain, *The Postman Always Rings Twice.* New York: Vintage Books, 1978 [1934], 29, 96. See also Dingley, Robert, "Eating America: The Consuming Passion of James M. Cain," *Journal of Popular Culture* (Winter 1999) 33(3): 63.

2. www.sabretthotdogcarts.com/history.htm.

3. Sol Tax, *Penny Capitalism.* Chicago: University of Chicago Press, 2nd printing, 1962.

4. Interview with Frank Tillotson, September 1998.

5. "Former Professor Peddling Peanuts on N.W.U. Campus," *Chicago Daily Tribune*, September 24, 1913.

6. Albert, Samantha, "A Street Cart Vendor Builds Community on Toronto's Hospital Row," http://edibletoronto.com/spring-2012/marianne-moroney.htm and interview April, 2011.

7. Steinberg, Ellen F., and Prost, Jack H., *From the Jewish Heartland: Two Centuries of Midwest Foodways,* Champaign: University of Illinois Press, 2011. Steinberg and Prost give a nice survey of the early history. For Jewish foodways in New York City see Berg, Jennifer, "From the Big Bagel to the Big Roti? The Evolution of New York City's Jewish Foods." In Hauck-Lawson, Annie, and Deutsch, Jonathan, *Gastropolis, Food and New York City.* New York: Columbia University Press, 2009, 253–73.

8. Gregory Papalexis interview.

9. Katsakiori, Nikoleta, *Drifting Away: Transnational Migration between Mathraki and New York City.* PhD dissertation, Department of Social Anthropology, University of Manchester, 2003. Katsakiori, chapter 5.

10. Meade, James W., "Have You Got The 'Hot Dog' Habit? No? Then Hurry for Everybody That's Anybody." *Atlanta Constitution*, Sunday, April 13, 1913, 14.
11. Yung, Katherine, and Grimm, Joseph, *Coney Detroit*. Detroit: Wayne State University Press, 2011, 5–13.
12. Interview, Albert Koegel, April 2011.
13. Lockwood, William, *The Coney in Southeast Michigan: "Something More Substantial for the Working Man,"* in Lysaght, Patricia (ed.), *Time For Food: Everyday Food and Changing Meal Habits in Global Perspective*. Åbo, Finland: Åbo Akademi University Press, 2012, 143–56.
14. Interview, Tom Zadrovsky, July 2011.
15. "One Hot Dog: How Tulsa became a Coney Town," *Journal Record* (Oklahoma City, OK), July 28, 2006.
16. Interview with Harry Dionyssiou, April 2011.
17. Lukas, Paul, "The Big Flavors of Little Rhode Island," *New York Times*, November 13, 2002.
18. Lloyd, Timothy, "Paterson's Hot Texas Wiener Tradition." *Folklife Center News* 17(2) (Spring 1995): http://memory.loc.gov/ammem/collections/paterson/essay6.html.
19. Popik, Barry, "Texas Hot Weiners (Texas Weiners, or Texas Wieners)," www.barrypopik.com, August 9, 2009.
20. Interview with James Racioppi, August 2011.
21. Interview with Dolores Ranieri, August 2011.
22. Interview with Daniel Contreras and Martin Miranda, operations manager, El Güero Canelo, November 2011.
23. Interview with Egla Guttierez, Los Michoacanos, November 2011.
24. Lui, Samantha, "Removing the Red Tape on Toronto's Street Food Industry," *Can Culture*, September 22, 2011: www.canculture.com/2011/09/22/food-carts/. See also Street Vendor Project, New York City, Asociación Vendadores Ambulantes in Chicago, www.streetnet.org.za, and www.openair.org, among others.
25. Bluestone, Daniel M., "'The Pushcart Evil': Peddlers, Merchants, and New York City's Streets, 1890–1940," *Journal of Urban History* 18 (1991): 74.
26. Barbara Olsen, talk at the "Encased Meats" conference, Greater Midwest Foodways Alliance, Chicago, Illinois, April 2009.
27. Interview with Mike Nolan, manager of The Windmill, Long Branch, New Jersey.
28. Interview with Jordan Monkarsh, November 2011.
29. Stern, Jane, and Stern, Michael, *Roadfood: The Coast-to-Coast Guide to Over 400 of America's Great Inexpensive Regional Restaurants, All within 10 Miles of a Major Highway*. New York: Random House, 1978.
30. Krall, Hawk, "The Search for America's Best Hot Dog: The Midwest." www.seriouseats.com/2011/02/what-is-the-best-hot-dog-in-america-midwest-chicago-detroit.html?ref=search. Other regions are covered as well. See also http://hawkkrall.blogspot.com/.
31. Interview with Hollister Moore, August 2011. See also www.hollyeats.com and www.hollyeats.com/me.htm.
32. Haden, Roger, "Lionizing Taste: Towards An Ecology of Contemporary Connoisseurship" in Jeremy Strong (ed.). *Educated Tastes: Food, Drink and Connoisseur Culture*. Lincoln: University of Nebraska Press, 2011, 276–77.
33. Interview with Joe and John Fencz, July 2011.
34. Interview with John Fox, July 2011.

CHAPTER 4

1. In an influential essay, literary theorist Roland Barthes remarked that the Eiffel Tower in Paris is an inescapable symbol because it means everything all at once. That is, the tower is seen by people—it is very large after all—but they know what it is because they latch onto its hidden meanings. The same holds for certain foods, hot dogs among them.

Barthes, Roland, *The Eiffel Tower and Other Mythologies*. Translated by Richard Howard. New York: The Noonday Press, 1979, 4–5.

2. Hine, Tomas, *I Want That!* New York: HarperCollins, 2002, 160.
3. Interview, Randy Garutti, general manager, Shake Shack, August 2011.
4. Gutman, Richard J. S., *The American Diner, Then and Now*. Baltimore: Johns Hopkins University Press, 1993, 13–15.
5. de Certeau, Michel, "Practices of Space," in *On Signs*, edited by Marshall Blonsky. Baltimore: Johns Hopkins University Press, 1985, 127.
6. Gutman, 22–31.
7. Interview, William Wolfe, Carney's owner, November 2011.
8. The concept of *carnevale* was invented by the Russian literary scholar, Michael Bakhtin. His idea of carnevale as "grotesque realism" is widely quoted in popular culture studies. Bakhtin, Mikhail Mikhailovich, *Rabelais and His World*. Translated by Hélène Iswolsky. Bloomington: Indiana University Press, 1984 [1965].
9. Marling, Karal Ann, *The Colossus of Roads: Myth and Symbol along the American Highway*. Minneapolis: University of Minnesota Press, 194.
10. Barthes, 124.
11. Bausinger, Herman, *Folk Culture in a World of Technology*. Translated by Elke Dettmer. Bloomington: Indiana University Press, 1990, 15.

CHAPTER 5

1. Schwartz, Bob, *Never Put Ketchup on a Hot Dog*. Chicago: Chicago's Books Press, 2008, 23–28. The earliest reference so far to relish on a Chicago dog is: Burns, Edward, "Judge, What We Need Are Standardized Hot Dogs," Chicago Daily Tribune, August 12, 1928. ProQuest Historical Newspapers Chicago Tribune (1849–1986). The author complains that the Chicago Cubs and White Sox ballparks do not serve piccalilli on their dogs, unlike vendors outside the ball fields.
2. Lee, Jennifer, "A Legacy of Hot Dog Onion Sauce," *New York Times*, January 12, 2009.
3. Gordinier, Jeff, "Redefining the Hot Dog, a Cart at a Time," *New York Times*, August 9, 2011.
4. Interview, Wayne Rosenbaum, owner of Papaya King, July 2011.
5. GutterGourmet, "Always Hungry: Queens Hot Dog Trucks," www.thedailymeal.com/queens-hot-dog-trucks, January 8, 2010.
6. See recipes for the sauce in Mercuri, Becky, *The Great American Hot Dog Book: Recipes and Side Dishes from across America*. Layton, UT: Gibbs Smith, 2007, 35.
7. See Strahan, Jerry E., *Managing Ignatius: The Lunacy of Lucky Dogs and Life in New Orleans*. New York: Broadway Books, 1998.
8. Lloyd, Timothy, "The Cincinnati Chili Culinary Complex," *Western Folklore* (1981), 28–40.
9. Interview, William Wolfe, owner of Carney's, November 2011.
10. Patent issued to Stanley Jenkins, Buffalo, New York, US1706491 (A)—Combined dipping, cooking, and article-holding apparatus, 1927, http://worldwide.espacenet.com/publicationDetails/biblio?CC=US&NR=1706491&KC=&FT=E&locale=en_EP
11. Interview with Sue Waldmeier, owner of Cozy Dog, August 2011.
12. Kraig, Bruce, "The Iconography of American Fast Food," *Proceedings of the Oxford Symposium* (1992).
13. Interview, Don and Rasheeda Scott, owners of Otis Jackson's Soul Dog, November 2011.
14. Interview, Doug Sohn, owner of Hot Doug's, July 2009.

Selected Bibliography

Bellwood, Peter. *First Farmers: The Origins of Agricultural Societies*. Malden, MA: Blackwell Publishers, 2005.

Consumer Reports, "Hot Dogs without Too Much Guilt," July 2007.

Dalby, Andrew, and Grainger, Sally. *The Classical Cookbook*. Los Angeles: J. Paul Getty Museum, 1996.

Douglas, Mary. *Purity and Danger: An Analysis of the Concepts of Pollution and Taboo.* London: Routledge (New edition), 1984.

Ferrières, Madeleine. *Sacred Cow, Mad Cow: A History of Food Fears.* Translated by Jody Gladding. New York: Columbia University Press, 2006.

Fischer, David Hackett. *Liberty and Freedom: A Visual History of America's Founding Ideas.* New York: Oxford University Press, 2004.

Fussell, Betty. *The Story of Corn*. New York: Alfred A. Knopf, 1992.

Geertz, Clifford. "Deep Play: Notes on the Balinese Cockfight." *The Interpretation of Cultures.* New York: Basic Books, 1973.

Horowitz, Roger. *Putting Meat on the American Table: Taste, Technology, Transformation*. Baltimore: Johns Hopkins University Press, 2006.

Lears, T. Jackson. *Fables of Abundance: A Cultural History of Advertising in America*. New York: Basic Books, 1994.

Mercuri, Becky. "Hoagies." *The Oxford Encyclopedia of Food and Drink in America*, vol. 1, Andrew F. Smith, editor. New York: Oxford University Press, 2004.

National Hot Dog and Sausage Council: http://www.hot-dog.org.

Pollan, Michael. *The Omnivore's Dilemma: A Natural History of Four Meals*. New York: Penguin, 2007.

Pollan, Michael. *In Defense of Food: An Eater's Manifesto*. New York: Penguin, 2009.

Popik, Barry. "Shaggy Dog (Frito chili pie + hot dog)."

http://www.barrypopik.com/index.php/new_york_city/entry/shaggy_dog_frito_chili_pie_hot_dog/

Potter, David. *People of Plenty: Economic Abundance and the American Character.* Chicago: University of Chicago Press, 1954.

Scott, Herbert. *Groceries: Poems*. Pittsburgh: University of Pittsburgh Press, 1976.

Smith, Andrew F. *Eating History: Thirty Turning Points in the Making of American Cuisine.* New York: Columbia University Press, 2011.

Smith, Bruce D. "The Origins of Plant Husbandry in Eastern North America," in C. Wesley Cowan and Patty Jo Watson, editors, *The Origins of Agriculture: An International Perspective.* Washington, DC: Smithsonian Institution Press, 1992.

Watts, Alison. "The Technology That Launched a City: Scientific and Technological Innovations in Flour Milling during the 1870s in Minneapolis," *Minnesota History* 57(2) (Summer, 2000): 86–97.

Zirin, Dave. *A People's History of Sports in the United States: 250 Years of Politics, Protest, People, and Play.* New York: The New Press, 2009.

Index

Note: Page numbers in italics indicate photographs.

Papalexis, Gregory, 66, 113. *See also* Sabrett
Papaya King, 66, 113, *114*, 118, *119*, 145
Pennsylvania, vii, 23, 24, 75, 120, 124
Physicians Committee for Responsible Medicine, 11
Pink, Beverly, 33, 69, *72*
Poles, 7, 24, 64, 98, 135
Polish sausage, 7, *25*, *41*, *54*, 123, 135
Popik, Barry, 29, 30, 51, 53, 54, 55, 75
Popoff, Alex and Maggie, *80*
Pronto Pups, 142
Poulos, Gus, 113, 118. *See also* Papaya King
puka dogs (Hawaii), 140

Racioppi, James, *7*. *See also* New Jersey hot dog eateries: Jimmy Buffs
Ranieri, Dee, *68*, 76, 77
Red Hot Chicago, 53, 66, 132
red hots, 51, 52, 66, 88, 113, 123, 127
regional hot dog styles, *6*
retro design, 110, 197
Rhode Island hot dog eateries: Hewtin's (truck) (Providence);
 New York System (Olneyville section, Providence and
 Cranston), 124; Original New York System (Providence),
 124; Spike's Junkyard Dogs, 124
Rhode Island hot dog styles, 124
Rippers, 35, 83, 120, 122
Rosa the dog, *50*
Rosenbaum, Wayne, 118. *See also* Papaya King

Sabrett, 53, 63, 66, 77, 85, 152
sandwich, 23–27, 29, 30, 31, 36, 39, 44–46, 75, 83, 89, 115, 119–43,
 177n9
sausage, 5, 7, 8, 13–20, 22, 23, 27–31, 39, 40, 44, 47–49, 57, 79,
 118, 125, 135, 147; sausage processing machinery, 14–17
Scott, Don and Rasheedah, *72*, 145. *See also* California hot dog
 eateries: Otis Jackson's Soul Dog
Scott, Walter ("lunchman"), 89
scrambled dogs, 127
Sinclair, Upton, 8, 15
skinless hot dogs, 5, 16, 127
slaw dogs, 118, 123, 125, 127, 136, 143, 144, 147; Sam's (West
 Virginia), 125
Smith, Andrew F., 23, 27

Sohn, Doug, 24, 147
Sonic Drive-In, 20, 65, 143
Sonoran Hot Dogs (recipe), 154
Split Pea Soup with Hot Dogs (recipe), 151
Steak 'n Shake, 20, 66
Stevens, Harry M., 47–49
Stern, Jane and Michael (Roadfood), 81
sustainable meats hot dogs, 22
Sweet-Sour Frankfurters (recipe), 168
Swift and Company, 15

Tetrazzini Hot Dogs (recipe), 171
Texas Pete's (sauce), 129
Thai Spicy Cucumber Sauce Hot Dogs (recipe), 156
Tillotson, Frank, 63, 65
tube steak, 5, 87

Urban Justice Center, New York City, 77; Vendy Awards, 78
Usinger's (Milwaukee), 18, 28, 81, 107

vaudeville, 40–42, 52, 53, 81
vegetarian hot dogs, 7, 11
Vendy Awards, 78
vernacular art, 3, 89–90, 107
Vienna Beef, 53, 66, 85
Viskase (Visking), 17

Waldmeier, Ed and Sue, 142. *See also* Illinois hot dog eateries:
 Cozy Dog
Washington, D.C., *116*, 124; Ben's Chili Bowl, 107, 124, *126*
Washington State, 164; Hot Dog Joe's truck, 140; Seattle, 140;
 Seattle-style, 77
Washington State Hot Dogs (recipe), 164
Webster, Frank "Uncle Frank," 107
wheat, 23, 31
wiener, 49, 75, 102, 120, 124, *128*
Wilson Packing, 59
Winner, Septimus (song writer), 49
Wolfe, John and Bill, 136. *See also* Carney's

Zadarovsky, Tom, *72*, 73–74
Zimmer, Ben (Visual Thesaurus.com), 51

About the Author and the Photographer

BRUCE KRAIG, professor emeritus at Roosevelt University, is a noted food historian who regularly publishes and speaks on the topic of world and American foodways. He has published widely on the history of hot dogs, including the book *Hot Dogs: A Global History* (2009), which won a Paris Book Fair Award. As the authority on the culture, lore, and history of hot dogs, he has appeared often in national media, including documentaries by the History Channel and the Discovery Channel.

PATTY CARROLL is adjunct professor of photography at the School of the Art Institute of Chicago. She specializes in photographing American popular culture. Her hot dog photographs are on permanent display at the Chicago History Museum and have been shown at the Chicago Water Tower Photography Gallery and in various group exhibitions. She has published and exhibited internationally on American cultural topics including Elvis impersonators, suburban lawns, and resorts at night. Her books include *Living the Life: The World of Elvis Tribute Artists* and *Culture Is Everywhere*, and her hot dog stand photos are included in *Changing Chicago*.